UNDERSTANDING
POPULAR CULTURE

UNDERSTANDING POPULAR CULTURE

John Fiske

LONDON and NEW YORK

First published in 1989
Second impression 1990

Reprinted in 1991 by
Routledge
11 New Fetter Lane, London EC4P 4EE
29 West 35th Street, New York, NY 10001

British Library Cataloguing in Publication Data

Fiske, John
 Understanding popular culture.
1. Popular culture
I. Title
306'.1
ISBN 0-415-07876-8

Library of Congress Cataloging-in-Publication Data

Fiske, John.
 Understanding popular culture.
Bibliography p.
Includes index.
1. Popular culture. 2. Capitalism.
I. Title
CB151.F574 1989 306.4 89-5720
ISBN 0-415-07876-8

Typeset in 10 on 12 point Palatino by Fotographics (Bedford) Ltd
and printed in Great Britain by Billing and Sons, Worcester

To Lisa
To Lucy and Matthew

Contents

Preface

In this book I attempt to outline a theory of popular culture in capitalist societies. It is published simultaneously with *Reading the Popular*, a collection of analyses of some key sites and texts where the people make their cultures: these range from the beach to Madonna, from TV news to Sears Tower.

Understanding Popular Culture moves from theories to readings, *Reading the Popular* from readings to theories. Each book is designed to be self-sufficient, but I hope those who read both will find that the readings flesh out and interrogate the theories, and the theories deepen and generalize the readings. But neither book requires the other, so those whose interests center more focusedly on either the theoretical or the analytical should not feel deprived if they confine themselves to one or the other.

One of the advantages of being an academic is that theories travel well, with only a touch of jet lag. Consequently, over the last decade I have been fortunate enough to move freely among the United Kingdom, Australia, and the United States. My nomadism has left many traces in these books, but my experiences in different continents are held together by a common thread running through them—the countries with which I am familiar, and whose cultures I write about, are all white, patriarchal, capitalist ones. Of course, each inflects the common ideology differently, but the differences are comparatively superficial, though fascinating to live through and think about.

Reading the Popular is more geographically specific than this book, because analyses are necessarily tied more closely to their social contexts than are theories. Indeed, the theories that I use are European in origin—Bourdieu, de Certeau, Barthes, Hall, and Bakhtin are their anchors—but I use them to analyze the popular culture of English-speaking countries. Shopping

malls, video arcades, beaches, skyscrapers, and Madonna all circulate their meanings in the United States and Australia, but I read them with a European eye. My work as an academic is as much a social product as that of a builder of motorcars. The history of cultural studies, my academic history, and my personal history all intersect and inform one another, and produce me as a speaking and writing voice at the end of the 1980s. Those familiar with my earlier writings will inevitably find echoes in these books. I hope, however, that such echoes are amplified enough for them to be not merely repetitious (though I do wish to acknowledge that one section of Chapter 4 appeared almost verbatim in *Television Culture*; Fiske, 1987b).

My histories and the multiple voices of my colleagues, friends, antagonists, students, teachers, and others constitute the resource bank that I·raid in order to speak and write: I take full responsibility for the use I make of them, but without them nothing would have been possible. I wish both of these books to be a grateful acknowledgment to all who, however unwittingly—or even unwillingly—have contributed to them. The vast majority of these I cannot name: some, whose contributions are in their own words, are referenced directly; others who have contributed in different ways to this book I wish to thank here.

First among them is Lisa Freeman of Unwin Hyman, whose editorial expertise and encouragement have been the most formative of influences, and a model of how productive the right relationship between publishing and academia can be. Three other colleagues have given more freely of their time, experience, and insight than I had any right to expect—they are David Bordwell, Larry Grossberg, and John Frow. Others who have helped include Graeme Turner, Jon Watts, Rick Maxwell, Mike Curtin, Henry Jenkins, Jule D'Acci, Lynn Spigel, Noel King, Bob Hodge, Tom Streeter, Jackie Byars, Bobby Allen, Jane Gaines, Susan Willis, Liz Ferrier, and Ron Blaber. My secretarial colleagues, Rae Kelly in Perth and Evelyn Miller and Mary Dodge in Madison, have contributed as much as my academic colleagues, and I thank them for their friendly expertise. I hope that these two books will give some pleasure to all who have contributed in one way or another to their production, and I look forward to many more years of friendship and collaboration

I also wish to acknowledge the following for permission to reproduce material: Wrangler Jeans, Zena Enterprises, and Weekly World News. Although every attempt has been made to trace the illustrations' sources, in some instances we have not been successful. For this we apologize and would welcome claims for acknowledgment in subsequent editions.

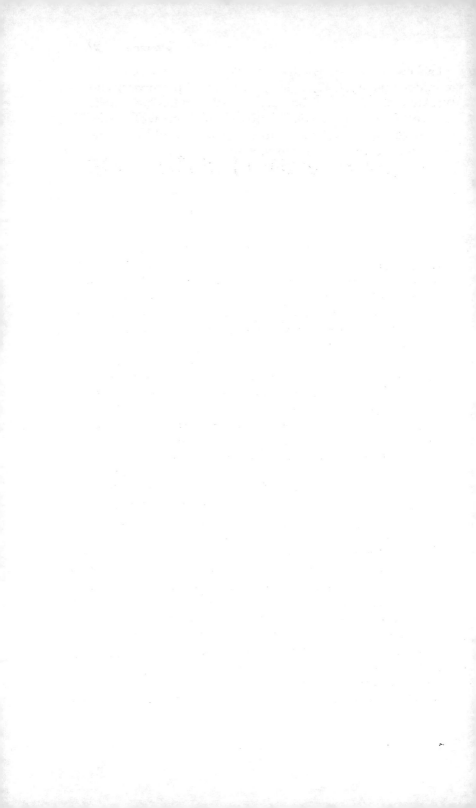

The Jeaning of America

Of 125 students of mine, 118 were, on the day that I asked, wearing jeans. The deviant 7, also possessed jeans, but did not happen to be wearing them. I wonder if any other cultural product—movie, TV program, record, lipstick—would be so *popular*? (T-shirts were as widely owned, but much less regularly worn.) Students may not be typical of the population as a whole, though jeans *are* widely popular among non-students in the same age group, and only slightly less widespread among older age groups. So thinking about jeans is as good a way as any to begin a book on popular culture.

Let's dismiss their functionality first, for this has little to do with culture, which is concerned with meanings, pleasures, and identities rather than efficiency. Of course jeans are a supremely functional garment, comfortable, tough, sometimes cheap, and requiring "low maintenance"—but so, too, are army fatigues. The functionality of jeans is the precondition of their popularity, but does not explain it. In particular, it does not explain the unique ability of jeans to transect almost every social category we can think of: we cannot define a jeans wearer by any of the major social category systems—gender, class, race, age, nation, religion, education. We might argue that jeans have two main social foci, those of youth and the blue-collar or working class, but these foci should be seen as semiotic rather than sociological, that is, as centers of meaning rather than as social categories. So a middle-aged executive wearing jeans as he mows his lawn on a suburban Sunday is, among other things, aligning himself with youthful vigor and activity (in opposition to the distinctly middle-aged office desk) and with the mythic dignity of labor—the belief that physical labor

is in some way more honest than wheeling and dealing is deeply imbued in a nation whose pioneers are only a few generations in the past, and is, significantly, particularly widespread among the wheelers and dealers themselves.

My students, largely white, middle-class, young, and well educated, are not a representative sample of the whole population, and so the meanings they made of their jeans cannot be extended to other groups, but the process of making and communicating meanings is representative even though the meanings made by it are not.

I asked my class to write briefly what jeans meant to each of them: these notes were then discussed generally. The discussions produced, unsurprisingly from such a homogeneous group, a fairly coherent network of meanings that grouped themselves around a few foci. These meaning clusters related to each other sometimes coherently, sometimes contradictorily, and they allowed different students to inflect the semiotic network differently, to make their own meanings within the shared grid.

There was one cluster of meanings that were essentially community integrative, that denied social differences. Jeans were seen as informal, classless, unisex, and appropriate to city or country; wearing them was a sign of freedom from the constraints on behavior and identity that social categories impose. *Free* was the single most common adjective used, frequently with the meaning of "free to be myself."

An article in the *New York Times* (20 March 1988) quotes a psychologist who suggests that jeans' lack of differentiation results not in a freedom to be oneself, but the freedom to hide oneself. Jeans provide a facade of ordinariness that enables the wearer to avoid any expression of mood or personal emotion—they are, psychologically at least, repressive. This flip-side of "freedom" was not evident among my students, and it appears to be a typical psychoanalyst's explanation in that it emphasizes the individual over the social and the pathological over the normal. Clothes are more normally used to convey social meanings than to express personal emotion or mood.

The lack of social differentiation in jeans gives one the freedom to "be oneself" (and, I suppose, in abnormal cases, to hide oneself), which, of course, points to a telling paradox that

the desire to be oneself leads one to wear the same garment as everyone else, which is only a concrete instance of the paradox deeply structured into American (and Western) ideology that the most widely held communal value is that of individualism. The desire to be oneself does not mean the desire to be fundamentally different from everyone else, but rather to situate individual differences within communal allegiance. There were, as we shall see below, signs of social differences between jeans wearers, but while these may contradict, they do not invalidate the set of communally integrative meanings of jeans.

Another cluster of meanings centered on physical labor, ruggedness, activity, physicality. These meanings, again, were attempts to deny class differences: the physical toughness connoted by jeans allowed these middle-class students to align themselves with a highly selective set of meanings of physical labor (its dignity and its productivity, but certainly not its subordination and exploitedness). Jeans were able to bear class-specific meanings of the American work ethic.

Their physicality and ruggedness were not just inflected toward work, they also bore meanings of naturalness and sexuality. *Natural* was an adjective used almost as frequently as *free*. The informality of jeans in contrast with the formality of other clothes was a concrete instance, or transformation, of the deeply structured opposition between nature and culture, the natural and the artificial, the country and the city. The body is where we are most natural, so there was an easy cluster of meanings around the physicality of jeans, the vigor of the adolescent body, and "naturalness." This meaning cluster could be inflected toward strength, physical labor, and sports performance (for, as argued in Chapter 4, sport allows the middle-class body the recognition of physical prowess that labor allows the working class) for the men, and toward sexuality for the women. Of course, such gender differences are not essential, but they are sites of struggle for control over the meanings of masculinity and femininity. Many women participated in the more "masculine" meanings of jeans' physicality, as did many men in their more "feminine" ones, of sexual display.

These natural/artificial and physical/nonphysical meanings joined with others in a set clustered around the American West.

The association of jeans with the cowboy and the mythology of the Western is still strong. The meanings that helped to make the West significant for these 1980s students were not only the familiar ones of freedom, naturalness, toughness, and hard work (and hard leisure), but also progress and development and, above all, Americanness. As the opening of the western frontier was a unique and definitive moment in American history, so jeans were seen as a unique and definitive American garment, possibly America's only contribution to the international fashion industry. Despite the easy exportability of the Western myth and its ready incorporability into the popular culture of other nations, it always retains its Americanness: it thus admits the forging of links between American values and the popular consciousness of other nationalities. Similarly, jeans have been taken into the popular culture of practically every country in the world, and, whatever their local meanings, they always bear traces of their Americanness. So in Moscow, for example, they can be made sense of by the authorities as bearers of Western decadence, and they can be worn by the young as an act of defiance, as a sign of their opposition to social conformity—a set of meanings quite different from those of contemporary American youth, though more consonant with those of the 1960s, when jeans could carry much more oppositional meanings than they do today.

If today's jeans are to express oppositional meanings, or even to gesture toward such social resistance, they need to be disfigured in some way—tie-dyed, irregularly bleached, or, particularly, torn. If "whole" jeans connote shared meanings of contemporary America, then disfiguring them becomes a way of distancing oneself from those values. But such a distancing is not a complete rejection. The wearer of torn jeans is, after all, wearing jeans and not, for instance, the Buddhist-derived robes of the "orange people": wearing torn jeans is an example of the contradictions that are so typical of popular culture, where what is to be resisted is necessarily present in the resistance to it. Popular culture is deeply contradictory in societies where power is unequally distributed along axes of class, gender, race, and the other categories that we use to make sense of our social differences. Popular culture is the culture of the subordinated and disempowered and thus always bears

within it signs of power relations, traces of the forces of domination and subordination that are central to our social system and therefore to our social experience. Equally, it shows signs of resisting or evading these forces: popular culture contradicts itself.

The importance of contradiction within popular culture is discussed in more detail in Chapters 2 and 5 and elaborated throughout this book, but for the moment we can turn to a discussion of two of its characteristics: the first I have noted, that contradiction can entail the expression of both domination and subordination, of both power and resistance. So torn jeans signify both a set of dominant American values and a degree of resistance to them. The second is that contradiction entails semiotic richness and polysemy. It enables the readers of a text, or the wearers of jeans, to partake of both of its forces simultaneously and devolves to them the power to situate themselves within this play of forces at a point that meets their particular cultural interests. So jeans can bear meanings of both community and individualism, of unisexuality and masculinity or femininity. This semiotic richness of jeans means that they cannot have a single defined meaning, but they are a resource bank of potential meanings.

Of course, the manufacturers of jeans are aware of all this and attempt to exploit it for their commercial interests. In their marketing and advertising strategies they attempt to target specific social groups and thus to give their product sub-culturally specific inflections of the more communal meanings. Thus a TV commercial for Levi's 501s shows three youths, obviously poor and of subordinate class and/or race, in a run-down city street. The impression given is one of the sharing of hard living and toughness: the picture is tinted blue-gray to connote the blueness of jeans, of blue-collar life, and of "the blues" as a cultural form that expresses the hardships of the socially deprived. The sound track plays a blues-influenced jingle. Yet, contradicting these pessimistic meanings are traces of cowboyness, of living rough but succeeding, of making a little personal freedom or space within a constrained environment, and of finding a masculine identity and community within the hard living. The ad bears distinct traces of the ideology of meritocratic capitalism that one can, should, make

one's success and identity out of hard conditions; one should not be born to them.

This image of jeans may seem very different from that promoted by an ad for Levi's 505s (Figure 1) that shows a girl wearing them looking up at the sky, where a skein of wild geese is flying in a formation that spells out "Levi's." This foregrounds meanings of freedom and naturalness, and then links feminine sexuality to them. In the two ads freedom, nature, and femininity are directly opposed to deprivation, the city, and masculinity, and Levi's jeans cross the opposition and bring to each side of it meanings of the other. So the inner-city youths can participate in the meanings of nature and freedom in their jeans, as the young woman can take these meanings with her into an urban environment, confident that they will fit easily. All meanings are ultimately intertextual—no one text, no one advertisement can ever bear the full meanings of jeans, for this can exist only in that ill-defined cultural space between texts that precedes the texts that both draw upon it and contribute to it, which exists only in its constant circulation among texts and society. The 501 and 505 ads specify quite different inflections of this intertextuality of jeans, but they necessarily draw upon it. For all their surface difference, their deep semiotic structure is shared, and thus the wearer of one bears, to a greater or lesser degree, the meanings of the other.

Jeans are no longer, if they ever were, a generic denim garment. Like all commodities, they are given brand names that compete among each other for specific segments of the market. Manufacturers try to identify social differences and then to construct equivalent differences in the product so that social differentiation and product differentiation become mapped onto each other. Advertising is used in an attempt to give meanings to these product differences that will enable people in the targeted social formation to recognize that they are being spoken to, or even to recognize their own social identity and values in the product. The different meanings (and therefore market segments) of 501s and 505s are created at least as much by the advertising as by any differences in the jeans themselves.

Designer jeans, then, speak to market segmentation and social differences: they move away from the shared values, away from nature, toward culture and its complexities. Wear-

ing designer jeans is an act of distinction, of using a socially locatable accent to speak a common language. It is a move upscale socially, to the city and its sophistication, to the trendy and the socially distinctive. The oppositions between generic jeans and designer jeans can be summarized like this:

generic jeans	*designer jeans*
classless	upscale
country	city
communal	socially distinctive
unisex	feminine (or more
	rarely, masculine)
work	leisure
traditional	contemporary
unchanging	transient
THE WEST	THE EAST
NATURE	CULTURE

Jeans' semiotic shift from the left to the right is partly a way in which grass-roots myths of America can be incorporated into a contemporary, urbanized, commodified society, one where the pressures of mass living and the homogenizing forces that attempt to massify us have produced a deep need for a sense of individuality and social difference. So the ads for designer jeans consistently stress how they will fit YOU; the physicality of the body is more than a sign of nature, vigor, and sexuality, it becomes a sign of individuality. Our bodies are, after all, where we are most ourselves and where our individual differences are most apparent: "Get into great shape, . . . your shape. With Wrangler. The jeans that give you the shape you want in the size you want . . . *A Fit for Every-Body*"(Figure 4) or "Your exact waist size, you've got it. Exact length? It's yours" (Chic jeans). The increasing individualism, of course, goes with a rise up the social ladder. So Zena jeans (Figure 6) are instrumental in enabling their owner (who, in the ad, has just stepped out of them for purposes left to our imaginations) to meet a hunk with a law degree from Yale who's into downhill skiing but hates French films. Jeans have moved into a world where class difference and fine social distinctions within class are all-important.

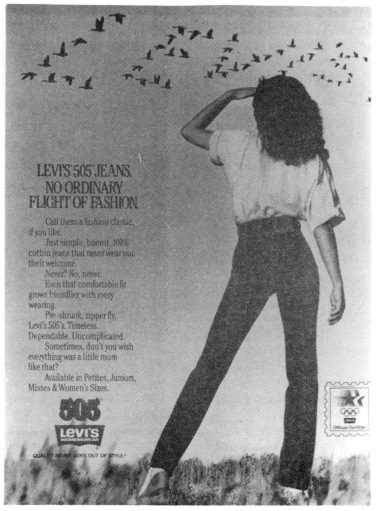

Figure 1. No mere "flight" of fashion, Levi's 505s stress the natural, eternal flight of the geese over the fanciful flights of fashion. Their durability is the material (literally) equivalent of the "timeless, dependable, uncomplicated" values of the heartland, whose welcome, like the jeans, is never outworn, but grows "friendlier with every wearing." These values are rooted in the past, physically and historically behind the wearer, yet she will carry them with her into the future, which she watches the geese flying into. The West is the past and the future, freedom, nature, tradition.

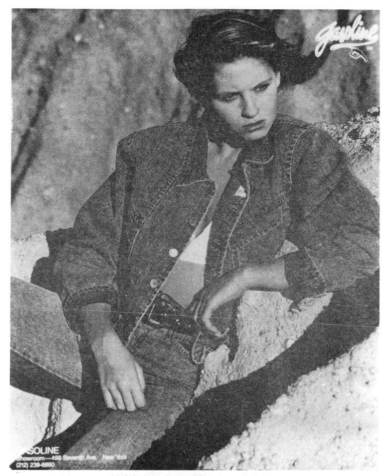

Figure 2. For Gasoline, however, the naturalness of the West is a
source of power, its ruggedness is transformed simultaneously and
paradoxically into the femininity of the model and the sophistication
of the Seventh Avenue showroom. The exclusivity of the showroom,
contrasted with Levi's ubiquity, is repeated in the individualistic style
of photography contra Levi's comfortable, generic anonymity. The
hard rock and the hardwearing denim naturalize the tension of New
York life and the toughness of those who live it. Today's sophisticate
needs all the toughness of the pioneers: only the frontier has changed.
The toughness of the absent masculine body is implied in the sexuality
of the feminine—the physicality of denim, of rock, of bodies.

Along with class difference goes gender difference. It is significant how many of the ads for designer jeans are aimed at women, for, in our patriarchal society, women have been trained more than men to invest their social identity, self-esteem, and sexuality in the appearance of their bodies.

Underlying these manifest differences are the more fundamental ones of the differences between East and West, and between culture and nature. The East was where the continent was first civilized (which means colonized by whites), and from this base of culture, nature was gradually pushed back westward until the pioneers reached the West Coast. Still, today, it is common to think of the East as sophisticated (i.e., belonging to culture), whereas the West is relaxed or cool (i.e., closer to nature). The development of "Silicon Valley" introduces a note of contradiction, but does not yet, I think, invalidate the cultural meaning of the difference between the two sides of the continent.

Robert McKinley (1982), in an essay called "Culture Meets Nature on the Six O'Clock News," suggests that the East will always stand for culture for geographical reasons. The time zones mean that news (accounts of the activities of culture) occurs first in the East, which helps to establish the East as the center of culture. The rotation of the earth, which gives the East its temporal advantage, also has another effect: it makes most of our weather come from the West, so the news (culture) moves East to West, and weather (nature) moves from West to East.

The Commercial and the Popular

The relationship between popular culture and the forces of commerce and profit is highly problematic, and it is one of the themes that runs throughout this book. We can begin to examine some of the issues by looking in more detail at the example of torn jeans.

At the simplest level, this is an example of a user not simply consuming a commodity but reworking it, treating it not as a completed object to be accepted passively, but as a cultural

resource to be used. A number of important theoretical issues underlie the differences between a user of a cultural resource and a consumer of a commodity (which are not different activities, but different ways of theorizing, and therefore of understanding, the same activity).

Late capitalism, with its market economy, is characterized by commodities—it is awash with them, it would be impossible to escape them, even if one wanted to. There are a number of ways of understanding commodities and their role in our society: in the economic sphere they ensure the generation and circulation of wealth, and they can vary from the basic necessities of life to inessential luxuries, and, by extension, can include non-material objects such as television programs, a woman's appearance, or a star's name. They also serve two types of function, the material and the cultural. The material function of jeans is to meet the needs of warmth, decency, comfort, and so on. The cultural function is concerned with meanings and values: All commodities can be used by the consumer to construct meanings of self, of social identity and social relations. Describing a pair of jeans, or a TV program, as a commodity emphasizes its role in the circulation of wealth and tends to play down its separate, but related, role in the circulation of meaning—a point that will be developed more fully in Chapter 2.

This difference of emphasis (on money or meanings) carries with it a corresponding difference in conceptualizing the balance of power within the exchange. The commodity-consumer approach puts the power with the producers of the commodity. It is they who make a profit out of its manufacture and sale, and the consumer who is exploited insofar as the price he or she pays is inflated beyond the material cost to include as much profit as the producer is able to make. This exploitation, in the case of jeans, often takes on a second dimension, in that the consumer may well be a member of the industrial proletariat whose labor is exploited to contribute to the same profit (the principle remains even if the commodity produced by the worker is not the actual jeans bought in his or her role as consumer).

When this approach tackles the question of meaning, it does so through a theory of ideology that again situates power with

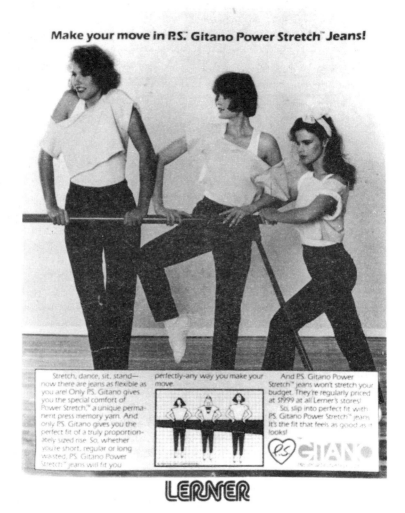

Figure 3. The power for P. S. Gitano moves the masculine rugged-
ness of the West into the feminine fitness center of the city: in the
metaphoric shift the power is transformed, not lost. The jeans *are* the
body—power stretching, perfect in fit and feel, the moves you make
are yours, you are your moves, you are your jeans.

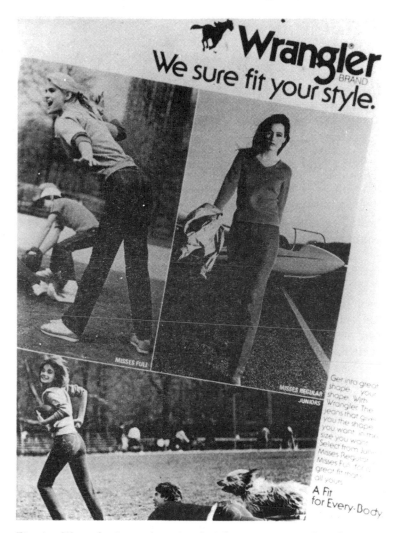

Fig. 4. Wrangler jeans do more than become your body—they give you the body you want, they give you the shape you want in the size you want. Your "great shape" merges physical strength into sexual attractiveness, and allows you access to masculine activity without losing the femininity that men desire. Your "great shape" is sexual for them and powerful for you; have it both ways and smile winsomely as you leave your man (and dog) sprawling in your wake—you know he'll catch you in the end.

the owners of the means of production. Here, the theory would explain that jeans are so deeply imbued with the ideology of white capitalism that no one wearing them can avoid participating in it and therefore extending it. By wearing jeans we adopt the position of subjects within that ideology, become complicit with it, and therefore give it material expression; we "live" capitalism through its commodities, and, by living it, we validate and invigorate it.

The producers and distributors of jeans do not *intend* to promote capitalist ideology with their product: they are not deliberate propagandists. Rather, the economic system, which determines mass production and mass consumption, reproduces itself ideologically in its commodities. Every commodity reproduces the ideology of the system that produced it: a commodity is ideology made material. This ideology works to produce in the subordinate a false consciousness of their position in society, false for two reasons: first because it blinds them to the conflict of interest between the bourgeoisie and proletariat (they may well be aware of the difference, but will understand this difference as contributing to a final social consensus, a liberal pluralism in which social differences are seen finally as harmonious, not as conflictual), and second because it blinds them to their common interests with their fellow workers—it prevents the development of a sense of class solidarity or class consciousness. Ideology works in the sphere of culture as economics does in its own sphere, to naturalize the capitalist system so that it appears to be the only one possible.

So how much of a resistance to this is wearing torn jeans? In the economic sphere there is a trace of resistance in that for jeans to become naturally ragged they need to be worn long past the time when they would normally be considered worn out and thus need replacing with another pair. Reducing one's purchase of commodities can be a tiny gesture against a high-consumption society, but its more important work is performed in the cultural sphere rather than the economic. One possible set of meanings here is of a display of poverty—which is a contradictory sign, for those who *are* poor do not make poverty into a fashion statement. Such a signified rejection of affluence does not necessarily forge a cultural allegiance with the economically poor, for this "poverty" is a matter of choice,

although it may, in some cases, signify a sympathy toward the situation of the poor. Its main power is in the negative, a resuscitation of jeans' ability in the 1960s to act as a marker of alternative, and at times oppositional, social values. But more significant than any other possible meaning of ragged jeans is the fact that the raggedness is the production and choice of the user, it is an excorporation of the commodity into a subordinate subculture and a transfer of at least some of the power inherent in the commodification process. It is a refusal of commodification and an assertion of one's right to make one's own culture out of the resources provided by the commodity system.

Such "tearing" or disfigurement of a commodity in order to assert one's right and ability to remake it into one's own culture need not be literal. The gay community made a heroine out of Judy Garland by "tearing" or disfiguring her image of the all-American, all-gingham girl-next-door, and reworked her as a sign of the masquerade necessary to fit this image, a masquerade equivalent to that which, in the days before sexual liberation, permeated the whole of the social experience of gays (see Dyer 1986).

Excorporation is the process by which the subordinate make their own culture out of the resources and commodities provided by the dominant system, and this is central to popular culture, for in an industrial society the only resources from which the subordinate can make their own subcultures are those provided by the system that subordinates them. There is no "authentic" folk culture to provide an alternative, and so popular culture is necessarily the art of making do with what is available. This means that the study of popular culture requires the study not only of the cultural commodities out of which it is made, but also of the ways that people use them. The latter are far more creative and varied than the former.

The vitality of the subordinated groups that, in various shifting social allegiances, constitute the people is to be found in the ways of using, not in what is used. This results in the producers having to resort to the processes of incorporation or containment. Manufacturers quickly exploited the popularity of ragged (or old and faded) jeans by producing factory-made tears, or by "washing" or fading jeans in the factory before sale. This process of adopting the signs of resistance incorporates

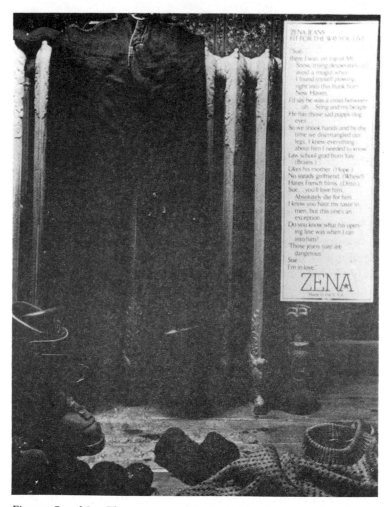

Figures 5 and 6. The movement through this ad sequence from West to East, from the country to the city, from masculine to feminine, from generic to designer, is also a move toward the individual. In these ads the individual has disappeared, leaving an absence to be filled by the unique individuality of (each) consumer. Sergio Valente's jeans "for the way you live and love" belong to the ghostlike figure who has just stepped out of them, leaving them miraculously empty but standing as though still on a body, inviting the body of the reader to make sense of the nonsense by filling the gap. The (odd) plaid connotes tradition and the past, contradicted but not erased by the trendy stripes and cut of the jeans. The freedom is found, in these citified jeans, by stepping out of them (contra Levi's 505s), and by discarding their accessories—

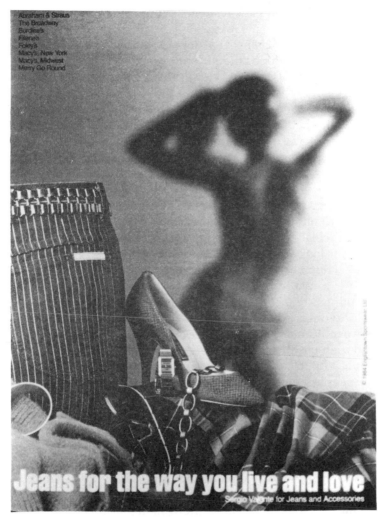

the hobbling high heels, the chain and bangle-manacle, the chain belt: bondage worn like a badge and discarded at will. Consumers *are* their commodities, yet, paradoxically, are themselves only when they discard them. The absent owner of Zena's jeans invites the consumer to fill her place (in the tub, in bed, in love). *Her* commodities (jeans, Shetland sweater, ski boots, old, classic radiator) are the feminine equivalents of *his* achievements and discrimination. They are metaphors for the prize they enable her to win, magically, end as well as means, product as well as process.

them into the dominant system and thus attempts to rob them of any oppositional meanings.

This approach claims that incorporation robs subordinate groups of any oppositional language they may produce: it deprives them of the means to speak their opposition and thus, ultimately, of their opposition itself. It can also be understood as a form of containment—a permitted and controlled gesture of dissent that acts as a safety valve and thus strengthens the dominant social order by demonstrating its ability to cope with dissenters or protesters by allowing them enough freedom to keep them relatively content, but not enough to threaten the stability of the system against which they are protesting.

So Macy's advertises "Expressions—Faded attraction . . . the worn out jean from Calvin Klein Sport." "Worn out in all the right places," the copy continues, "brand new jeans slip on with the look and feel of old favorites. And when Calvin's cool white crew neck is added (a soon-to-be new favorite) you're set for a totally relaxed mood." Any possible oppositional meanings are incorporated and tamed into the unthreatening "old favorites." The producers exert their control over the signs of wear by ensuring that they occur only in the "right places," and then use this incorporated and thus defused language of opposition to sell more commodities (the white crew neck) to the people they have stolen it from. In such ways, the theory of incorporation tells us, signs of opposition are turned to the advantage of that which they oppose and fashionably worn-torn garments become another range of commodities: the raggedness of worn-out jeans, far from opposing consumerism, is turned into a way of extending and enhancing it.

Such explanations of popular culture tell us only part of the story; they concentrate almost exclusively on the power of dominant groups to maintain the system that advantages them and thus they assume, rather than question, the success of the strategy. They fail to recognize the social differentiation that still exists between the wearers of "really" old, torn jeans and Macy's customers, and thus overlook any resistances to incorporation that ensure that its victories are never more than partial. Consequently, they paradoxically align themselves with the forces of domination, for, by ignoring the complexity and creativity by which the subordinate cope with

the commodity system and its ideology in their everyday lives, the dominant underestimate and thus devalue the conflict and struggle entailed in constructing popular culture within a capitalist society.

De Certeau (1984; see Chapter 2) uses a military metaphor to explain this struggle; he talks about the strategy of the powerful, deploying their huge, well-organized forces, which are met by the fleeting tactics of the weak. These tactics involve spotting the weak points in the forces of the powerful and raiding them as guerrilla fighters constantly harry and attack an invading army. Guerrilla tactics are the art of the weak: they never challenge the powerful in open warfare, for that would be to invite defeat, but maintain their own opposition within and against the social order dominated by the powerful. Eco (1986), too, speaks of "semiotic guerrilla warfare" as being the key to understanding popular culture and its ability to resist the dominant ideology. This, in its turn, I would argue, helps to maintain the sense of social differences and the conflict of interest within those differences that is essential if the heterogeneity of our society is to be productive and not static, progressive and not reactionary.

Change can come only from below: the interests of those with power are best served by maintaining the status quo. The motor for social change can come only from a sense of social difference that is based on a conflict of interest, not a liberal pluralism in which differences are finally subordinated to a consensus whose function is to maintain those differences essentially as they are.

Popular culture always is part of power relations; it always bears traces of the constant struggle between domination and subordination, between power and various forms of resistance to it or evasions of it, between military strategy and guerrilla tactics. Evaluating the balance of power within this struggle is never easy: Who can say, at any one point, who is "winning" a guerrilla war? The essence of guerrilla warfare, as of popular culture, lies in not being defeatable. Despite nearly two centuries of capitalism, subordinated subcultures exist and intransigently refuse finally to be incorporated—people in these subcultures keep devising new ways of tearing their jeans. Despite many more centuries of partriarchy, women

have produced and maintained a feminist movement, and individual women, in their everyday lives, constantly make guerrilla raids upon patriarchy, win small, fleeting victories, keep the enemy constantly on the alert, and gain, and sometimes hold, pieces of territory (however small) for themselves. And gradually, reluctantly, patriarchy has to change in response. Structural changes at the level of the system itself, in whatever domain—that of law, of politics, of industry, of the family—occur only after the system has been eroded and weakened by the tactics of everyday life.

Until recently, the study of popular culture has taken two main directions. The less productive has been that which has celebrated popular culture without situating it in a model of power. It has been a consensual model, which viewed popular culture as a form of the ritual management of social differences out of which it produced a final harmony. It is a democratic version of elite humanism, which merely resituates the cultural life of a nation in the popular rather than the highbrow.

The other direction has been to situate popular culture firmly within a model of power, but to emphasize so strongly the forces of domination as to make it appear impossible for a genuine popular culture to exist at all. What replaced it was a mass culture imposed upon a powerless and passive people by a culture industry whose interests were in direct opposition to theirs. A mass culture produces a quiescent, passive mass of people, an agglomeration of atomized individuals separated from their position in the social structure, detached from and unaware of their class consciousness, of their various social and cultural allegiances, and thus totally disempowered and helpless.

Recently, however, a third direction has begun to emerge, one to which I hope this book will contribute. It, too, sees popular culture as a site of struggle, but, while accepting the power of the forces of dominance, it focuses rather upon the popular tactics by which these forces are coped with, are evaded or are resisted. Instead of tracing exclusively the processes of incorporation, it investigates rather that popular vitality and creativity that makes incorporation such a constant necessity. Instead of concentrating on the omnipresent, insidious practices of the dominant ideology, it attempts to

understand the everyday resistances and evasions that make that ideology work so hard and insistently to maintain itself and its values. This approach sees popular culture as potentially, and often actually, progressive (though not radical), and it is essentially optimistic, for it finds in the vigor and vitality of the people evidence both of the possibility of social change and of the motivation to drive it.

Commodities and Culture

FORMATIONS OF THE PEOPLE

Popular culture in industrial societies is contradictory to its core. On the one hand it is industrialized—its commodities produced and distributed by a profit-motivated industry that follows only its own economic interests. But on the other hand, it is of the people, and the people's interests are not those of the industry— as is evidenced by the number of films, records, and other products (of which the Edsel is only the most famous) that the people make into expensive failures. To be made into popular culture, a commodity must also bear the interests of the people. Popular culture is not consumption, it is culture— the active process of generating and circulating meanings and pleasures within a social system: culture, however industrialized, can never be adequately described in terms of the buying and selling of commodities.

Culture is a living, active process: it can be developed only from within, it cannot be imposed from without or above. The fears of the mass culture theorists have not been borne out in practice because mass culture is such a contradiction in terms that it cannot exist. A homogeneous, externally produced culture cannot be sold ready-made to the masses: culture simply does not work like that. Nor do the people behave or live like the masses, an aggregation of alienated, one-dimensional persons whose only consciousness is false, whose only relationship to the system that enslaves them is one of

unwitting (if not willing) dupes. Popular culture is made by the people, not produced by the culture industry. All the culture industries can do is produce a repertoire of texts or cultural resources for the various formations of the people to use or reject in the ongoing process of producing their popular culture.

"The people" is not a stable sociological category; it cannot be identified and subjected to empirical study, for it does not exist in objective reality. The people, the popular, the popular forces, are a shifting set of allegiances that cross all social categories; various individuals belong to different popular formations at different times, often moving between them quite fluidly. By "the people," then, I mean this shifting set of social allegiances, which are described better in terms of people's felt collectivity than in terms of external sociological factors such as class, gender, age, race, region, or what have you. Such allegiances may coincide with class and other social categories, but they don't necessarily: they can often cut across these categories, or often ignore them. So that while there clearly are interrelationships between the structure of the social system and cultural allegiances, they are not rigidly determinate ones at all.

The necessity of negotiating the problems of everyday life within a complex, highly elaborated social structure has produced nomadic subjectivities who can move around this grid, realigning their social allegiances into different formations of the people according to the necessities of the moment. All these reformulations are made within a structure of power relations, all social allegiances have not only a sense of *with whom*, but also of *against whom:* indeed, I would argue that the sense of oppositionality, the sense of difference, is more determinant than that of similarity, of class identity, for it is shared antagonisms that produce the fluidity that is characteristic of the people in elaborated societies.

The various formations of the people move as active agents, not subjugated subjects, across social categories, and are capable of adopting apparently contradictory positions either alternately or simultaneously without too much sense of strain. These popular allegiances are elusive, difficult to generalize and difficult to study, because they are made from within, they

are made by the people in specific contexts at specific times. They are context- and time-based, not structurally produced: they are a matter of practice, not of structure.

Young urban Aborigines in Australia watching old Westerns on Saturday-morning television ally themselves with the Indians, cheer them on as they attack the wagon train or homestead, killing the white men and carrying off the white women: they also identify with Arnold, the eternal black child in a white paternalist family in *Diff'rent Strokes*—constructing allegiances among American blackness, American Indianness, and Australian Aboriginality that enable them to make their sense out of their experience of being nonwhite in a white society (Hodge & Tripp, 1986). They evade the white, colonialist ideology of the Western to make their popular culture out of it, they evade the "white father will look after you" message of *Diff'rent Strokes* in order to find their meanings and their pleasures in Arnold's everyday practices of coping with it. But the dominant ideology has to be there: the pleasure produced by Arnold exists only because he is subject to (but not subjugated by) a white ideology whose paternalism is seen by them as antagonistic, not benevolent. So, too, the pleasure in the Indians' successes in the middle of the Western narrative is, in part, dependent on their inevitable defeat at the end. Popular culture has to be, above all else, *relevant* to the immediate social situation of the people. Aboriginal meanings and pleasures can be made only within and against white domination: without the textual reproduction of the power that is being struggled against, there can be no relevance.

A text that is to be made into popular culture must, then, contain both the forces of domination and the opportunities to speak against them, the opportunities to oppose or evade them from subordinated, but not totally disempowered, positions. Popular culture is made by the people at the interface between the products of the culture industries and everyday life. Popular culture is made by the people, not imposed upon them; it stems from within, from below, not from above. Popular culture is the art of making do with what the system provides (de Certeau 1984). The fact that the system provides only commodities, whether cultural or material, does not mean that the process of consuming those commodities can be adequately

described as one that commodifies the people into a homo-
genized mass at the mercy of the barons of the industry. People
can, and do, tear their jeans.

THE COMMODITIES OF CULTURE

Let us take television as the paradigm example of a culture
industry, and trace the production and distribution of its
commodities (or texts) within two parallel, semiautonomous
economies, which we may call the *financial* (which circulates
wealth in two subsystems) and the *cultural* (which circulates
meanings and pleasures). They can be modeled thus:

	Financial Economy		*Cultural Economy*
	I	II	
Producer:	production studio	program	audience
	↓	↓	↓
Commodity:	program	audience	meanings/pleasures
	↓	↓	↓
Consumer:	distributor	advertiser	itself

The Two Economies of Television

The production studios produce a commodity, a program,
and sell it to the distributors, the broadcasting or cable
networks, for a profit. This is a simple financial exchange
common to all commodities. But this is not the end of the matter,
for a television program, or cultural commodity, is not the same
sort of commodity as a material one such as a microwave oven
or a pair of jeans. The economic function of a television
program is not complete once it has been sold, for in its moment
of consumption it changes to become a producer, and what it
produces is an audience, which is then sold to advertisers.

For many, the most important product of the culture indus-
tries is the commodified audience to be sold to advertisers.
Smythe (1977) argues that capitalism has extended its power

from the world of work into that of leisure, and so, by watching television and thus participating in the commodification of people, we are working as hard for commodity capitalism as any worker on the assembly lines. This argument is both accurate and incisive as far as it goes, but it remains fixed within the economic base of society, and can explain meanings or ideologies only as mechanistically determined by that base. It can account for the popularity of jeans only in terms of their durability, cheapness, and easy availability, but not in terms of their variety of cultural meanings.

In a consumer society, all commodities have cultural as well as functional values. To model this we need to extend the idea of an economy to include a cultural economy where the circulation is not one of money, but of meanings and pleasures. Here the audience, from being a commodity, now becomes a producer, a producer of meanings and pleasures. The original commodity (be it a television program or pair of jeans) is, in the cultural economy, a text, a discursive structure of potential meanings and pleasures that constitutes a major resource of popular culture. In this economy there are no consumers, only circulators of meanings, for meanings are the only elements in the process that can be neither commodified nor consumed: meanings can be produced, reproduced, and circulated only in that constant process that we call culture.

We live in an industrial society, so of course our popular culture is an industrialized culture, as are all our resources; by "resources" I mean both semiotic or cultural ones and material ones—the commodities of both the financial and cultural economies. With very few and very marginal exceptions, people cannot and do not produce their own commodities, material or cultural, as they may have done in tribal or folk societies. In capitalist societies there is no so-called authentic folk culture against which to measure the "inauthenticity" of mass culture, so bemoaning the loss of the authentic is a fruitless exercise in romantic nostalgia.

However, the fact that the people cannot produce and circulate their own commodities does not mean that popular culture does not exist. As de Certeau (1984) puts it, people have to make do with what they have, and what they have are the products of the cultural (and other) industries. The creativity of

popular culture lies not in the production of commodities so much as in the productive use of industrial commodities. The art of the people is the art of "making do." The culture of everyday life lies in the creative, discriminating use of the resources that capitalism provides.

In order to be popular, then, cultural commodities have to meet quite contradictory needs. On the one hand there are the centralizing, homogenizing needs of the financial economy. The more consumers any one product can reach, and the more any one product can be reproduced by the existing processes within the cultural factory, the greater the economic return on it. It must therefore attempt to appeal to what people have in common, to deny social differences. What people in capitalist societies have in common is the dominant ideology and the experience of subordination or disempowerment. The economic needs of the cultural industries are thus perfectly in line with the disciplinary and ideological requirements of the existing social order, and all cultural commodities must therefore, to a greater or lesser extent, bear the forces that we can call centralizing, disciplinary, hegemonic, massifying, commodifying (the adjectives proliferate almost endlessly).

Opposing these forces, however, are the cultural needs of the people, this shifting matrix of social allegiances that transgress categories of the individual, or class or gender or race or any category that is stable within the social order. These popular forces transform the cultural commodity into a cultural resource, pluralize the meanings and pleasures it offers, evade or resist its disciplinary efforts, fracture its homogeneity and coherence, raid or poach upon its terrain. All popular culture is a process of struggle, of struggle over the meanings of social experience, of one's personhood and its relations to the social order and of the texts and commodities of that order. Reading relations reproduce and reenact social relations, so power, resistance, and evasion are necessarily structured into them.

As Stuart Hall (1981: 238) says,

> The people versus the power-bloc: this, rather than "class-against-class," is the central line of contradiction around which the terrain of culture is polarized. Popular culture, especially, is organized around the contradiction: the popular forces verses the power-bloc.

This leads him to conclude that the study of popular culture should always start wth "the double movement of containment and resistance, which is always inevitably inside it" (p. 228).

Tearing or bleaching one's jeans is a tactic of resistance; the industry's incorporation of this into its production system is a strategy of containment. Maintaining the relative autonomy of the cultural economy from the financial opens up cultural commodities to resistant or evasive uses: attempts to close the gap, to decrease the autonomy are further strategies of containment or incorporation. Advertising tries to control the cultural meanings of commodities by mapping them as tightly as possible onto the workings of the financial economy. Advertising works hard to match social differences with cultural differences with product differences.

White patriarchal capitalism has failed to homogenize the thinking and the culture of its subjects, despite nearly two centuries of economic domination (and much longer in the domains of gender and race). Our societies are intransigently diverse, and this diversity is maintained by popular and cultural forces in the face of a variety of strategies of homogenization. Of course capitalism requires diversity, but it requires a controlled diversity, a diversity that is determined and limited by the needs of its mode of production. It requires different forms of social control and different social institutions to reproduce itself and its subjects, so it produces class differences and fractional or sectional differences within those classes. The owners of capital can maintain their social position only because the social order in which they flourish has produced legal, political, educational and cultural systems that, in their own spheres, reproduce the social subjectivities required by the economic system.

But social diversity exceeds that required by capitalism, by patriarchy, by racial dominance. Of course patriarchy requires and thrives on gender differences, but it does not require feminism, it does not require women to opt out of marriage or to decide to raise children with no father figure. Racial dominance does not require black separatism, or that black high school students should opt out of the whitist educational system, to the extent that success in that system can be seen as a betrayal of blackness.

Society is structured around a complex matrix of axes of difference (class, gender, race, age, and so on), each of which has a dimension of power. There is no social difference without power difference, so one way of defining the popular is, as Hall does, to identify it by its oppositionality to "the power-bloc."

The popular can also be characterized by its fluidity. One person may, at different times, form cultural allegiances with different, not to say contradictory, social groups as he or she moves through the social formation. I may forge for myself quite different cultural allegiances to cope with and make sense of different areas of my everyday life. When, for instance, the age axis appears crucial, my allegiances may contradict those formed when, at other times, those of gender or class or race seem most pertinent.

People watching Archie Bunker, the bigoted male in *All in the Family*, made sense of him quite differently according to how they positioned themselves within the social formation and thus the cultural allegiances they forged. "His" meanings could and did move fluidly along the axes of class, age, gender, and race, to name only the most obvious, as viewers used him as a cultural resource to think through their social experience and the meanings they made out of it. The polysemic openness of popular texts is required by social differences and is used to maintain, question, and think through those differences.

Similarly, product differences are required by social differences, but do not produce them, though they can be used to maintain them. Advertising tries to maintain as close a match as possible between social difference and product difference, and to give the latter some control over the former. The ubiquity of advertising and the amount of resources it requires are evidence of how far social differences exceed the diversity required by the economic system. There is so much advertising only because it can never finally succeed in its tasks—those of containing social diversity within the needs of capitalism and of reducing the relative autonomy of the cultural economy from the financial, that is, of controlling not only what commodities people buy but the cultural uses they put them to. The advertising industry is undoubtedly successful at persuading manufacturers and distributors to buy its services: its success in persuading consumers to buy particular products is much

more open to question—between 80 per cent and 90 per cent of new products fail despite extensive advertising. To take another example, many films fail to recover even their promotional costs at the box office.

Information such as the fact that a 30-second television commercial can cost as much to produce as the 50-minute program into which it is inserted can lead to a moral panic about the subliminal manipulation of commercials being in direct proportion to their production values. Yet Collett's report for the IBA in London showed how typical it is for the TV viewer's attention to leave the screen as soon as the commercials appear. And the children who occasionally watch commercials so carefully are not necessarily being turned into helpless consumers. The Sydney children who in 1982 turned a beer commercial into a scatological playground rhyme were neither untypical nor commodified as they sang, "How do you feel when you're having a fuck, under a truck, and the truck rolls off? I feel like a Tooheys, I feel like a Tooheys, I feel like a Tooheys or two" (Fiske 1987a). Similarly, the kids who sang jeeringly at a female student of mine as she walked past them in a short skirt and high heels, "Razzmatazz, Razzmatazz, enjoy that jazz" (Razzmatazz is a brand of panty hose, and its jingle accompanied shots of long-legged models wearing the brightly colored products) were using the ad for their own cheeky resistive subcultural purposes: they were far from the helpless victims of any subliminal consumerism, but were able to turn even an advertising text into their popular culture.

Two recent reports add fuel to my optimistic skepticism. One tells us that the average Australian family has 1,100 advertisements aimed at it every day. Of these, 539 are in newspapers and magazines, 374 on TV, 99 on radio, and 22 at the movies. The remainder are flashed on illuminated signs or displayed on billboards, taxis, buses, shop windows, and supermarket checkouts. But, the research concluded, people remember only three or four ads each day (*Daily News*, 15 October 1987). Another survey tested recall of eight popular slogans from TV ads. A total of 300 women between ages 20 and 30 were tested to see if they could add the name of the product to the slogan. The highest score achieved was 14 per cent; the average was 6 per cent (*West Australian*, 2 November 1987). Neither of these

surveys evidences a terrifyingly powerful and manipulative industry that is a cause for moral panic.

Of course, all ads sell consumerism in general as well as a product in particular; their strategy of commodification is not in dispute, only its effectiveness. We all have a lifetime's experience of living in a consumer society and of negotiating our way through the forces of commodification, of which ads are one, but only one, and they are no more immune to subversion, evasion, or resistance than any other strategic force.

If a particular commodity is to be made part of popular culture, it must offer opportunities for resisting or evasive uses or readings, and these opportunities must be accepted. The production of these is beyond the control of the producers of the financial commodity: it lies instead in the popular creativity of the users of that commodity in the cultural economy.

EVERYDAY LIFE

The everyday life of the people is where the contradictory interests of capitalist societies are continually negotiated and contested. De Certeau (1984) is one of the most sophisticated theorists of the culture and practices of everyday life, and running through his work is a series of metaphors of conflict—particularly ones of strategy and tactics, of guerrilla warfare, of poaching, of guileful ruses and tricks. Underlying all of them is the assumption that the powerful are cumbersome, unimaginative, and overorganized, whereas the weak are creative, nimble, and flexible. So the weak use guerrilla tactics against the strategies of the powerful, make poaching raids upon their texts or structures, and play constant tricks upon the system.

The powerful construct "places" where they can exercise their power—cities, shopping malls, schools, workplaces and houses, to name only some of the material ones. The weak make their own "spaces" within those places; they make the places temporarily theirs as they move through them, occupying them for as long as they need or have to. A place is where strategy

operates; the guerrillas who move into it turn it into their space; space is practiced place.

The strategy of the powerful attempts to control the places and the commodities that constitute the parameters of everyday life. The landlord provides the building within which we dwell, the department store our means of furnishing it, and the culture industry the texts we "consume" as we relax within it. But in dwelling in the landlord's place, we make it into our space; the practices of dwelling are ours, not his. Similarly, the readings we make of a text as we momentarily "dwell" within it are ours and ours alone. Lefebvre (1971: 88) is thinking along the same lines as de Certeau when he uses the distinction between compulsion and adaptation to point out the opposition between the strategy of the powerful (compulsion) and the tactics of the weak (adaptation): "He who adapts to circumstances has overcome compulsion . . . adaptation absorbs compulsions, transforms and turns them into products."

Against what he calls "the misery of everyday life," with "its tedious tasks and humiliations," Lefebvre sets "the power of everyday life," the manifestations of which include:

> its continuity . . . the adaptation of the body, time, space, desire: environment and the home . . . creation from recurrent gestures of a world of sensory experience; the coincidence of need with satisfaction, and, more rarely, with pleasure: work and works of art; the ability to create the terms of everyday life from its solids and its spaces. (p. 35)

De Certeau (1984: 18), with his greater emphasis on popular resistances, argues that the culture of everyday life is to be found in "adaptation" or "*ways of using* imposed systems," which he likens to "trickery—(ruse, deception, in the way one uses or cheats with the terms of social contracts)."

> Innumerable ways of playing and foiling the other's game . . . characterise the subtle, and stubborn resistant activity of groups which, since they lack their own space, have to get along in a network of already established forces and representations. People have to make do with what they have. In these combatants' stratagems, there is a certain art in placing one's blows, a pleasure in getting around the rules of a constraining space. . . . Even in the field of manipulation and enjoyment (p. 18).

The key words characterizing the tactics of everyday life are words like *adaptation, manipulation, trickery.* As de Certeau asserts so confidently, "People have to make do with what they have," and everyday life is the art of making do.

Cohen and Taylor (1976) trace the origin of their more pessimistic account of the resistances and evasions of everyday life to their work with long-term prisoners. As good Marxists, they initially sought to explain criminal behavior as forms of radical resistance to bourgeois capitalism. However, the prisoners themselves were "more concerned" with "ways of making out in the world than radical techniques for confronting it" (p. 12). Cohen and Taylor came to wonder if the important question was not how to change the world, but rather "in what ways should one resist or yield to its demands in order to make life bearable, in order to preserve some sense of identity" (p. 13). Their account traces resistances, and particularly evasions—hence the title of their book, *Escape Attempts*: it does not ascribe to the subordinate the power to raid the system, to turn the resources it provides into the means of attacking or evading it. De Certeau's distinctive contribution (contra Lefebvre's and Cohen and Taylor's) is his insistence on the power of the subordinate and on the system's points of vulnerability to this power.

In the consumer society of late capitalism, everyone is a consumer. Consumption is the only way of obtaining the resources for life, whether these resources be material-functional (food, clothing, transport) or semiotic-cultural (the media, education, language). And, of course, the difference between the two is only analytical convenience—all material-functional resources are imbricated with the semiotic-cultural. A car is not just transport, but a speech act; cooking a meal is not just providing food, but a way of communicating. All the commodities of late capitalism are "goods to speak with," to twist a phrase of Lévi-Strauss's. Their speech potential is not affected by economics, so there is no value in distinguishing between what is paid for directly (clothes, food, furniture, books), those whose costs are indirect (television, radio), and those that appear to be "free" (language, gesture). Linguistic resources are no more equitably distributed in our society than are economic resources. The meanings we speak with our bodies

are as much directed and distributed by the agencies of social power as those of television or of the catalog from which we furnish our homes.

What is distributed is not completed, finished goods, but the resources of everyday life, the raw material from which popular culture constitutes itself. Every act of consumption is an act of cultural production, for consumption is always the production of meaning. At the point of sale the commodity exhausts its role in the distribution economy, but begins its work in the cultural. Detached from the strategies of capitalism, its work for the bosses completed, it becomes a resource for the culture of everyday life.

The productivity of consumption is detached from wealth or class. Often the poor are the most productive consumers— unemployed youths produce themselves as street art in defiant displays of commodities (garments, makeup, hairstyles) whose creativity is not determined by the cost. Neither the expense of the commodity nor the number of commodities that can be afforded determines the productivity of their consumption.

Consumption is a tactical raid upon the system. As de Certeau (1984: 31) puts it:

> In reality, a rationalized, expansionist, centralized, spectacular and clamorous production is confronted by an entirely different kind of production, called "consumption" and characterized by its ruses, its fragmentation (the results of the circumstances), its poaching, its clandestine nature, its tireless but quiet activity, in short by its quasi-invisibility, since it shows itself not in its own products (where would it place them?) but in an art of using those imposed on it.

The products of this tactical consumption are difficult to study—they have no place, only the space of their moments of being, they are scattered, dispersed through our televised, urbanized, bureaucratized experience. They blend in with their environment, camouflaged so as not to draw attention to themselves, liable to disappear into their "colonizing organization" (de Certeau 1984: 31). The Viet Cong guerrilla becomes the innocent villager obeying the law of the state; the student smoking in the toilets or carving her name in the school's desk receives the graduation certificate as proof of her part

in the system; the television viewer making scandalous, oppositional meanings is still head-counted and sold to advertisers—his oppositional acts blend cunningly into the commercial environment.

But not all of these tactical maneuvers are invisible, immaterial. Guerrillas may not be able to accumulate what they win, but what they do keep is their status as guerrillas. Their maneuvers are the ancient art of "making do," of constructing *our* space within and against *their* place, of speaking *our* meanings with *their* language. De Certeau's (1984: 30) example is a model:

> Thus a North African living in Paris or Roubaix (France) insinuates *into* the system imposed upon him by the construction of a low-income housing development or of the French language the ways of "dwelling" (in a house or language) peculiar to his native Kabylia. He super-imposes them and, by that combination, creates for himself a space in which he can find *ways of using* the constraining order of the place or of the language. Without leaving the place where he has no choice but to live and which lays down its law for him, he establishes within it a degree of *plurality* and creativity. By an art of being in between, he draws unexpected results from his situation.

The "art of being in between" is the art of popular culture. Using *their* products for *our* purposes is the art of being in between production and consumption, speaking is the art of being in between *their* language system and *our* material experience, cooking is the art of being in between *their* supermarket and *our* unique meal.

> The consumer cannot be identified or gratified by the . . . commercial products he assimilates: between the person (who uses them) and these products (indexes of the "order" which is imposed on him), there is a gap of varying proportions opened by the use he makes of them. (de Certeau 1984: 32)

Lefebvre (1971: 31–32), in his earlier and less optimistic (than de Certeau's) account of everyday life, also stresses that the distinction between production and consumption is blurred in the culture of everyday life:

A culture is also a *praxis* or a means of distributing supplies in a society and thus directing the flow of production; it is, in the widest sense a means of production, . . . the notion of production then acquires its full significance as production by a human being of his [*sic*] own existence. . . . This implies first that culture is not useless, a mere exuberance, but a specific activity inherent in a mode of existence, and second that class interests (structurally connected to production and property relations) cannot ensure the totality of society's operative existence unaided.

Despite his emphasis on the power of "the bureaucratic society of controlled consumption" (p. 68) to order our social and interior lives, a process he calls "cybernetization," he concludes that, finally,

the consumer, especially the female of the species, does not submit to cybernetic processes. . . . As a result, not the consumer, but consumer-information is treated to conditioning—which may perhaps restrict cybernetic rationality and the programming of everyday life. (p. 67)

The object of analysis, then, and the basis of a theory of everyday life is not the products, the system that distributes them, or the consumer information, but the concrete specific uses they are put to, the individual acts of consumption-production, the creativities produced from commodities. It is a study of enunciation, not of the language system. Enunciation is the appropriation of the language system by the speaker in a concrete realization of that part of its potential that suits him or her. It is the insertion of the language system into a unique moment of social relations, it exists only in the present and creates a speaking space that exists only as long as the speech act. Descriptions of the linguistic system and how it "speaks," its subjects, cannot account for the concrete specifics of its uses; the study of enunciations investigates the specifities of each context of use, for it is these that materialize the gap between the system and the user.

The young are shopping mall guerrillas par excellence. Mike Pressdee (1986) coins the productive term "proletarian shopping" to describe the activities of the young unemployed he studied in an Australian mall (see *Reading Popular Culture*,

Chapter 2). With no money but much time to spend, they consumed the place and the images, but not the commodities. They turned the place of the mall into their space to enact their oppositional culture, to maintain and assert their social difference and their subordinated but hostile social identities. They would cluster around store windows, preventing legitimate consumers from seeing the displays or entering; their pleasure was in disrupting the strategy and in provoking the owner-enemy to emerge and confront them, or to call in the security services to move them on. These security services were visible strategic agents whose power invited raids and provocations. Drinking alcohol was forbidden in the mall, so the youths would fill soda cans with it and, while consuming the rest places provided for legitimate shippers, would also drink their alcohol under the surveillance of the guards. The guards, of course, knew what was going on, and would make sudden excursions into guerrilla territory only to find that an apparently inebriated youth was actually drinking soda—the power had been subjected to a guileful ruse. De Certeau points to the importance of the "trickster" and the "guileful ruse" throughout history in peasant culture; the ruse is the art of the weak, like taking a trick in a card game, a momentary victory, a small triumph deriving from making do with the resources available that involves an understanding of the rules, of the strategy of the powerful. This constant "trickery" is, for de Certeau, at the heart of popular culture:

> The actual order of things is precisely what "popular" tactics turn to their own ends, without any illusion that it will change any time soon. Though elsewhere it is exploited by a dominant power or simply denied by an ideological discourse, here order is *tricked* by an art. Into the institution to be served are thus insinuated styles of social exchange, technical inventions and moral resistance, that is, an economy of the *"gift"* (generosities for which one expects a return), an aesthetics of *"tricks"* (artists' operations) and an ethics of *tenacity* (countless ways of refusing to accord the established order the status of a law, a meaning or a fatality). (p. 26)

Shoplifting is another area of constant trickery and tenacity. The accessible, tempting display of goods is clearly a strategy of power, but to exert the power the army has to emerge from

its fortress into guerrilla terrain. Commodities are "lifted" for numerous reasons, from the pathological to the material-economic, but among them are the tactical—the pleasure of spotting and exploiting the strategic moment of weakness, and, sometimes, of tricking the order further by returning the stolen goods and claiming a refund because they were unsuitable. Katz's (1988) study of the attractiveness of crime may be more individualistic and moralistic than de Certeau would wish, but it does reveal the pleasures of such (illegal) tactics. Katz writes of amateur shoplifters' "delights in deviance" and, when describing middle-class adolescents, shows how their shoplifting is fueled not by economic need but by a desire for the "sneaky thrills" that the boredom and discipline of everyday life denies them. Shoplifting is not a guerrilla raid just upon the store owners themselves, but upon the power-bloc in general; the store owners are merely metonyms for their allies in power—parents, teachers, security guards, the legal system, and all the agents of social discipline or repression.

Moving the price tag from a lower- to a higher-priced item before taking it to the cashier is as illegal as shoplifting, and stores enforce the law as rigorously as possible, but we must wonder just how different in kind such practices are from the legal "trickery" of two secretaries spending their lunch hour browsing through stores with no intention to buy. They try on clothes, consume their stolen images in the store mirrors and in each other's eyes, turn the place of the boutique into their lunchtime space, and make tactical raids upon its strategically placed racks of clothes, shoes, and accessories. The boutique owners know these tactics but are helpless before them: one estimated that one in thirty browsers becomes a consumer. And no one can tell which is which. The U.S. Army could not tell the Viet Cong from the innocent villager, for at a different time, in a different space, one became the other in a constant and unpredictable movement into and out of the order. Browsers become consumers when and if they choose; many never do, but steal the image or style, which they then reproduce at home out of last year's clothes, last month's styles. One must wonder how different this "browsing," this "proletarian shopping," is from the white-collar worker's equipping his school-age children with pens and rulers from his office or xeroxing the

minutes of his community council meeting on the copier at work. How different is shoplifting from the university professor asking the university television technician to clean the heads on her video recorder? In legal terms, distinctions are made, however uncertainly; in terms of popular culture, all are guileful tactics, the everyday arts of the weak. Eco (1986: 174) tells the story of the Yale student telephoning his girlfriend in Rome for "free" by dialing the credit number of a multinational: "It's not the immediate saving that counts, the student explained, it's the fact that you're screwing the multinationals who support Pinochet and are all fascists." Eco goes on to show that, paradoxically, the larger and more complex the systems become, the easier they are to trick, and the more damage such tricks can cause. The trickster with unauthorized access to a computer system is in a position of enormous power. But such tricks differ only in technological sophistication from de Certeau's (1984: 25) definitive example of "la perruque," the wig:

> *La Perruque* is the worker's own work disguised as work for his employer. If differs from pilfering in that nothing of material value is stolen. It differs from absenteeism in that the worker is officially on the job. *La Perruque* may be as simple a matter as a secretary's writing a love letter on "company time" or as complex as a cabinetmaker's "borrowing" a lathe to make a piece of furniture for his living room. In the very place where the machine he must serve reigns supreme, he cunningly takes pleasure in finding a way to create gratuitous products whose sole purpose is to signify his own capabilities through his *work* and to confirm his solidarity with other workers or his family through *spending* his time in this way. With complicity of other workers (who thus defeat the competition the factory tries to instill among them), he succeeds in "putting one over" on the established order on its home ground. Far from being a regression toward a mode of production organized around artisans or individuals, *la perruque* re-introduces "popular" techniques of other times and other places into the industrial space (that is, into the present order).

The place of shopping malls is turned into numberless spaces temporarily controlled by the weak. Teenagers use them as their personal spaces in which to meet, to make trysts, to display and consume fashions; the stores are an inexhaustible resource bank of images, available to be turned into personal

style, personal enunciations. Mothers and children, and older people, consume the malls' heating or air conditioning in extremes of weather. In winter, shopping malls become indoor exercise areas for many; some malls have notices welcoming "mall walkers," others have exercise areas conveniently placed along the "walks," so that walkers can enhance their use of the resources, can get more out of the system, even if the system knows it. How many and which of these "tricking" walkers become consumers nobody knows. The colonizing power cannot tell if it has ceded terrain to the guerrillas or has contained their activity. But to call this containment is to talk strategically and to discount the innumerable tactical raids that are not contained.

The place of malls is designed strategically for commerce: the magnet of a big supermarket and/or department store, selling necessities, around it/them myriad specialty stores selling luxuries, spontaneous purchases, or more everyday specialties—pharmaceutical goods, T-shirts. Among them are leisure services, hairdressers, travel agents, movie theaters and coffee shops and eateries, from bistros to fast-food chains. Between and around them are open spaces, rest areas, telephones, banking machines, fountains, plants. And, at strategically determined times, they offer entertainments and displays, fashion shows, dance displays by local schoolchildren, carol singing, magic shows, versions of TV game shows and celebrity appearances.

The place and the timing of scheduled uses are clearly the strategy of commerce, but there is a huge paradox here—power can achieve its ends only by offering up its underbelly to the attacker; only by displaying its vulnerabilities to the guerrillas can the occupying army hold its terrain, however tenuously. So the place that is the strategy of commerce represses its organizing strategy: it has been forced to know that the popular uses will not conform to its strategic plan, so it becomes formless, open. People use it as they will. To attract consumers is to attract tricksters; encouraging consumption encourages trickery, robbery, la perruque.

De Certeau (1984: 40) argues that the very success of the bureaucratic commercial order within which we live has created, paradoxically, the means of its own subversion, its

very existence now depends upon those fissures and weak-
nesses that make it so vulnerable to the incursions of the
popular:

> In any event, on the scale of contemporary history, it also seems
> that the generalization and expansion of technocratic rationality
> have created, between the links of the system, a fragmentation and
> explosive growth of these practices which were formerly regulated
> by stable local units. Tactics are more and more frequently going off
> their tracks. Cut loose from the traditional communities that
> circumscribed their functioning, they have begun to wander
> everywhere in a space which is becoming at once more homo-
> geneous and more extensive. Consumers are transformed into
> immigrants. The system in which they move about is too vast to be
> able to fix them in one place, but too constraining for them ever to be
> able to escape from it and go into exile elsewhere. There is no longer
> an elsewhere. Because of this, the "strategic" model is also
> transformed, as if defeated by its own success.

Jameson (1984), reflecting on Portman's *Bonaventure* Hotel
in Los Angeles, notices how the space here is so disordered as
to be anarchic—it has failed totally to impose any order on itself
or the consumer in its shopping malls. In this organizational
failure, the ability of the human body "to organize its immediate
surroundings perceptually, and cognitively map its position in
a mappable external world" is transcended, and, I would argue,
stands for the inability of the order of things to order the place
of the individual. Jameson goes on to argue that

> this alarming disjunction point between the body and its built
> environment . . . can itself stand as the symbol and analogue of that
> even sharper dilemma which is the incapacity of our minds . . . to
> map the great global multinational and decentred communicational
> network in which we find ourselves caught as individual subjects.
> (pp. 83–84)

Jameson's argument that the "new decentred global network
of the third stage of capital" is a "network of power and control"
that is particularly "difficult for our minds and imaginations to
grasp" (p. 80) suggests that its power to determine our
subjectivities is so diffuse as to be questionable. In fact, the
power may be so distant that it imposes no order, but produces

only the fragmented postmodern subject. As Eco points out, the larger the system, the easier it is to trick, and the less effectively it can control those who move within it.

The structures of early capitalism were visible, its agencies of power easily apprehensible. When the factory owner lived in the house on the hill and workers in terraced cottages in the shadow and smoke of the factory or pithead, everyone knew the system that ordered where he or she worked or dwelt. The system was as visible as its inequalities; its power was naked. The shift to corporate capitalism was a shift toward invisibility; the system became more abstract, more distanced from the concrete experiences of everyday life and thus less apprehensible. In late capitalism's further shift to the multinational that transcends nations or states, the system has become so distant, so removed, so inapprehensible that its power to control and order the details of everyday life has paradoxically diminished. So the postmodern place of the *Bonaventure* is a disorder, a disorganization of the fragmented, transitory, discontinuous spaces of each of its users. The order of the system that builds and manages the shopping malls is consistently at risk of being turned into the disorder of those who use them, in a way that the small corner deli never was.

DEFINING THE POPULAR

There can be no popular dominant culture, for popular culture is formed always in reaction to, and never as part of, the forces of domination. This does not mean that members of dominant social groups cannot participate in popular culture— thay can and do. But to do so they must reform their allegiances away from those that give them their social power. The businessman entertaining his colleagues in a private box at a football game is not participating in popular culture; the same man, however, devoid of his business suit and sporting the favors of his local team as he cheers them on from the bleachers, can be. To participate in the popular, however, he must be able to call up other social allegiances, possibly those formed as a

youth in the neighborhood. His tastes and his cultures are social, not individual; as a social agent he can exert some control over the allegiances he forms, but not over the social order that frames them.

Similarly, popular readings of mass cultural texts are not the only ones. *Dallas* may be read *popularly* as a criticism of capitalism or of patriarchy (and we know that sometimes it is), but this does not mean that all of its readers find popular meanings and pleasures in viewing it all of the time. It is perfectly feasible theoretically and probable practically that some viewers decode it dominantly and find pleasure in aligning themselves with the capitalist, consumerist, sexist, racist values that are as clearly there in the program as they are in the society that produces and circulates it. The fact that ethnographic studies of *Dallas* viewers have not discovered such perfectly positioned subjects may be the result of the ideological framings of the investigations themselves, for they have concentrated (though not exclusively) on nonmainstream audiences. Ang's (1985) viewers were, of course, self-selected fans, and thus their readings may be typical of the dedicated audiences, but they were Dutch, and not American, and so they read *Dallas* under social conditions that were quite different from those of its production. But if there are readings that fail to activate its contradictions—that is, readings that consent to its hegemonic strategy—these are not part of popular culture: they are complicit with the interests of the power-bloc against which the formations of the people are variously situated (Hall 1981).

In understanding the interplay of forces in this constant struggle between the power-bloc and the people, it is important to avoid essentializing meanings and taking them out of their culturally and historically specific moments of production. Ang's Dutch fan of *Dallas* may have found great pleasure in its representation of wealth and life in the fast lane; but the "meaning" of this pleasure will be quite different in Holland from that of apparently similar pleasure experienced by an American yuppie. Its Americanness may well, in Holland, bear resisting meanings that it cannot in the United States. The Americanness of American popular cultural commodities is often, in other nations, used to express opposition to the forces of domination within those societies. A reading, like a text,

cannot of itself be essentially resistant or conformist: it is its use by a socially situated reader that determines its politics.

The role of the critic-analyst, then, is not to reveal the true or hidden meanings of the text, or even to trace the readings that people make of it; rather, it is to trace the play of power in the social formation, a power game within which all texts are implicated and within which popular culture is always on the side of the subordinate.

If a reading must not be essentialized, neither must it be equated directly with a reader. A reading is the interplay of tactics and strategy, it is a poaching raid, it is part of the power game of culture; a reader is the terrain within which the game is played. Popular readings are always contradictory; they must encompass both that which is to be resisted and the immediate resistances to it. This is why popular culture is such an elusive concept: it cannot be firmly located in its texts or in its readers. One cannot go, for instance, to working-class Hispanic women and guarantee to find popular culture among them. Cultural forces and social categories do not always match so precisely. But they do intersect, and we might predict that there will be more instances of popular forces at work in Brooklyn than on Wall Street. However, we must also expect to find many instances of the subordinate being complicit with the strategies of power, and, equally, of members of the dominant classes making popular meanings and pleasures that oppose the forces of domination. The same person can, at different moments, be hegemonically complicit or resistant, as he or she reforms his or her social allegiances. Resistance fighters are law-abiding citizens much of the time; their acts of resistance are selectively sporadic, determined by a mix of the requirements of their situation and the opportunities afforded them by the strategies of the dominant. Popular culture is to be found in its practices, not in its texts or their readers, though such practices are often most active in the moments of text-reader interaction.

"The popular," then, is determined by the forces of domination to the extent that it is always formed in reaction to them; but the dominant cannot control totally the meanings that the people may construct, the social allegiances they may form. The people are not the helpless subjects of an irresistible ideological system, but neither are they free-willed, biologically

determined individuals; they are a shifting set of social allegiances formed by social agents within a social terrain that is theirs only by virtue of their constant refusal to cede it to the imperialism of the powerful. Any space won by the weak is hard won and hard kept, but it *is* won and it *is* kept.

Popular culture is produced under conditions of subordination. Bourdieu's (1984) massive work *Distinction* is one I shall turn to frequently, for it is the most detailed study we have of the interrelationships between social class and culture. His account of the working of bourgeois and proletarian cultures in contemporary France is useful insofar as we understand proletarian culture to be a form of popular culture—that produced by a people subordinated by class in a capitalist society. But class is not the only axis of domination-subordination, and within classes there are many different formations of the people. While recognizing the close interconnections between class and culture, we must not map them too deterministically one onto the other. The proletarian and the popular are overlapping but not coterminous concepts.

Equally, the correspondences between social class and cultural taste may be less precise in countries other than France, but these differences do not invalidate Bourdieu's insights. What he gives us is an account of social and cultural forces working interactively, and by applying his findings to a sociocultural model that stresses social allegiances in constant reformation rather than objective social class, we can use his account of the cultural practices of the French bourgeoisie and proletariat to shed light upon cultural allegiances and practices that are shaped by class (and other) interests, but are not bound by stable social categories.

To give a personal example, a friend and I recently attended, on successive evenings, the opening of an exhibition at an art gallery and a concert by the Grateful Dead. The sociocultural allegiances we formed were, on each occasion, completely different, and the differences were manifest in many ways—in our topics and style of conversation and in the accents in which we spoke; in our behavior toward each other and toward other people; in our dress, gestures, and postures; in our attitude and behavior toward the art object/performance; in what we ate and drank; and so on. All of these differences had a dimension of class and

power, and all of them are recognizable in the differentiated tastes that Bourdieu calls bourgeois and proletarian.

Bourdieu's work is valuable because in his account of proletarian culture he reveals cultural practices that are typical of subordinate allegiances. So women, regardless of their class, can and do "participate" in soap opera in a way that parallels what Bourdieu has identified as a mark of proletarian culture, but that can be generalized out to refer to the culture of the subordinate, or popular culture. Similarly, Rogge (1987) in Germany has shown how women's tastes in news are functional (another characteristic of proletarian taste identified by Bourdieu): women prefer the local news to the national because they can use its accounts of burglary and assaults in the local streets, or road accidents, and of missing children as part of their maternal function of preparing their children to face their immediate social world. Women's tastes and proletarian tastes are similar not because women are proletarian or because the proletariat is feminine, but because both are disempowered classes and thus can easily align themselves with the practices of popular culture, for the people are formed by social allegiances among the subordinate.

Everyday life is constituted by the practices of popular culture, and is characterized by the creativity of the weak in using the resources provided by a disempowering system while refusing finally to submit to that power. The culture of everyday life is best described through metaphors of struggle or antagonism: strategies opposed by tactics, the bourgeoisie by the proletariat; hegemony met by resistance, ideology countered or evaded; top-down power opposed by bottom-up power, social discipline faced with disorder. These antagonisms, these clashes of social interests (which will be explored more fully in succeeding chapters) are motivated primarily by pleasure: the pleasure of producing one's own meanings of social experience and the pleasure of avoiding the social discipline of the power-bloc. It is to these pleasures that we turn next.

Productive Pleasures

There have been many attempts to theorize the role of pleasure in culture; they vary immensely, but all share the desire to divide pleasure into two broad categories, one of which they applaud, and the other they deplore. Sometimes this antithesis is seen as aesthetic (high, sublime pleasure versus low enjoyment), sometimes political (reactionary versus revolutionary pleasures), sometimes discursive (the pleasures of making meanings versus accepting ready-made ones), sometimes physiological (the pleasures of the spirit versus those of the body), sometimes disciplinary (the pleasures of exerting power versus those of evading it). I, too, wish to recognize that pleasures are multiple, and can take contradictory forms, but I wish to concentrate on popular pleasures as opposed to hegemonic ones, and thus to emphasize what is typically thought of as the more disreputable side of each antithesis.

Popular pleasures arise from the social allegiances formed by subordinated people, they are bottom-up and thus must exist in some relationship of opposition to power (social, moral, textual, aesthetic, and so on) that attempts to discipline and control them. But there are pleasures associated with this power, and these pleasures are not confined to members of the dominant classes. There is a pleasure for many a subordinate man in exerting power over others, especially women and children. There is also a pleasure in exerting power over oneself, in disciplining oneself. The pleasures of conformity by which power and its disciplinary thrust are internalized are real pleasures and are widely experienced. They are not, however, popular pleasures, but hegemonic ones.

The work of popular pleasure takes two main forms: evasion (or offensiveness) and productivity. Its resistances are practiced differently in each form. In categorizing its work in such a way, we must remember that this is an analytical strategy only; popular pleasure exists only in its practices, contexts, and moments of production, and thus much of it escapes the sort of structuring that generalization and theory call for. While evasion and production may be two of the main elements in popular pleasure, they are never all of it, because much that is unique to the person and the moment is beyond description or analysis.

The evasive element centers on the body (see Chapter 4). It is significant that those theorists who are on the left (e.g., Bakhtin and Barthes) tend to find positive values in the pleasures of the body, whereas those on the right (e.g., Kant and Schopenhauer) find the body a source of false or inferior pleasure. The struggle over the meanings of the body and the validation of its pleasures is a power struggle in which class, gender, and race form complexly intersecting axes. Mulvey (1975) is uneasily poised in my schema—she distrusts the popular pleasure she finds in mainstream cinema, yet she is clearly a left-wing theorist. Her focus is purely on gender (her theory would have to be greatly elaborated were she to take account of class differences) and she is primarily concerned with exploring the hegemonic force of patriarchal cinematic pleasure, rather the ways it can be evaded or resisted.

Barthes (1975b) goes further in his well-known distinction between *jouissance* and *plaisir*. *Jouissance*, translated variously as bliss, ecstasy, or orgasm, is the pleasure of the body that occurs at the moment of the breakdown of culture into nature. It is a loss of self and of the subjectivity that controls and governs the self—the self is socially constructed and therefore controlled, it is the site of subjectivity and therefore the site of ideological production and reproduction. The loss of self is, therefore, the evasion of ideology.

The body has a core of nature to it: the struggle to control its meanings has such high stakes because the prize is the right to control the meanings of culture and the relationship between the two. The orgasmic pleasure of the body out of control—the loss of self—is a pleasure of evasion, of escape from the self-control/social-control by which, in Foucault's telling phrase,

"men govern themselves and others." It is an escape from meaning, for meaning always is socially produced and reproduces social forces in the subject. Making meanings of anything always involves making meanings of the subject, however fluid or nomadic it may be.

Barthes extends this to the metaphor of "reading with the body," when the body of the reader responds physically to the body of the text, its physical signifiers, not its conceptual/ideological/connotative signifieds. An example he gives is that of the "grain" of a singer's voice, its timbre that lies outside the melody, the harmony, and the lyrics; it is the unique embodiedness of the voice in that specific performance that can produce this loss in a listener. So, too, the presence and play of words in literature or images on the movie screen can be read and related to only physically—they lie outside ideology or meaning. This *jouissance* is context-specific. The same text and the same reader in a different context or time might have no such experience. *Jouissance* is not a quality of the text, it cannot be identified by analysis; it occurs in the body of the reader at the moment of reading when text and reader erotically lose their separate identities and become a new, momentarily produced body that is theirs and theirs alone, that defies meaning or discipline.

Many popular pleasures, particularly those of youth, who are perhaps the most highly motivated of all to evade social discipline, turn to excessive bodily consciousness to produce this *jouissance*-like evasion. Rock and roll that is played so loud that it can be experienced only in the body, not listened to by ear, forms of dancing such as "head banging," the flashing lights of discos, the use of drugs (both legal and illegal)—all are harnessed to provide physical, evasive, offensive pleasures. And consequently all attract the forces of social discipline—moral, legal, aesthetic.

Foucault (1978) has shown how sexuality, too, has been subject to complex discursive disciplines, so that the nineteenth century attempted to control and discipline the bodily pleasures it offered. Thus any form of childhood sexual pleasure, particularly masturbation, was seen as evil and unhealthy; women's sexual pleasure was confined within boundaries so tight that it could hardly exist, and if it strayed beyond these

was classified as hysterical and thus in need of psychiatric or medical attention. Any form of pleasure beyond that of straight heterosexuality was designated perversion and subject to legal, moral, and medical discipline. Finally, procreation itself was taken beyond the realm of the couple and subjected to the control of the state in the name of "the population." The pleasures of the sexual body could not be allowed to escape the social discipline that the developing capitalist (and continuing patriarchal) state required.

It is not surprising, then, that Barthes uses sexual metaphors to explain *jouissance*, or that those who sought to limit the carnivalesque popular pleasures in the nineteenth century found it so easy to link sexual promiscuity with threats to the social order (see Chapter 4).

Bakhtin (1968), too, found the excessive bodily pleasures an essential of carnivalesque inversions and evasions, though his account is much more social that that of Barthes. While sexuality (along with eating and drinking) is one bodily expression of this liberation, it is not the liberation of the individual orgasm that concerns Bakhtin so much as the liberation of the social body. The physical pleasures are communal and public; carnival occurs in the streets, *jouissance* in the study.

Bourdieu (1984) goes back to romantic philosophy, particularly that of Kant, to trace the origins of a prevalent disgust with the body and its sensations that makes it the site of the anti-aesthetic. Paradoxically, the body remains the area of experience that escapes and threatens "pure" taste, which can come about only through social training and discipline. Sensuousness, the perception of the senses, is, for Kant, natural and therefore low. Civilized people learn to think as well as feel, and thus achieve a distance from the body that makes the aesthetic available to them. The bodily senses are the site of impure taste that must be refused; art that appeals to the senses is "agreeable" rather than "beautiful" and produces "enjoyment" rather than "pleasure." This impure taste is what Kant calls "the taste of the tongue, the palate and the throat," a phrase that Bourdieu (1984: 486) glosses as "a surrender to immediate sensation which in another order looks like imprudence"; it parallels Schopenhauer's distinction between the "sublime" and the "charming." The charming is that which

"excites the will by presenting to it directly its fulfillment, its satisfaction," it is that "which draws the beholder away from the pure contemplation which is demanded by all apprehension of the beautiful because it necessarily excites this will by objects which directly appeal to it." The translation used by Bourdieu (and his translators) does not draw out clearly enough the similarity between "will" and "desire," a similarity that emerges more clearly when Bourdieu quotes two of Schopenhauer's examples of the charming—paintings of fruit that look good enough to eat, and paintings or sculptures of women whose "general treatment are calculated to excite the passions of the beholder" (in Bourdieu 1984: 487). The body is exemplified by the pleasures of orality and sex, both of which threaten the pure aesthetic of beauty, and must therefore arouse "disgust" (literally "anti-taste").

For Kant the pleasures of the senses were tyrannical; only in the contemplation of the aesthetic could people be free. The object that insists on being enjoyed threatens ethical resistance to it, and denies the distancing required by the aesthetic. This threat exists in both art and life, in the representation and the real: painted fruits are equally as threatening as real fruits, a sculptured nude as threatening as a naked woman. By promoting what Bourdieu (1984: 489) calls "the animal attachment to the sensible," enjoyment destroys the purity and universality of beauty, and enslaves people:

> In the face of this twofold challenge to human freedom and to culture (the anti-nature), disgust is the ambivalent experience of the horrible seduction of disgusting and of enjoyment, which performs a sort of reduction to animality, corporeality, the belly and sex, that is, to what is common and therefore vulgar. (p. 489)

The bodily pleasures, alternately denigrated or praised by theorists, are readily enlisted for evasive purposes. Their resistance is one of refusal, not of a semiotic insurgence. Such a refusal of social control may not have direct political effects; its political effectiveness lies rather in maintaining a social identity that is separate from and oppositional to the one preferred by social discipline. It is also the site of energy and powerful affect: it is possibly the intensity of the pleasure it

offers, and thus the totality of the evasion, that makes it appear threatening from above and liberating from below. The recognition of this popular, vulgar energy, a force consistently threatening to burst out of control, is also a validation of it. The assertion of the people's right to enjoy popular pleasures may not in itself change the system that subjugates them, but it does preserve areas of life and meanings of experience that are opposed to normal disciplined existence. They are oppositional pleasures, and insofar as they maintain the cultural territory of the people against the imperialism of the power-bloc, they are resistant.

This evasion is experienced as empowering, but does not determine, or necessarily even influence, the use to which that empowerment may be put. Asking this question points us toward the realm of popular productivity. Barthes (1975b) argues that *plaisir* is a different (and, by implication, inferior) form of pleasure from *jouissance*. It is socially produced, its roots lie within the dominant ideology, it is concerned with social identity, with recognition. If *jouissance* produces the pleasures of evading the social order, *plaisir* produces those of relating to it. *Plaisir* is more of an everyday pleasure, *jouissance* that of special, carnivalesque moments. *Plaisir* involves the recognition, confirmation, and negotiation of social identity, but this does not mean that it is necessarily a conformist, reactionary pleasure (though it may be). These are pleasures in conforming to the dominant ideology and the subjectivity it proposes when it is in our interest do so; equally there are pleasures of opposing or modifying that ideology and its subjectivities when they fail to meet our interests. Insofar as people are positioned complexly in society, in simultaneous relationships of conformity and opposition to the dominant ideology, so the form of *plaisir* that will be experienced will vary from the reactionary to the subversive.

What I wish to stress, more than Barthes, is that *plaisir* is pleasurable only because it is produced by the people experiencing it: it is not delivered to them from the outside. Producing this pleasure requires both energy and self-esteem, and this suggests one possible relationship between evasive and productive pleasures: evasive pleasures produce the energy and empowerment that underlie the production of

meanings (possibly resistive) of self and of one's social relations that may eventually result in politically active resistance.

Let me take an example of this—a hypothetical one, but one based on an empirical study—Radway's (1984) study of romance readers. I shall return to this study again because it is a major ethnographic study of the processes of popular culture at work. The book contains evidence enough for one to sketch the following scenario as "based on real events."

A housewife regularly buys romance novels and find some pleasure in her husband's disapproval—buying a romance is both spending money on herself instead of on the family (an indulgent evasion of the ideology of the housewife) and buying a cultural place of her own. The act of reading is evasive: she "loses" herself in the book in an evasion of the ideology of femininity which disciplines women to find themselves only in relation to other people, particularly within the family. This loss is characteristic of *jouissance* and enables her to avoid the forces that subjugate her, which in turn produces a sense of empowerment and an energy otherwise repressed. These evasive pleasures are not text-specific: any book will produce them provided it can take her out of the social self. It is the act of reading rather than the specific text that is the producer of this form of evasive pleasure. But only certain books *can* do this, books with a relevance to her social situation. The ability to experience the *jouissance*-like loss of self is interrelated with the *plaisirs* of identity and meanings. The romances that produce this loss are ones in which a feisty, spunky heroine endures and survives cruelty and coldness from the hero, but who constantly fights against this victimization and never succumbs to it. One effect of this is that the hero becomes "feminized," he softens toward her and starts to treat her with care and sensitivity, and only when he has been sufficiently feminized can she consider him fit to marry. In her reading the housewife finds and validates feminine values in opposition to patriarchal ones. These values are shown to be morally and socially superior to the more politically powerful patriarchal ones, which have the power to make the heroine suffer, but not to subjugate her entirely. The pleasure of making these resistive meanings of femininity and gender relations is a socially

produced *plaisir*, but it is connected with the extrasocial *jouissance*, for *jouissance* provides energy, motivation, and empowerment, while *plaisir* provides the socially relevant meanings. As a result of this mix of empowerment and self-interested, self-produced meanings of gender relations, the reader is motivated to challenge the patriarchal power exerted through everyday relations with her husband, and to increase her own space within it, to redistribute it, however slightly, toward herself.

Such a hypothetical narrative of popular pleasures and their politics oversimplifies for the sake of clarity, and we must not allow it to imply that the relationships among *jouissance*, *plaisir*, and the politics of everyday life are linear, sequential (let alone consequential), and obedient to the laws of cause and effect. They are not. They are multidirectional, nonnecessary, dispersed, and difficult to trace in specific instances. The relationships among the domains of popular pleasure or entertainment are never so direct and singular (see Chapter 7).

I find it helpful to categorize popular pleasures into two types—those of evasion, which center around the body and which socially tend to cause offense and scandal, and those of producing meanings, which center around social identity and social relations, and work socially through semiotic resistance to hegemonic force. In the rest of this chapter I focus on the pleasures and politics of constructing meaning, in Chapter 4 I discuss those of evasion.

The politics of popular culture is that of everyday life. This means that it works on the micropolitical level, not the macro level, and that it is progressive, not radical. It is concerned with the day-to-day negotiations of unequal power relations in such structures as the family, the immediate work environment, and the classroom. Its progressiveness is concerned with redistributing power within these structures toward the disempowered; it attempts to enlarge the space within which bottom-up power has to operate. It does not, as does radicalism, try to change to system that distributes that power in the first place, for that is politics at the macro level; this is dealt with more fully in Chapter 7. The politics of popular culture is micropolitics, for that is where it can play the greater part in the tactics of everyday life.

The pleasures of micropolitics are those of producing meanings that are both relevant and functional (see Chapters 5 and 6). Relevance requires that both the forces of domination (hegemonic, disciplinary) and the resistances to them be contained in the meanings produced as they are structured into the social experience of the individual subordinate. Functionality requires that these meanings be usable in making sense of everyday life and in affecting an individual's internal or external behaviors in that life. Pleasure results from this mix of productivity, relevance, and functionality, which is to say that the meanings I make from a text are pleasurable when I feel that they are *my* meanings and that they relate to my everyday life in a practical, direct way.

Michaels (1986) gives a clear example of this process. He found that *Rambo* was one of the most popular movies among Aborigines living a tribal life in the deserts of central Australia. They made their meanings out of the text, for they understood the major conflict to be that between Rambo, whom they saw as a representative of the Third World, and the white officer class—a set of meanings that were clearly relevant to their experience of white, postcolonial paternalism and that may well have been functional in helping them to make a resistant sense of their interracial relationships. Certainly these were meanings of a more relevant conflict than that between the free West and the unfree Eastern bloc that a more socially conformist reading would be likely to emphasize. The Aborigines also produced tribal or kinship relations between Rambo and the prisoners he was rescuing that were more relevant to their social experience than any nationalistic relationships structured around the East-West axis: Aborigines do, after all, occupy a massively disproportionate number of places in Australian prisons.

The Aboriginal meanings of *Rambo* were pleasurable because they were relevant, functional meanings produced *from* the text, not *by* it. Presumably, Ronald Reagan experienced his own pleasure in the very different meanings that served his political purposes when he praised the movie for its message of get-up-and-go individualism. His pleasures, though, were hegemonic, preferred by the text, and thus required little, if any, productivity from him. The Aboriginal

meanings, on the other hand, were resistant and were produced by a more productive and popular process.

The activity of production involves a recognition of social difference and an assertion of the subcultural rights and identities of those on the subordinate end of these structures of difference. The recognition of social difference produces the need to think differently: thinking differently reproduces and confirms the sense of social difference. What is crucial here is that the thinking is *different*, not free, not divorced from social reality: thinking differently involves the subordinate in making *their* sense of their subordination, not in accepting the dominant sense of it or in making a sense with no relationship to domination. The dominant sense of the subordinate and their social experience is typically a demeaning one: the subordinate sense resists, offends, or evades these dominant, disempowering meanings. Popular pleasures, then, consist of both the producerly pleasures of making one's own culture and the offensive pleasures of resisting the structures of domination.

On a recent edition of *The Newlywed Game*, four husbands were asked if their wives' response to their "romantic needs" could best be summed up by the words "Yes, master," "Get serious, man," or "No way, Jose!" Of course all four answered "Yes, master," even though one was a little hesitant (and was teased for it); others glossed their answers with remarks "She's very accommodating," or "She always does what I want." When their wives came back on camera to give their responses, two agreed with their husbands ("Yes, master"), one said her response was more like "Get serious, man," and one said, "No way, Jose!"

Two classes of students and I gained considerable pleasure from this small moment of popular culture. To investigate it working, I approached it three ways: I asked myself how I watched the program and why I enjoyed it, I asked my students the same questions, and I advertised locally for fans of the show to contact me by phone or letter and tell me how and why they watched it.

In investigating my own pleasure, I found that I used three main discourses in viewing, that is to say, I brought three sets of social allegiances to bear upon the text. I am an academic

theoretician of popular culture interested in how the voices of the people and the voices of the dominant converse or argue in popular texts, so I allied myself with academia and used an academic discourse to note its contradictions, its points of controversy, the weak spots that exposed the white underbelly of its ideology—I distanced myself from the text, as any true academic should. But I also watched it from the inside, I used a more popular discourse to connect it to the conditions of my everyday life, those of a white, middle-class, middle-aged male, deeply dissatisfied with patriarchy and the sexual relations it promotes, concerned with the relationship between aging and potency, with masculinity and sexual performance. This discourse, or, rather, coherent discursive set, by which I make sense of my class/age/gender/race, and by which I bring these meanings of my social self and my social experience to bear upon the texts that I enjoy—this discursive set was, to an extent, contradicted, but also complemented, by a populist discourse. I have vulgar tastes and democractic inclinations— the garish, the excessive, and the tasteless provide me with pleasures that I know are "naughty" because they offend the aesthetic and cultural tastes of the class to which I, objectively, "belong," and these pleasures are pleasurable partly because of their offensiveness to those class standards and their ideology. They are a form of populism at work. I could not, therefore, study the text without also studying myself as viewer, for the text is a text only when I read it, only when I activate its potential in specific ways at a specific moment, only when I actually use the resources it offers me. And here "I" is not the "I" of individualism, but a discursive terrain: "I" am the arena within which the discourses of my social life intersect and constitute "me" and where they are brought to bear upon the discursive resources of the text in the practice of reading. These discursive resources may limit the meanings I can make out of them, but they cannot limit the everyday creativity to which they are put, and, indeed, in one sense, they are actually defined by that creativity.

The responses of my students to the text, as might be expected, differed from mine, and also differed among themselves. Some feminists were appalled by the question. For them it enshrined patriarchy in its assumption that women had no

sexual desires of their own, but that their sexuality was limited to responding to men's needs. Some of the men watching the show, however, were equally appalled—but for quite different reasons: they thought that the men had been put on the spot by the question, and that no man, in public, on television, would be able to answer anything other than "Yes, master," however ill at ease he might feel with his response in the privacy of the bedroom. The ideology of masculinity left men no choice. Their options were oppression or failure. They felt that the embarrassment of the two husbands whose wives "showed them up" in public by not answering "Yes, master" was greater than that of the compliant wives who did. They argued that men in the audience would both identify with and distance themselves from this embarrassment. They would squirm with the contestant while feeling pleasure in his public discomfort, and because this male embarrassment was much more rarely seen on television than female compliance, they argued that it produced by far the stronger effect. In other words, the men thought the question exposed patriarchy rather than enshrined it, and that men's failure to live up to it was more critical of the ideology than the women's compliance was supportive of it.

Some of the women who did not claim to be "feminists," however, found real pleasure in the answers of the two wives who rejected the "Yes, master" response and in the discomfiture of the husbands. They laughed delightedly at this point in the show, and in the subsequent discussion turned to it immediately. The feminists replied that their radical offense at the sexism of the question was so strong that it blocked what they could understand, but not feel, as the "progressive" pleasure of the nonfeminist, "everyday" women. This pleasure lay in the perception and productive exploitation of the gap between the ideology of patriarchy and the everyday experience of women. Their resistance was not, as was that of the feminists, at the structural level of the system itself, but at the everyday level of how women coped with it, how they enlarged their own spaces within it, how they made sense of their opposition to it in the practices of their everyday lives.

Of course, the wives who agreed with their husbands on the show and who appeared to comply with the dominant ideology and their own subordination by it were rewarded with points.

However, while those who resisted—who "lost"—received no official (ideological) points, they won the popular points in the pleasure of the viewers. The program is based on the official ideology of the couple in patriarchy: its questions reproduce it, and its format rewards those couples who best conform to it. But its popular pleasures lie in its "losers," those whose experiences contradict or question the dominant ideology—they provide the moments at which the studio audience laughs most happily, their experiences are the ones the question master draws out and elaborates, they are the popular winners of the show. The gap between the popular winners and the official ones is precisely the difference between everyday experiences and the strategic power of the ideology of the patriarchal couple. Despite the patriarchy inscribed into the question, for some viewers the men on the show came off worse than the women; the vulnerability of their power was revealed and women's tactical ability to deal with it was publicly validated.

I would call this an example of the progressive potential of popular culture. Its progressiveness lies both in its recognition of the difference between patriarchal power and the everyday experiences of women and in the validation of their tactical resistance to it. The televisual representation of this gap enables women to articulate it to their own experiences; in perceiving points of pertinence they can make their sense of both their own experience of patriarchal power and the relevance of this particular television text. There are an indefinable number of everyday experiences that can be articulated with the wife saying "No way, Jose!" and, we must recognize, a number of accents in which "Yes, master" can be spoken—total compliance is by no means the only meaning of the words. There is the potential, at least, that this thinking through of the micropolitics of gender relations may, in some specific instances, be part of a negotiated change in the sexual distribution of power—such a popular representation of the workings of patriarchal power may be part of individual men and women being able to live that power differently, and more equally, in their own relationships.

I do not wish to criticize the feminists' response to this tiny segment of popular culture. Their response was perfectly valid, but so too was the response of nonfeminist women. But the gap

between the two illustrates the difference between the radical and the progressive, between strategic and tactical resistances, between structural and practical perspectives. In fact, *The Newlywed Game* was not part of the popular culture of these particular feminists: They found no pleasure in the text (except, possibly, that of confirming their knowledge of the horror of patriarchy in the raw), they did not choose to watch the show as part of their everyday lives, and so they made no producerly use of the resources it offered. For them the text was neither producerly nor popular.

The responses of the "real" fans enhanced those of my students, and, in particular, showed how readily the watching of the show was woven into the fabric of their everyday lives. Four general points can be made from their responses.

First, the gender of the respondent: Out of 22, 21 were female, and the lone male admitted that he was responding only because his girlfriend had urged him to—she was, apparently, too shy to do so herself.

Second, the show was typically watched by couples, married and single, and typically at the urging of the woman over the reluctance or embarrassment of the man. Women consistently used the show to articulate and understand their sexual relationships, they used it as a tool to think with, a tool they could use in their everyday lives. Typical of many was this response:

Dear Mr. Fiske,
Although I'm not sure exactly what you want to know, I can tell you, with some embarrassment, that I have become an avid viewer of THE NEWLYWED GAME. I don't know if I can really explain why, but I know I started watching it over three months ago, mostly because the time it comes on fits my schedule well. After I come home from work, I make dinner while watching the evening news, and then at 7.00 it's ready, and I can sit down and eat dinner while watching THE NEWLYWED GAME.
 Probably the thing I like about it is that I can relate a lot of that trivial domestic stuff to my relationship with my own husband, and it's a little uncomfortable realizing how much we are like those couples on the show. In fact, I usually will answer the questions, and then guess how my husband would respond. If he's home at that time and watches the show with me, I urge him to answer the questions, so we can compare our answers. Actually, we do learn

something about one another, not always what we want to know. So, for that reason I enjoy the show. Another reason might be that I probably like to see people making fools of themselves. Well, maybe not fools, but just being themselves with all their peculiar idioscyncrasies. It makes for good comedy in my opinion.

The last reason has got to be because I just can't stand game shows like "Wheel of Fortune" or "Jeopardy." I don't get excited about games of chance or gambling, or that type of thing.

I just thought of something else: it has to do with the MC of the show. He definitely goads the contestants to get them going. Stirring up conflict between the husband and wife does seem like part of the show's appeal.

That about covers it, Mr. Fiske. For what its worth, I also watch THE NEW DATING GAME which follows THE NEWLYWED GAME, but I don't enjoy that as much. If I were single, I probably would prefer that one more.

There are two immediate points to make here—the first is that the respondent's comment on the pleasure to be found in watching marital conflict supports the theorization of the difference between the official and the popular winners—while the show officially rewards domestic harmony, its appeal lies in gender conflict: the official ideology of the couple is promoted only to be subverted. The second point is related to this woman's comment that what she and her husband learned about each other was not always what they wanted to know. This, again, was a typical response; it was common for the way that the contestants made the private into the public to be extended into the viewing couple. What was private or repressed in each member of the couple was brought out into the couple's own "public" arena, their shared consciousness of each other and their relationship, in a miniaturization of the show's making public of what is normally private.

It seems to be the women who gain most from this revelation of the repressed. What is repressed are the disagreements between the couple, the moments of everyday experience that contradict the dominant ideology. As another respondent told me over the telephone:

It gets us thinking about us, it's real fun when we disagree, like seeing how well we know each other, or don't know each other, like it's real fun . . . but it gets real serious at times, real serious . . .

As she was telling me how "real serious" she and her boyfriend became she was laughing so hard that I could hardly make out her words. Laughter is hard to interpret, but I think that in this case it not only signaled her embarrassment at discussing this topic with a stranger, however anonymously, but also, more significantly, it was a marker of where much of her pleasure was focused. In one form or another, women reported the pleasure of revealing normally silenced misunderstandings, and reported that their men's reactions often ranged from mild embarrassment through incomprehension to a desire to evade the issue and write the whole process off as "silly."

I suspect that underlying this is our ideological practice of making the responsibility for emotional management part of femininity rather than of masculinity. Consequently, failures in relationships, or stresses in them, are more likely to produce guilt in females than in males, for the responsibility of such failure is ideologically laid firmly upon the feminine. Making such stresses fun, turning them into the stuff of public comedy, takes them out of the guilt-producing realm of feminine responsibility, and can be both liberating and subversive for most women and for those men who are discontented with some, at least, of the characteristics of masculinity that patriarchy has prepared for them.

This leads us to the third commonly reported pleasure—that of embarrassment, for the word occurred in almost every response. There were three types of embarrassment experienced: the embarrassment of admitting to enjoying the show, the embarrassment produced in the couple watching the show, and the embarrassment of the couples on the show. Clearly, embarassment is a key pleasure.

Embarrassment is, I suggest, experienced at the point of conflict between the conventional and the subversive, between the dominant and the subordinate, between top-down and bottom-up power. Exposing and enjoying the disagreements in a couple is embarrassing only because the dominant group's ideological values are experienced simultaneously with the everyday values of the subordinate that contradict them. The pleasures of liberating repressed or subordinate meanings can never be experienced freely, but only in conflict with those forces that seek to repress or subordinate them. The women's

embarrassment is a sign that they simultaneously and contradictorily internalize the discipline of patriarchy while subverting or resisting it. So, too, the ideological (aesthetic) values that judge the show to be trivial or trashy are accepted only up to the point that the women are embarrassed by their pleasure in it, but this hegemonic thrust is not strong enough to stop them watching it or to destroy their enjoyment. Indeed, the embarrassment is the pleasure. Embarrassment is a popular pleasure because it contains the values of both the dominant and the subordinate, the disciplinary and the liberating, it occurs when the ideologically repressed clashes with the forces that repress it.

The fourth point has already been discussed, though not directly: this is the directness of the connections that viewers were able to make between the show and their everyday lives. The letter quoted above gives a specific and typical example. One set of interconnections is made between the parallel routines of the household and the TV schedule. Like housework, popular texts are ephemeral, rapidly consumed, and need to be repeated, so the seriality and repetition of popular culture produce a routinization that is easily mapped onto the routines of everyday life. Watching the news helps to make the chore of cooking dinner pleasurable; watching *The Newlywed Game* is part of the reward for the chore's completion. To the extent that they are required, the routines of everyday life disempower those subjected to them. This is not to say that there is no pleasure in cooking—there clearly is, but the pleasure lies in its creativity, not in its necessity: the opposition between top-down power and bottom-up creativity is familiar. But the routines of popular culture, in this case television, are voluntary; they are chosen, they are pleasurable. They thus provide a means of evading the sense of subjection to the parallel, required, repressive routines of domestic labor. Routine lives require routine pleasures; one of the essential functions of cultural forms is that they should give a shape to time, so narrative and music (our two dominant cultural forms) give a pattern and structure to time that enable us to have some sense of control over it, even if the control is only that of being able to handle it conceptually. Without this, time's formless, irresistible forward march can, like the endless demands of domestic labor, be experienced as demoralizingly dominant.

The routine pleasures of popular culture may derive ultimately from the sense of chronological control it offers, but within this lie the associated pleasures of making relevant meanings. The writer finds the *Newlywed Game* more pleasurable than *The Dating Game* because, as a married woman, it is more *relevant* to her. She can therefore use it as a discursive resource with which to make sense of her relationship with her husband, and the act of making sense is an empowering one; in the popular productivity of making *her* sense of *her* marriage she is better able to cope with the form that it takes.

This pleasure of hers has an element of resistance in it. Her second paragraph moves from her liking of the show through an account of its relevance to her marriage to an empowered act in the micropolitics of marriage; she "urges" her husband to answer the show's questions, apparently against his will. This may, taken in isolation, be a tiny act of power, but the experiences of everyday life are full of such minutiae of micropolitics that gradually and irresistibly accumulate.

This is a structurally typical instance of popular culture in practice, for it consists of a continuous movement between popular pleasures and their productivity, the construction of relevance between the producerly text and the reader's immediate social situation, and a sense of empowerment that is transferable from the production of meanings to material social relations. This matrix of pleasure, relevance, and empowerment lies at the core of popular culture.

D'Acci's (1988) study of the women fans of *Cagney & Lacey* provides further evidence of the close association, in popular culture, of pleasure, relevance, and power. Letter after letter sent by the fans to the producers in a (successful) attempt to save the show from the network's ax shows both how closely viewers were able to match the representation of Cagney and Lacey's lives in television to their own social experience, and how intensely pleasurable this was:

> There is one regular show which I always make time for—it's something I enjoy, not in the way one enjoys reading the Sunday comics, but more in the way one enjoys the Op-Ed page—it's intriguing and a reflection of aspects of my own life. It is *Cagney and Lacey*. (D'Acci 1988: chap. 7, p. 18)

The writer indicates that her pleasure in *Cagney & Lacey* is greater even than that offered by the op-ed page by her switch from the personal pronoun to the third person *one* and back again. Many other writers quoted by D'Acci are much more specific in the details of the show's relevance to their daily experiences of working in a variety of organizations formed and dominated by men. For one, at least, the relevance was precise, even to the nature of the organization:

> I totally enjoy *Cagney and Lacey*. You are the best female cops TV has ever seen. I myself enjoy the show because I am going to the State Police Academy in a few months. I am presently a female corrections officer in an all male penal institution. Believe me its no "gravy" job. It's pretty rough. You have to put up with a lot of harassment. (chap. 7, p. 21)

The switch of pronoun to the direct address of "you" in the first line again evidences how directly personal the relevance and the pleasure are. While this letter does not explicitly suggest that such relevant pleasures can lead to empowerment, it does discursively associate them with the experience of disempowerment: pleasure, relevance, and the desire to be less disempowered or humiliated by patriarchy come together in this woman's consciousness.

Some writers, however, are much more explicit in their experience of empowerment. D'Acci (1988: chap. 3, p. 55) writes:

> Sharon Gless's Cagney is repeatedly credited by the writers as giving them "courage" to effect change in their lives; and providing an unprecedented model. "When I saw Cagney," a viewer writes, "I knew she was who I wanted to be like and I started slowly and, well, I have changed. I speak my mind now and I even got up enough courage to try my hand at my own photography business." Other viewers say, "each week she somehow gives me the courage to be myself more around others and to strive for something more in my life. She makes her character become real to me." . . . A teenage girl says that the series, "gives me the confidence in myself to know that I can do just as well as boys in sports and other things."

The sense of empowerment experienced by the fans of both *Cagney & Lacey* and *The Newlywed Game* is produced in two

ways, first because the meanings that led to it were produced by subordinated people from the text, and second because their relevance made them directly usable in the everyday tactics of coping with patriarchy. Pleasure and relevance are not necessarily associated with empowerment, but they often are, and this empowerment does not always result in action within the social world, but it sometimes does, and always creates the possibility for, and increases the probability of, such action. Improved self-esteem in the subordinate is a political prerequisite of tactical or even strategic resistances.

Offensive Bodies and Carnival Pleasures

In the last two chapters we looked at ways in which the people can turn cultural commodities to their own interests and find pleasure in using them to make their own meanings of their social identities and social relations. Insofar as these are meanings of subordination made by and in the interests of the subordinate, they oppose those promoted by the power-bloc and its ideological practices. But resistance to domination can take many forms, only some of which lie in the production of oppositional meanings.

Other resistances are those of evasion, of getting around social control, of dodging the discipline over self and others that those with power attempt so insistently to exert. Anything out of control is always a potential threat, and always calls up moral, legal, and aesthetic powers to discipline it. The signs of the subordinate out of control terrify the forces of order (whether moral, legal, or aesthetic), for they constitute a constant reminder of both how fragile social control is and how it is resented; they demonstrate how escaping social control, even momentarily, produces a sense of freedom. That this freedom is often expressed in excessive, "irresponsible" (i.e., disruptive or disorderly—the adjectives are significant) behavior is evidence both of the vitality of these disruptive popular forces and the extent of their repression in everyday life. The pleasures of evasion tend to center on the body; those of the production of contrary meanings center on the mind.

In this chapter, I wish to trace some of the ways in which the body and its pleasures have been, and continue to be, the site

of a struggle between power and evasion, discipline and liberation; though the body may appear to be where we are most individual, it is also the material form of the body politic, the class body, the racial body, and the body of gender. The struggle for control over the meanings and pleasures (and therefore the behaviors) of the body is crucial because the body is where the social is most convincingly represented as the individual and where politics can best disguise itself as human nature.

STRATEGIES OF DISCIPLINE

Industrialization and urbanization in the early nineteenth century produced, among other things, a widespread consciousness of the differences between classes and the growing fear that these differences constituted a real threat to the ability of the bourgeoisie to control the social order for their own interests. There was nothing that could be done, short of reorganizing the whole capitalist system of production to change or mitigate this threat in the conditions of work, for class differences and oppositional interests were inevitably produced by the way work was organized. Consequently, the disciplinary energy of the bourgeoisie was directed to the leisure of the lower classes, for the significance of leisure in opposition to work is another semiotic product of industrial capitalism: in rural societies the opposition is more muted and given quite different meanings.

There were two main strategies by which the dominant attempted to control the leisure and pleasures of the subordinate: those of repressive legislation, and those of appropriation by which "vulgar," uncontrolled leisure pursuits could be respectable and disciplined.

Malcolmson (1982) provides a comprehensive account of the legislative strategies by which certain popular pleasures were progressively suppressed or transformed into more respectable variants. These popular recreations were either blood sports—cockfighting, bull baiting, and so on—or carnivalesque festivals

such as annual sports events or fairs. Here I am less concerned with the legal and parliamentary processes involved than with their cultural dimension, that is, the discourses that were mobilized to give certain meanings to these processes and to rule out others. The discourses that were overwhelmingly favored to promote this control were those of morality, law and order, and the Protestant work ethic; that of class interest was, not surprisingly, repressed, and was used only by those who attempted to oppose the process. Malcolmson shows how "naturally" these three disciplinary discourses joined together to promote a particular set of meanings of blood sports. Five examples from nineteenth-century writers, journalists, and parliamentarians will make my point (all from Malcolmson 1982: 37). The first two are concerned with cockfighting and throwing at cocks:

(1) "Much of the misery and crime of the English rural districts, is to be ascribed to the influence" of cockfighting, "which has trained many a victim for the gallows, and reduced many a family to want and beggary."

(2) "Whatever is morally bad cannot be politically right. The monster, who can wilfully persevere to torture the dumb creation, would feel little or no compunction, to serve a purpose, in aiming his bludgeon at the head, or ingulfing the murderous blade within the warm vitals of his fellow creature."

The next two refer to bull baiting:

(3) Sir William Pulteney declared that the sport "was cruel and inhuman; it drew together idle and disorderly persons; it drew also from their occupations many who ought to be earning subsistence for themselves and families; it created many disorderly and mischievous proceedings, and furnished examples of profligacy and cruelty."

(4) Sir Richard Hill pointed out that "men neglected their work and their families, and in great crowds spent whole days in witnessing those barbarous exhibitions. From the baiting-field they retired to the alehouse, and wasted the whole night in debauchery, as they had done the day in idleness."

And the fifth is more general in its concerns:

(5) "All such trainings of the mind of a people to delight in scenes of cruelty, are as dangerous in their tendency to the public peace and order, as they are corruptive of the young and uninstructed, whose most natural principles, (benevolence and compassion) they extinguish, and pervert their hearts to the contrary."

The first quotation directly displaces the cause of "the misery of the English rural districts" from the economic system that produced the poverty to the leisure practices of the victims of the system in an early example of the ideological strategy of blaming the victim. In the second and third examples fear of lawlessness and disorder surfaces in imagined threats to the individual and, more vaguely, to society in general. The third and fourth examples both show how these pleasures oppose productive labor (the meaning of which, of course, is always that of men providing for their families, never of labor making profits for the bourgeoisie), while the fifth explicitly links public law and order with private (and "natural") morality.

Fairs attracted identical discursive discipline; a magistrate complained at the

> almost riotous assembly of men and women dancing and walking about on the road, clasping each other in a loving manner, all along the turn-pike road. He thought this was not conducive to the morals of the public, which was the chief object he should have in view. (in Malcolmson 1982: 85)

The disciplinary work of his discourse, which attempts to turn loving and dancing into "riotous assembly," evidences the terror caused by popular behavior when it appears to exceed social control. The fairs that encouraged such behavior once were socially acceptable because they served the economic functions of hiring labor and selling stock. This validation was, however, no longer available when their main function was the production of popular pleasure:

> But whilst these Fairs are of the smallest possible conceivable worth in a commercial point of view, indefensibly and indisputably they

are the prolific seed plots and occasions of the most hideous forms of moral and social evil—drunkenness—whoredom—robbery—idleness and neglect of work. (in Malcolmson 1982: 34–35)

Football (soccer), too, attracted similar attempts to control it (at that time it was played through the streets or over open fields—confining it to specified and controlled places was part of the other middle-class strategy of appropriating and reforming rather than repressing popular pleasures). Kingston Town Council in 1860 heard that it should prohibit the annual Shrove Tuesday football game because it

> is an obstruction to the passengers, a great annoyance to the peaceable Inhabitants, subversive of good order and prejudicial to the morality of the Town. (in Malcolmson 1982: 29)

Such an appeal to morality is less common in the attempts to repress football than it is in those to repress fairs. Those opposing football stressed rather its disorderliness and its disruption of business: The game in Derby was attacked in 1832 because it interfered with

> the avocation of the industrious part of the community; it is not a trifling consideration that a suspension of business for nearly two days should be created to the inhabitants for the mere gratification of a sport at once so useless and barbarous. (in Malcolmson 1982: 29)

A similar rhetoric was deployed in 1865 by the mayor of Derby (though words such as *evils* and *wickedest* show how readily the discourse of morality can be made to underpin that of economics, and thus to mask its class origin by universalizing it):

> In former times, when the town contained but few inhabitants, the game was not attended with its present evils, but it was now a well ascertained fact that many of the inhabitants suffered considerable injury, in person as well as property, from this annual exhibition; and he himself knew of instances where persons having an interest in houses, especially the larger ones, had experienced losses from want of occupiers, at adequate rents; parties who would otherwise have expended many thousands a year on the trade of the town, having left it, or declined to reside in it, because they did not like to

bring up their families here, under the idea that Derby was one of the lowest and wickedest places in the kingdom. (in Malcolmson 1982: 30)

The class-based nature of such discourse reveals itself in two main ways—the first is the paternalistic tone with which the concern for the morality of the lower orders is expressed, their "debauching of servants, apprentices and other unwary people" (in Malcolmson 1982: 33). The other is the defense of middle- or upper-class leisure activities, which, on the face of it, might have appeared identical to those being made illegal for the lower classes. Richard Martin in Parliament argued the difference in naively revealing terms:

Hunting and shooting, in his opinion, were amusements of a totally different character. Many gentlemen who indulged in those recreations had been the foremost to support his bill for preventing cruelty to animals. "Those who sported on their own manors, or fished in their own streams," he suggested, "were a very different sort of men." He had known men as humane as men could be who followed the sports of the field. (Malcolmson 1982: 36)

Malcolmson quotes a revealing passage that shows how the "field sports" of the upper classes (in unspoken opposition to the "blood sports" of the lower) can call upon God and nature to justify their existence.

[We are] yet constrained to believe that there is such a provision made for it by an all-wise Providence in the constitution of man, the instinct of hounds, and even in the strategems of fleetness of the hare herself, who may often have a gratification in eluding or out-stripping her pursuers, as to afford some justification of the practice. It has been strongly argued that the great propensity to field sports, which operates on many like an uncontrolled instinct, is a sure indication of the intention of the Deity, not only to permit, but to stimulate to those pursuits. And here, as in all things else, we may discern wisdom and goodness. (in Malcolmson 1982: 38–39)

Stedman-Jones (1982) charts similar movements in the development of popular culture in nineteenth-century London. He also stresses the opposition between work and leisure and points to the importance of the pub and the music hall in

popular culture. Both attracted moral disapproval and legislative control, both were seen as threatening and disruptive because they were sites of drunkenness, prostitution, and rowdiness.

Throughout this period a consistent cultural pattern can be traced. Popular pleasures were recognized to lie outside social control and thus to threaten it. Their unruliness was characterized by the middle classes as immoral, disorderly, and economically improvident. These social threats were localized within the individual; the proletarian body became the individual body. So the pleasures and excesses of the body—drunkenness, sexuality, idleness, rowdiness—were seen as threats to the social order. The pleasures of the individual body constituted a threat to the body politic. Such a threat becomes particularly terrifying when the pleasures are indulged in to excess, that is, when they exceed the norms proposed as proper and natural by those with social control, when they escape social discipline, and, thus, when allied with class interests, acquire a radical or subversive potential. Drunkenness or sexual promiscuity among the aristocracy may be frowned on by the bourgeoisie, but it is not seen as socially threatening and thus in need of the repression meted out to its lower-class equivalent. Excessive pleasures always threaten social control, but when these pleasures are those of subordinated groups (whether the subordination is by class, gender, race, or whatever) the threat is particularly stark, and disciplinary, if not repressive, action is almost inevitable.

Such disciplinary activity was not purely repressive. As Mercer (1983) points out, the Victorians were as much concerned with producing pleasure as with repressing it, but this production consisted of redefining, repositioning, and regulating pleasure. In particular, he argues, the Victorians

> were concerned to shift pleasures from the sites of mass activity (fairs, football matches with unlimited players, carnivals verging on riot) to the site of private and individualized activity. (p. 89)

The productive but paternalist means of controlling the pleasures of the subordinate classes typically took the form of attempting to impose middle-class meanings and behaviors

upon lower-class leisure; the bourgeoisie was trying to exert the same control over the conditions of leisure as it did over those of work. I do not wish to go into this in great detail here, but merely to outline three major thrusts through which this strategy was put into practice, which took the form of attempts to control the meanings and behaviors associated with holidays, culture, and sport.

The contradictory social forces contesting the issue of fairs—popular pleasure versus respectability and discipline—are also at work in the struggle over the meanings of holidays and how they should be spent. As fairs were progressively banned in the name of morality, sobriety, and order, they were replaced with official national holidays. Clearly, there was some hope that an "official holiday," the designation of which came from above, would be more amenable to discipline than a popular holiday that had a motive force from below.

The official meanings of holiday were those of "recreation" and underpinned the work ethic. A holiday, in this sense, was both earned by the industrious, an extension of the wage principle from the sphere of work to that of leisure, and a re-creation of the workers, a period in which they could regain their strength and prepare for more productive work on their return. The popular meanings of holiday, on the other hand, were those of carnivalesque release from the discipline of labor and a licensed indulgence in pleasures that the conditions of everyday life repressed. The difference was one between recreation and release.

Of course the bourgeoisie preferred the recreative meanings and set up organizations to produce them. Factory owners organized "works outings" for their workers, and temperance societies provided holidays for deserving workers and their families that offered no hint of alcoholic or other liberatory pleasures.

In the seaside resorts the difference between recreation and release was experienced as the difference between the excursionist and the holidaymaker. Railways enabled the mass transportation of people necessary for the development of the resort, but they also created the "excursion," by which the maximum number of people could travel at minimum cost (and comfort). The cheap excursion ticket enabled members of the

working class to pay for their own holiday and thus to "possess" it, to control its meanings, and to escape the discipline of the holiday provided by and organized from above.

Walton (1982) has shown how Blackpool developed its policies and growth to accommodate the contradictions between the excursionist looking for release and the holiday-maker looking for recreation. Different amenities were developed for each—fairground amusements and stalls for the one, the Winter Garden concerts and promenades for the other. Gradually Blackpool evolved into two towns, or at least a town with two ends, a respectable one and a popular one. Other resorts aimed for one or other of the markets, becoming either bourgeois havens of peace (e.g., Frinton-on-Sea) or vulgar working-class fairgrounds (such as the nearby Clacton-on-Sea).

Similar forces can be traced in the realm of entertainment. Music hall grew steadily in popularity among the London working class throughout the nineteenth century:

> Music hall stood for the small pleasures of working class life. . . .
> Its attitude was "a little of what you fancy does you good". Music
> hall was perhaps the unequivocal response of the London working
> class to middle-class evangelism. (Stedman-Jones 1982: 108)

The association of music hall with working-class pleasures, with drunkenness, rowdiness, and prostitution, made it an inevitable target for social control. Social control strategies varied from attempts to supplant it with the respectable "palace of varieties" to attempts to ban, censor, and control it by law. Though it was essentially a form of working-class culture and thus contained elements threatening to the middle classes, it nonetheless held a fascination for some members of those apparently threatened classes. Middle- and upper-class men visited some of the more respectable halls in order to meet working-class women; when classes and genders mixed in the music hall it was a place of work for the lower-class women (either as performers or as prostitutes) but of leisure for the upper-class men. It is not surprising, therefore, that when such activities attracted social discipline it was directed toward the work of the women rather than the leisure of the men.

In music hall, as in Blackpool and fairs, popular disruptive pleasures were always present, threatening social control. Marie Lloyd, who, more than any other performer, expressed these pleasures both in her "naughty" songs and in her defiantly "loose" life-style, found herself the embodied site of the struggle between these opposed social forces. Despite her enormous popularity, she was the only major music hall star never to perform at a royal command performance, and, on one occasion at least, made explicit the opposition between the respectable and the popular:

> A short distance from the Palace Theatre where the Command Performance was establishing a long and enduring tradition of dreariness, Marie staged her own show at the London Pavilion. Loyal fans had returned their Command tickets and came to see Marie instead. She was billed as "The Queen of Comedy" and she introduced new songs. Outside the posters bore strips which announced "Every Performance by Marie Lloyd is a Command Performance By Order of the British Public." (Archer and Simmonds 1986: 19)

The difference between the vulgar and respectable faces of popular entertainment made itself felt in the United States as well. Allen (1977) charts how vaudeville developed as the respectable form of burlesque, and how this respectability was sought and secured in the patronage of middle-class women and their families. The development of the department store in the late nineteenth century provided the first public space where a woman could legitimately and safely go without a male escort, and to capitalize on this, Proctor's Pleasure Palace was opened in the main shopping district of New York in the early 1890s. Its innovative policy was to offer continuous-performance vaudeville so that women could walk straight into it as they finished their shopping in the nearby stores. Linking shopping with entertainment for women as release from the domestic workplace originated long before the shopping malls that now continue the practice (see *Reading the Popular*, Chapter 2).

The middle classes did not confine their attempts to appropriate the leisure culture of other classes into their own value system to the lower orders: upper-class culture became their

target as well, as they tried to extend their cultural control throughout the social order. Painting and music, previously the preserve of the upper classes, were subject to middle-class appropriation, so the nineteenth century saw the growth of public art galleries, museums, and concert halls, usually in architectural versions of aristocratic houses or salons, and of public parks as accessible versions of the private parklands of the landed gentry. This bourgeois appropriation of upper-class culture, in rhetoric at least, made it public and available to all, including the proletariat. The price of admission, however, was to be paid not in hard cash (for most of these institutions of public culture were free), but ideologically—the admission ticket was the adoption of the middle-class values enshrined in the educational, improving function of the institutions. Popular pleasure had to be left outside the imposing entrances of the museums and galleries; it had no place in their marbled, reverential interiors. By the late twentieth century these cultural institutions have changed little, despite the changes in their architecture. Elsewhere, my colleagues and I have argued that art galleries in their design and their deployment of security guards have added the connotations of a bank or Fort Knox to those of aristocracy and religion, as befits a society where the investment, aesthetic, and spiritual values of art are inseparable (Fiske et al. 1987).

Sport, too, was a domain of leisure that the bourgeoisie attempted to colonize. Always in sport, rules and unruliness balance each other precariously; indeed, in many sports the aim is to push the rules to their extremes, to play on the borderline of the illegal. This insecure equilibrium between the forces of order and control on the one hand and those of disruption and disorder on the other is not confined to the structure of the games themselves, but can also be traced in their social functions and official organizations. The origins of some sports, such as athletics and archery, lay in their social utility— they developed military skills—but others, football and boxing, for example, show stronger traces of their origins in the people; they offer release as much as recreation, and admit the forces of disorder as openly as those of order. So it is no surprise that in contemporary Europe football matches can become occasions for disorder, whereas athletic meetings do not, nor is it

surprising that boxing attracts a set of "unsporting" and often illegal behaviors that tennis, for example, does not.

Cunningham (1982) shows how consistently throughout the nineteenth century the middle classes attempted to impose their ethos and forms of organization upon sport. Football and cricket, for instance, were "stolen" from their popular, disorderly origins, and were organized, made respectable, and turned into the means of building the character of young gentlemen, and thus of the nation. This strategy, like all strategies of control, was successful only up to a point, and its comparative failure is evidenced by the way sport split along class lines. Rugby union, for instance, became the form played by gentlemen amateurs, rugby league by working-class professionals. Soccer was appropriated more briefly by the amateur gentlemen of the Corinthians and has since been reclaimed by those who use it to express subordinate, disruptive pleasures. Rowing, originally a competition among watermen, has lost its popular origins and appeal entirely, and now exists solely as a sport with bouregois practitioners, practices, and ethos. Boxing and wrestling were much more recalcitrant to this sort of control, and the struggle is evidenced in the differences between their "clean" amateur versions, played in universities, boys' clubs, and the Olympic Games, and their "dirtier," professional, popular ones. The attempt to control and organize professional boxing to make it conform to the middle-class ethos of the sportsmanlike is a constant one, and its relative, though insecure, success is seen in the way that professional boxing still bears close similarities to amateur boxing. Wrestling, however, is quite a different matter—here the middle-class ethos has quite failed to control the professional sport to the extent that it becomes doubtful if the bourgeois word *sport* is even remotely appropriate. In wrestling, probably more than in any other "sport," the disorderly popular pleasures are given free and public expression. Cunningham (1982) also mentions a different, though parallel, strategy of control: as well as attempting to appropriate existing sports, the middle classes also invented new sports, such as tennis, mountaineering, or skiing, where their ethos could be planted on virgin soil and could flourish free from the competition of working-class weeds.

The development of the industrial middle classes, with their fear of the equally developing proletariat, has been marked by their consistent attempts to extend their control over the workplace into the leisure of the subordinate. Areas of popular culture that were "out of control" were cast as threats to the stability and moral (or physical) health of society. Popular pleasures were thus designated "antisocial," and so it became legitimate to subject them to a whole range of disciplinary and repressive powers. But the powers failed. People still got drunk and rowdy, excursionists demanded and were given their vulgar, carnivalesque pleasures, sport intransigently retained elements of disorderly license, and popular entertainment remained vulgar, offensive, excessive, and of generally "poor taste."

Popular pleasures work through and are experienced or expressed through the body, so control over the meanings and behaviors of the body becomes a prime disciplinary apparatus. Professional wrestling on television is as good a text as any within which to explore this play between the forces of discipline and social control and those of disorder and popular pleasure as they work themselves out in the body of the wrestler. For it is here that television comes closest to offering its viewers the offensive bodily pleasures of carnival.

THE CARNIVALESQUE

In his study of Rabelais, Bakhtin (1968) developed his theory of the carnival to account for the differences between the life proposed by the disciplined social order and the repressed pleasures of the subordinate. The physical excesses of Rabelais's world and their offensiveness to the established order echoed elements of the medieval carnival: both were concerned with bodily pleasure in opposition to morality, discipline, and social control.

The carnival, according to Bakhtin, was characterized by laughter, by excessiveness (particularly of the body and the bodily functions), by bad taste and offensiveness, and by

degradation. The Rabelasian moment and style were caused by a collision of two languages—the high, validated language of classical learning enshrined in political and religious power, and the low, vernacular language of the folk. The carnivalesque is the result of this collision and is a testament to the power of the "low" to insist upon its rights to a place in the culture. The carnival constructs a "second world and a second life outside officialdom" (Bakhtin 1968: 6), a world without rank or social hierarchy.

> Carnival celebrated temporary liberation from the prevailing truth from the established order: it marked the suspension of all hierarchical rank, privileges, norms and prohibitions. (p. 10)

Its function was to liberate, to allow a creative playful freedom,

> to consecrate inventive freedom, . . . to liberate from the prevailing point of view of the world, from conventions and established truths, from cliches, from all that is humdrum and universally accepted. (p. 34)

In carnival life is subject only to "the laws of its own freedom" (p. 7). Carnival is an exaggeration of sport, the space for freedom and control that games offer is opened up even further by the weakening of the rules that contain it. Like sport, carnival abides by certain rules that give it a pattern, but unlike sport (whose rules tend to replicate the social), carnival inverts those rules and builds a world upside down, one structured according to the logic of the "inside out" that provides "a parody of the extracarnival life" (p. 7).

Bennett (1983a: 148) suggests that the white-knuckle rides of amusement parks are carnivalesque partly because they invert the extracarnival relationship of the body to machinery:

> In releasing the body for pleasure rather than harnessing it for work, part of their appeal may be that they invert the normal relations between people and machinery prevailing in an industrial context.

The same claim can be made for video games, particularly the pay-as-you-use ones, where the skill of the operator decreases the profit of the owner (see *Reading the Popular*, Chapter 2).

This release is through the body: the intense concentration of video games or the subjection of the body to the terrifying physical forces of the white-knuckle rides result in a loss of self, a release from the socially constructed and disciplined subjectivity. The body's momentary release from its social definition and control, and from the tyranny of the subject who normally inhabits it, is a moment of carnivalesque freedom closely allied to Barthes's notion of *jouissance*.

Carnival is concerned with bodies, not the bodies of individuals, but with the "body principle," the materiality of life that underlies and precedes individuality, spirituality, ideology, and society. It is a representation of the social at the level of materiality on which all are equal, which suspends the hierarchical rank and privilege that normally grants some classes power over others. The degradation of carnival is literally a bringing down of all to the equality of the body principle.

ROCK 'N' WRESTLING

Rock 'n' Wrestling is television's carnival of bodies, of rule breaking, of grotesquerie, of degradation and spectacle. Barthes (1973) alerts us to the function of wrestling as a popular spectacle in terms that are remarkably similar to those used by Bakhtin to describe carnival. Both authors refer to the *commedia dell'arte* as an institutionalized form of popular spectacle; both point to the centrality of the body, to excess, exaggeration, and grotesqueness; both refer to the spectacle as an important principle, and to the way that wrestling or carnival exists on the borderline of art and not-art (or life).

Bakhtin (1968: 5, 11) finds three main cultural forms of folk carnival:

(1) ritual spectacles
(2) comic (verbal) compositions—inversions, parodies, travesties, humiliations, profanations, comic crownings and uncrownings

(3) various genres of billingsgate—curses, oaths, popular
blazons

The spectacular involves an exaggeration of the pleasure of
looking. It exaggerates the visible, magnifies and foregrounds
the surface appearance, and refuses meaning or depth. When
the object is pure spectacle, it works only on the physical senses,
the body of the spectator, not in the construction of a subject.
Spectacle liberates from subjectivity. Its emphasis on excessive
materiality foregrounds the body, not as a signifier of some-
thing else, but in its *presence*. Barthes argues that the
physicality of the wrestlers *is* their meaning: Thauvin does not
stand for ignobility and evil—his body, his gestures, his posture
are ignobility and evil. The wrestlers in *Rock 'n' Wrestling* have
excessive bodies and the rituals they perform are excessively
physical—the forearm smash, the flying body slam, the
hammer, the pile driver are movements whose meaning is the
clash of flesh on flesh. The forms the rituals take emphasize the
spectacular, the physical force, rather than their effectiveness
in "winning" the context; the immobility of a wrestler in a hold
is "the spectacle of suffering" (Barthes 1973: 20), for they are
moments of ritual, not the skills of sport. As Barthes says, the
function of a wrestler is not to win or lose, but "to go exactly
through the motions which are expected of him" (p. 16). The
humiliation and degradation of defeat exist only in the body
and helpless flesh of the fallen wrestler, not in a structure of
moral and social values that gives them "meaning." Hence the
audience, and the "victor," is licensed to gloat over and glory in
the crumpled body, and indeed the victor will frequently
continue his attacks and degradations of the vanquished body
after he has been declared the winner, after the bout has
officially ended. In defeat,

> the wrestler's flesh is no longer anything but an unspeakable heap
> spread out on the floor, where it solicits relentless reviling and
> jubilation. (Barthes 1973: 21)

A bout between Andre the Giant and Big John Stud finished
with Andre the "winner." King Kong Bundy, Big John's partner
in "tag wrestling", tore into the ring, apparently in an

uncontrollable rage, and Big John suddenly grabbed Andre's legs, throwing him onto his back. Bundy, a gross figure with a bald head and wide expanses of smooth white flesh, then executed a number of body slams upon the Giant, brushing the helpless referee out of the way as he did so. The commentator was excitedly and joyfully screaming, "This is despicable, this is despicable . . . come on referee, do something even if it's wrong. There's no way the referee . . . no way he's going to stop King Kong Bundy, who's fouling Andre. . . . he's obviously hurt, look at that sternum bone just sticking right out there!" The (apparently) broken sternum bone of Andre the Giant became an object of spectacle, divorced from the real social world of moral values and law, its meaning was its appearance as a swelling on the huge chest of Andre, which the camera zoomed in on, then and in the subsequent interview.

Earlier in the bout, Big John Stud's manager had thrown him a huge pair of scissors, with which he was threatening to cut Andre's hair. The two fought for the scissors, with Andre finally forcing Big John to let them go by sinking his teeth into the wrist of the hand holding them. The cold steel of the scissors against the sweating flesh of the wrestlers, the image of sharp teeth on yielding skin, all heightened the physicality of the contest, the plane of the body on which it occurred.

The carnival form of inversion and parody is equally clearly exhibited: the main inversion is that between control and disruption. The rules of the "game" exist only to be broken, the referee only to be ignored.

A regular "character" on *Rock 'n' Wrestling* is "Lord Alfred Hayes," who provides one or two "updates" of information about wrestlers and the World Wrestling Federation. His name, his dress, and his accent all parody the traditional English aristocrat; he is a carnivalesque metaphor of social power and status who is there to be laughed at. The social rules that he embodies are to be broken at the same time the information he imparts is accepted.

Rules organize the social and the everyday and control the sense we make of it; they determine not only behaviors and judgments, but also the social categories through which we make sense of the world. In carnival, categories are broken as enthusiastically as rules: the wrestlers' managers fight as often

as the wrestlers, wrestlers not officially involved join in the bouts, the ropes that separate the ring (the area of contest) from the audience are ignored and the fight spills into the audience, who become participants, not only verbally but sometimes physically.

> Carnival does not know footlights, in the sense that it does not acknowledge any distinction between actors and spectators. . . . Carnival is not a spectacle seen by the people: they live in it, and everyone participates because its very idea embraces all the people. (Bakhtin 1968: 7)

This participation ranges from the physical—raining (ineffective) blows on one wrestler, or helping the other to his feet—through the verbal—shouting encouragement and abuse or holding up placards—to the symbolic—waving mannequin models of one's favorite wrestler, or wearing his image on T-shirts. The television camera plays on the crowd, who performs for it as much as do the wrestlers: the categorical distinction between spectacle and spectator is abolished, all participate spectacularly in this inverted, parodic world.

Wrestling is a parody of sport: it exaggerates certain elements of sport so that it can question both them and the values that they normally bear. It recovers the offensive popular pleasures that the nineteenth-century bourgeoisie struggled so hard to appropriate and make respectable. In sport, teams or individuals start equal and separate out into winners and losers. In *Rock 'n' Wrestling* the *difference* is typically asserted at the beginning of the bout. Bouts often start with one wrestler (or pair) already in the ring, dressed conventionally and minimally in shorts or tights, and given an everyday name such as Terry Gibbs. The camera then cuts to his opponent coming through the crowd, spectacularly dressed in outlandish carnivalesque costume and equipped with an outlandish name such as Randy "Macho Man" Savage, Giant Haystacks, or Junkyard Dog. The contest is between the normal and the abnormal, the everyday and the carnivalesque.

Rock 'n' Wrestling refuses "fairness." It is *unfair*. Nobody is given a "sporting chance" and anyone who attempts to "play fair" is taken advantage of and suffers as a result. Yet the

commentators return us again and again to this rejected standard as a point from which to make sense of the action. The pleasure lies not in the fairness of the contest, but in the foul play that "exists only in its excessive signs" (Barthes 1973: 22).

Wrestling is a travesty of justice, or rather, justice is the embodiment of its possible and frequent transgression. "Natural" justice, enshrined in social law, is inverted; the deserving and the good lose more frequently than they win. It is the evil, the unfair, who triumph in a reversal of most dramatic conflict on television. There is a "grotesque realism" here that contrasts with the idealized "prevailing truth" of the social order: despite the official ideology, the experience of many of the subordinate is that the unfair and the ugly *do* prosper, and the "good" go to the wall.

In sport, the loser is not humiliated or degraded, but in *Rock 'n' Wrestling* he is, excessively. Sport's respect for a "good loser" is part of its celebration of the winner; wrestling's "license" for the bad to win allows also the degradation and humiliation of the loser's body. Sport's almost religious respect granted to the human body and to the individual is here profaned, blasphemed against.

And this body is almost invariably the male body. Female wrestling occurs, though rarely on television. It is interesting to note that in its nontelevisual form in clubs and pubs it frequently exaggerates the humiliation and degradation even further by being held in wet, slippery mud. In television sport the male body is glorified, its perfection, strength, and grace captured in close-up and slow motion. Morse (1983) suggests that slow motion, which is so characteristic of sport on television but used more rarely in *Rock 'n' Wrestling*, has the effect of making the male body appear large in scale, and thus more powerful, and of presenting it as a perfection of almost spiritual beauty. She cites the Greek ideal of *kalagathon*, in which the beautiful male body was linked to social and political power. Following Mulvey (1975), Morse suggests that there is a difference between the masculine gaze upon active, moving male bodies and upon passive female ones. She divides this masculine gaze upon the male into two types: one is a scientific investigative look of the will to know, which is a sublimation of the voyeuristic look and produces a repressed homoerotic

pleasure; the other derives its pleasure from the slow motion replays that produce the repetition that is associated with desire. The female spectator, however, is different. She is traditionally the uninvited observer (which presumably gives her the powerful position of the voyeur), but the televising of sport has, according to Morse, eroticized the male body so that it can become an object of feminine desire and pleasure. She wonders if there has been a significant shift in what she describes as sport's precarious balance between "play and display" (p. 45). In "play," the look upon the male body is transformed into an inquiry into the limits of human performance, in "display" the look has no such alibi. In this context she quotes a warning sounded by Stone (1971) that commercialization was transforming the inherently noble *game* into the inherently ignoble *spectacle*; she comments somewhat sardonically, "The surest sign of the degradation of sport into spectacle—as far as Stone was concerned—was the predominance of female spectators" (Morse 1983: 45).

The "live" audience of *Rock 'n' Wrestling* includes many, often very participatory, female spectators (whose presence is acknowledged in the names of one tag wrestling pair— Beefcake and Valentine, and it may well be that the construction of the male body as spectacle for the female viewer is more empowering than Morse allows. Her account of the pleasures offered by the display of the male body in televised sport leaves it aestheticized and eroticized, an object of admiration that can still appropriately bear the dominant ideology of patriarchy.

But in wrestling the male body is no object of beauty: it is grotesque. Bakhtin (1968) suggests that the grotesque is linked to a sense of earthy realism; indeed, he talks about "grotesque realism." The realism of the grotesque is opposed to the "aesthetics of the beautiful" (p. 29) represented in sport's vision of the perfect body. The grotesque body is "contrary to the classic images of the finished, completed man" (p. 25); cleansed of, or liberated from, the social construction and evaluation of the body, it exists only in its materiality. If the body beautiful is the completed, formed social body, then the body grotesque is the incomplete, the unformed. Its appeal to children (whose heroes, such as the Incredible Hulk or Mr. T, often have grotesque bodies) may well lie in the relevances they see

between the grotesque body and their own childishly incomplete, unformed ones. The grotesque allies their incompleteness with adult strength. There is a sense, too, in which principles of growth and change are embodied in the grotesque, for it is in direct opposition to the stasis of the beautiful. The grotesque is properly part of the vernacular of the oppressed.

The grotesque male body, then, offers to the female pleasures different from those of sport. Seeing masculine strength and power embodied in ugliness and engaged in evil distances them from social power (*kalagathon*) and sets up contradictory pleasures of attraction and repulsion. The excessiveness of this strength, in alliance with its ugliness, opens a space for oppositional and contradictory readings of masculinity; the grotesqueness of the bodies may embody the ugliness of patriarchy, an ugliness that is tempered with contradictory elements of attraction. There is a sense, too, in which this grotesqueness liberates the male viewer from the tyranny of the unattainably perfect male body that occupies so much of the "normal" television screen. Wrestling's carnival inverts televisual norms as successfully as social ones.

The third component of folk carnival is its billingsgate, its curses, oaths, and imprecations. In *Rock 'n' Wrestling* these are both verbal and nonverbal, carried in what Barthes calls the "grandiloquence" (literally, the "excessive speech") of gesture, of posture, and the body. The wrestlers "swear" kinesically at each other, at the referee, at the spectators: the spectators similarly curse and cheer, hold up placards. The breaking of linguistic conventions is obviously "modified for TV," in that actual obscenities and blasphemies are not permitted, but the process of bad-mouthing, of insulting, is enthusiastically entered into. The interviews between the bouts consist largely of wrestlers lauding themselves and bad-mouthing opponents. This billingsgate is typically delivered not to the interviewer, but directly to camera, involving the home viewer in the process as actively as the live audience. Billingsgate is oral, oppositional participatory culture, making no distinction between performer and audience.

Bourdieu (1984) picks up on a similar point when he contrasts middle-class with working-class culture and the role of the body and of participation or distance in each. Briefly, middle-class

cultural forms and the appropriate responses to them are characterized by distance, by critical appreciation. Bodily participation is confined to applause (a distanced, controlled trace of real participation) and occasional calls of "encore" (whose foreignness for the anglophone is a strong marker of distance). Working-class cultural forms, on the other hand, involve intense verbal and bodily participation, strong partisanship and involvement. Cheers, jeers, and all forms of billingsgate, "invasions" of the sporting arena or stage, the literal transformation of sporting conflict in the ring or on the field into social conflict on the terraces or in the aisles, the wearing of team/pop group/star favors, dress style, or images all typify what Bourdieu calls working-class participation in cultural forms as opposed to middle-class appreciation.

BODILY CONTROL

The body principle, upon which wrestling and the carnival are based, draws our attention to the politicization of the body in patriarchal capitalism. Foucault (1978) has revealed in detail the ways in which Western societies have used the body as the site where social power is most compellingly exerted. The body is where the power-bearing definitions of social and sexual normality are, literally, embodied, and is consequently the site of discipline and punishment for deviation from those norms.

Thus, disciplining the body became particularly critical in the nineteenth century, as the growing awareness of class conflict produced a bourgeois terror of the proletarian body and its popular, bodily pleasures. The individual body is the incarnation of the body politic, and thus class terror produces terror of the body, and the development of apparatuses of social control must be accompanied by discursive practices working to control the meanings and behaviors of the body.

The Christian church has traditionally defined the body as the terrain of the devil, as a threat to the purity and control of the soul, and has conceptualized the relationship between the two as one of hostility. This is a displacement of class and social

control onto the body in the name of individual morality. And, predictably, law and medicine in the nineteenth and twentieth centuries have joined hands with religion in attempting to exercise social control through disciplining the meanings and behaviors of the individual body.

De Certeau (1984) argues that juridical law can be effective only if people have bodies upon which it can be imposed. Thus the history of the law is the history of the tools devised to transform an abstract system of justice into social behavior—the scarifying instruments of torture, the prison cell, handcuffs and riot sticks, the prisoner's box in court, and ultimately, of course, the gallows, the electric chair, and the cross:

> And for Kant and Hegel, there is even no law unless there is capital punishment, that is, unless in extreme cases the body signifies by its destruction the absolute power of the letter and of the norm—a questionable assertion. However that may be it remains that the law constantly writes itself on bodies. (pp. 139–140)

Tools are the means by which the law is written on the body; the body itself is meaningless, until the law, as the agent of social discipline, writes it into a text, and thus inserts it into the social order. "This machinery transforms individual bodies into the body politic" (de Certeau 1984: 142).

The history of medicine, too, can be written in the history of the tools by which it writes social norms of physical and mental health upon the body. Leeches, knives, bleeding bowls, drugs, hospitals, madhouses—tools that are "active in cutting, gripping, shaping the flesh constantly offered up to a creation that makes it into bodies in a society" (p. 143). De Certeau sums up the process as one in which a social law or power is transformed by an instrumental apparatus onto a body: the law or *logos* of a society is made flesh, is incarnated, and, simultaneously, the bodies of people in that society are transformed into signifiers of these rules, in a process of "intextuation."

This incarnation of the law and intextuation of the body occur not only at the moments of transgression, though they occur most clearly and insistently there; they are also at work in ordinary, everyday practices. Clothing, cosmetics, slimming, jogging are all means of incarnating rules and intextuating the

body. The relationship between the body beautiful and the body ugly, between the healthy and the unhealthy, the well and the badly dressed, the groomed and the unkempt, the muscular and the flabby are social relationships of norms and deviations, and therefore political relationships aimed at naturalizing in the body the norms of those with most power in the social formation. The meanings of health are social and not physical, the meanings of beauty are political and not aesthetic: health and beauty are equally sociopolitical and are therefore discourses for the exercise of social power. Leslie Stern (1981) gives us a fine example of medicine's attempt to exert discursive control over the pleasures of the subordinate (in this case, women) and to establish as medically bad for the individual the pleasures that escaped, and thus threatened, patriarchal control. She quotes:

"The reading of works of fiction is one of the most pernicious habits to which a young lady can become devoted. When the habit is once thoroughly fixed, it becomes as inveterate as the use of liquor or opium. The novel-devotee is as much a slave as the opium-eater or the inebriate. The reading of fictitious literature destroys the taste for sober, wholesome reading and imparts an unhealthy stimulus to the mind the effect of which is in the highest degree damaging.

When we add to this the fact that a large share of the popular novels of the day contain more or less matter of a directly depraving character, presented in such gilded form and specious guise that the work of contamination may be completed before suspicion is aroused, it should become apparent to every careful mother that her daughters should be vigilantly guarded against this source of injury and possible ruin. We wish to put ourself upon record as believing firmly that the practice of novel reading is one of the greatest causes of uterine disease in young women. There is no doubt that the influence of the mind upon the sexual organs and functions is such that disease may be produced in this way, . . . Reading of a character to stimulate the emotions and rouse the passions may produce or increase a tendency to uterine congestion, which may in turn give rise to a great variety of maladies, including all the forms of displacement, the presence of which is indicated by weak backs, painful menstruation, leucorrhea, etc. . . . Thousands of women whose natural love for purity leads them to shun and abhor everything of an immoral tendency, yet find themselves

obliged to wage a painful warfare for years to banish from their minds the impure imagery generated by the perusal of books of this character. We have met cases of disease in which painful maladies could be traced directly to this source." *Ladies Guide*, Kellog, J. H., W. D. Conduit Co., Des Moines, USA, 1882.

Allen (1985), in his study of another source of pleasure for women, soap opera, gives a similar example of patriarchy's use of medicine as a means of disciplining women and their bodies:

In March 1942 a New York psychiatrist, Louis Berg, told the Buffalo Advertising Club that listening to soap operas caused "acute anxiety state, tachycardia, arrhythmias, increase in blood pressure, profuse perspiration, tremors, vasomotor instability, nocturnal frights, vertigo, and gastrointestinal disturbances."

A thorough analysis of a contemporary use of medicine as a disciplinary discourse has been provided by Treichler (1987) in her account of AIDS as "an epidemic of meaning."

Magazines aimed at women in lower socioeconomic groups are full of advertisements for products designed to help them change their bodies and intextuate into them the norms of the dominant social values. There is, perhaps surprisingly, little attempt to promote slimming in terms of physical health: its advantages are social and individual—it makes you feel better, and it improves your social life. In more middle-class magazines physical health may be more emphasized, but it is still related to social meanings—it enables one to be more effective at work. Jogging, exercise, and dieting are tools for incarnating the work ethic into the body of the individual.

Being defiantly fat, can, therefore, be an offensive and resisting statement, a bodily blasphemy. "Fat is a feminist issue" (as the title of a book by Orbach has it) precisely because it refuses the incarnation of patriarchy upon the female body: being fat can then become an empowering utterance. Blue-collar men are more likely than white-collar men to be overweight (the prefix *over* indicates the relational, nonessential nature of the concept) and to sport a defiant "beer belly": the norms of class- and gender-based social power are intextuated into the everyday body of the individual as they are into the body politic of society.

The ugliness of many male wrestlers is thus a form of class speech, an accent of the subordinated. But this accent can, and does, take another form, that of its excessive reversal. Many wrestlers now are "body builders," that is, they make their bodies into excessive texts of *kalagathon*: the norms of the "good" body are exaggerated, so that they exceed their "official" functions of health or effectiveness, and become a spectacle. Making norms spectacular rather than naturalizing them is a potentially subversive semiotic practice: it is the naturalized and thus invisible norms that perform their ideological and disciplinary work most effectively. By making itself invisible and natural, discourse makes itself believable: its credibility is weakened to the extent that its discursivity is foregrounded.

> The *credibility* of a discourse is what first makes believers act in accord with it. It produces practitioners. To make people believe is to make them act. But by a curious circularity, the ability to make people act—to write and to machine bodies—is precisely what makes people believe. Because the law is already applied with and on bodies, "incarnated" in physical practices, it can accredit itself and make people believe that it speaks in the name of the "real." It makes itself believable by saying: "This text has been dictated for you by Reality itself." People believe what they assume to be real, but this "reality" is assigned to a discourse by a belief that gives it a body inscribed by the law. The law requires an accumulation of corporeal capital in advance in order to make itself believed and practiced. (de Certeau 1984: 148)

Despite the disciplinary use of the body to incarnate and intextuate the law, the body remains a desperately insecure site for social control, which is why society has had to develop such powerful and all-encompassing apparatuses to deal with it. *Jouissance* is theorized as a moment of pleasure when the body breaks free from social and cultural control (see Chapter 3); it occurs at that moment of fracture when culture breaks down into nature and exists in that unstable border between the two. It is often expressed by erotic and orgasmic metaphors. The orgasmic pleasure of *jouissance* is the moment of bodily pleasure that escapes and thus threatens social control, so a whole disciplinary apparatus of "sexuality" has been created

to control it. But pleasure is not the only "threatening" capacity of the body; pain is threatening, too.

Pain is an important means by which social control is written on the body: it is inflicted juridically as punishment for those who deviate, and it is eliminated medically as reward for those who conform. The "spectacle of suffering" in wrestling evacuates pain from the social systems of justice, medicine, and morality and makes of it a spectacular bodily experience, the reverse of *jouissance*. Andre's broken sternum bone is painful-pleasurable only because it is a spectacular signifier, a bodily sensation outside the control of the law, medicine, or morality. It is an unnameable moment because it is outside the intextuation of the body:

> The intextuation of the body corresponds to the incarnation of the law; it supports it, even seems to establish it, and in any case it serves it. For the law plays on it: "Give me your body and I will give you meaning, I will make you a name and a word in my discourse." The two problematics maintain each other, and perhaps the law would have no power if it were not able to support itself on the obscure desire to exchange one's flesh for a glorious body, to be written, even if it means dying, and to be transformed into a recognized word. Here again, the only force opposing this passion to be a sign is the cry, a deviation or an ecstasy, a revolt or flight of that which, within the body, escapes the law of the named. (de Certeau 1984: 149)

Perhaps, de Certeau concludes, "all experience that is not a cry of pleasure or pain is recuperable by the institution" (p. 149). Wrestling's "spectacle of suffering" makes pain into an inversion of social norms, a liberating moment from normality, a symbolic statement of the desire for freedom from social control that the terrified social order can never extinguish or finally discipline. It is not surprising, then, that the painful and the grotesque offer threatening, undisciplined pleasures, or that they are subject to the discursive control of being given meanings of the unnatural, the deviant, that which must be cured or hidden, and that both are emphatically classed as socially undesirable.

In a similar vein, Dyer (1986) argues that our culture's obsession with the individual body and the ways we attempt to

make sense of it, and thus to discipline it, is bourgeois ideology at work: the sexualization of the body, its aestheticization and its signification of social norms and deviation all work to disguise the fact that the body provides the essential labor of capitalism. It is the bodies of the majority that make the profits for the few:

> The problem of the body seems to me to be rooted in the justification of the capitalist system itself. The rhetoric of capitalism insists that it is capital that makes things happen; capital has the magic property of growing, stimulating. What this conceals is the fact that it is human labour and, in the last instance, the labour of the body, that makes things happen. The body is a "problem" because to recognize it fully would be to recognize it as the foundation of economic life; how we use and organize the capacities of our bodies is how we produce and reproduce life itself. (p. 135)

Bourdieu (1984: 384) also finds class-based meanings of the masculine body when he notes the prevalence of "the popular valorization of physical strength as a fundamental aspect of virility and of everything that produces and supports it ('strong' food and drink, heavy work and exercise)." He reminds us that

> a class which, like the working class, is only rich in its labour power can only oppose to the other classes—apart from the withdrawal of its labour—its fighting strength, which depends on the physical strength and courage of its members, and also their number, i.e., their consciousness and solidarity, or, to put it another way, their consciousness of their solidarity. (p. 384)

For Bourdieu the body becomes the site where working-class consciousness is materialized, particularly the strong, excessive body. This working-class body, with its strength and virility,

> is perhaps one of the last refuges of the autonomy of the dominated classes, of their capacity to produce their own representation of the accomplished man and the social world, that is being threatened by all the challenges to working-class identification with the values of virility, which are one of the most autonomous forms of their self-affirmation as a class. The most fundamental principles of class identity and unity, those which lie in the unconscious, would be

affected if, on the decisive point of relation to the body, the dominated class came to see itself only through the eyes of the dominant class, that is, in terms of the dominant definition of the body and its uses. (p. 384)

A defiantly grotesque, excessively strong body bears the values of class consciousness, for it is the political meanings of the body that matter. The individual body becomes the class body as the site of the subjection of the proletariat in capitalism: it is therefore appropriate that the physical body, particularly in its grotesque, offensive, dirty aspects, should become the means of evading, resisting, and scandalizing that social power. The body that refuses to be aestheticized (for aesthetics is merely class disciplinary power displaced into metaphors of beauty, symmetry, and perfection), works culturally as both the language of the subordinate (though not of subordination) and the means of participation in subordinate cultural forms. Middle-class aesthetic/critical distance is a homology for the distancing of the bourgeoisie from the labor of production. Similarly, proletarian bodily participation in cultural forms is a homology for the laboring body as the heart of capitalist production.

A racial inflection of these incarnated social relations can be seen in many of the mixed-race hero pairs and teams that populate so many of our popular narratives. In them the black (or less white) will typically be the "body" of the team, particularly when this body receives its mechanical extension into cars or planes. So BA is the driver and mechanical expert in *The A-Team*, TC is the helicopter pilot in *Magnum, P.I.*, and Mark was Ironside's driver. In his analysis of the problems of cultural meaning posed by Paul Robeson for American society, Dyer (1986) links blackness with labor, and, however regretably, it will be many generations before blackness in American society will be able to shake itself free from the meanings of slavery, where the blacks were literally enslaved to a production system in a way that makes the white proletariat's slavery a mere metaphor. The black body intextuates social meanings in ways similar to the grotesque white one, and it is significant that Mr T., who plays BA in *The A-Team*, is also a television wrestler; his exaggerated muscularity embodies both blackness

and grotesqueness, his body intextuates racial and class meanings simultaneously. He specifically relates the gold chains that he wears to the chains of slavery. The grotesque black body, more even than the white, "speaks" subordination.

Sport's celebration of the body beautiful becomes, by contrast, a depoliticized ideological celebration of physical labor in capitalism. The sporting male body is, consequently, an active hegemonic agent. The sporting values of fairness and equality for all its players, of respect for the loser and proper celebration of the winner, are the moral equivalent of the body beautiful and represent the dominant ideology by which democratic capitalism values itself.

But if sport is clean, if capitalism is clean, then wrestling is triumphantly, defiantly dirty. For Douglas (1966), dirt is matter out of place, and the terror it invokes in the respectable bourgeoisie derives from its power to demonstrate the fragility of the conceptual categories by which semiotic and social control are exercised over unruliness and the forces of deception. Dirt disrupts and threatens social control because it fractures the categories upon which that control depends.

Allen (1987a) gives a fine, and relevant, example of the offense caused by such category breaking. He cites the appearance in some Chicago bars of female Jell-O wrestling and comments on the threats it offers. First is the threat to the category of the masculine posed by women taking traditionally male roles; then comes the threat to sport posed by the impossibility of any athletic movement in such a slippery medium. More deeply threatening is its insertion of "food" into the category normally occupied by "mud" or "dirt," and possibly the sharpest threat of all is that to the commodity, so that a spokesperson for the manufacturer was moved to complain how the very idea of Jell-O wrestling sent their trademark attorneys "into conniption fits."

Such a use of the body to transgress the categories that produce normal meanings may not in itself be progressive, but it is potentially subversive in its inversion of social discipline—a potential taken advantage of by one of the wrestlers, who commented:

Women's lib opened the door for female Jell-O wrestling. . . .
Women view it as aggressive, a thing they've never done, whereas
men are going to think it's just something sexy. It took me two years
to get aggressive enough to be a good wrestler. I'd never hit
anybody before. I had to learn to be aggressive, and that's hard for
a woman because we were taught to be sweet and nice and cute.
We do it for the high. That adrenaline pumping, that forcefulness.
(Allen 1987a: 3)

Cleanliness is order—social, semiotic, and moral (it is, after all,
next to godliness)—so dirt is disorder, is threatening and
undisciplined.

The body is inherently "dirty": all its orifices produce dirt—
that is, matter that transgresses its categorical boundary, that
denies the difference between me and not-me and that
contaminates the separateness of the body, and therefore its
purity as a category. In threatening the category of the body,
dirt threatens also the category of the individual for which the
body stands as a naturalizing metaphor. No wonder then that
so many bodily functions and physical pleasures have to be
disciplined by the designation "dirty."

The aestheticized body is a body without dirt that offers no
categorical challenges to social control and disciplined "cleanli-
ness." So the bourgeois body, applauding politely at the end of
a ballet, and keeping to its category as audience, is clean and
unthreatening. But the working-class body, shouting its
billingsgate or fighting in the aisles, erupting out of its category
as audience, is dirty and threatening. The incipient loss of
control is not just behavioral (for behavior can be contained by
the police), it is semiotic: the disruption of social categories is
the real threat because it occurs beyond the reach of any police
precinct. The "grotesque body" in its "earthy realism" is
intransigently, obstinately dirty, a constant reminder of the
fragility of disciplinary power.

The bourgeois sterilized body is categorically pure enough
for it to slip easily into that abstract principle of capital (the
opposite of the body principle) that is itself so uncontaminated
as, apparently, to need no discipline—it is a self-governing
principle. The body of labor, on the other hand, is dirty,
threatening, always about to erupt from its socioeconomic

category, always challenging its own semiotics, and thus always in need of more and more discipline, a discipline that is exerted through the discourses and practices of economics, of the law, of morality, and of "common sense."

Wrestling's grotesque realism of the ugly body is therefore opposed semiotically and politically to the forces of domination. The body is an appropriate medium through which to articulate the social experience of many subordinated and oppressed groups in capitalism whose everyday sense of the social system is not one of fairness and equality: positioned as they are as "losers," the subordinated (whether by class, gender, or race) have little sense of being "respected" by the ·winners, nor do they necessarily feel admiration for the socially successful. They are not "good losers," for society has not given them the "sporting chance" it claims to have given everyone. If beauty has been harnessed as a metaphor for the socially dominant, then ugliness metaphorically expresses the experience and the resistance of the subordinate. The grotesque body is both what must be repressed and the impossibility of repressing it, and carnival is the licensed moment of its eruption.

The word *licensed* points to how problematic the politics of carnival is in practice. It can be argued (e.g., by Eagleton 1981) that because carnival's disruptive moment is licensed by the prevailing order it is finally recuperated into that order. It is a strategy of containment that acts as a safety valve that allows the controlled release of popular pressure, and thus enables the subordinate to fit more comfortably into their oppression. The safety valve strengthens rather than dislodges the apparatus of social control.

Stallybrass and White (1986) argue that the safety valve debate is both unnecessary and misguided because of its tendency to essentialize carnival and its political effectiveness. On some occasions, in some contexts, carnival can work to strengthen the social order, but on others, particularly in times of social tension, its effects can be much more disruptive:

> For long periods carnival may be a stable and cyclical ritual with no noticeable politically transformative effects, but . . . given the presence of sharpened political antagonism, it may often act as a catalyst and site of actual and symbolic struggle. (Stallybrass and White 1986: 14)

These authors summarize the many occasions throughout early
modern Europe when violent social uprisings occurred during
carnivals and conclude that carnival's effects spread well
beyond its licensed place and moment.

> Carnival also refers to a mobile set of symbolic practices, images and
> discourses which were employed throughout social revolts and
> conflicts before the nineteenth century. (p. 15)

In support of this they point out that between the seventeenth
and twentieth centuries

> there were literally thousands of acts of legislation introduced
> which attempted to eliminate carnival and popular festivity from
> European life. (p. 176)

Of course, the traces of the carnivalesque remaining in
today's popular culture are unlikely to have any direct politi-
cally transformative effects, for, as I argue in Chapter 7, the
spheres of politics and entertainment never interact so directly.
But the carnivalesque may still act as a deep modeling of a
pleasurable ideal of the people that is at once both utopian and
counterhegemonic. It is demystifying, for it exposes both the
arbitrariness and the fragility of the social order.

Stam (1982) stresses particularly this demystifying work.
After referring to the "ecstatic collectivity" carnival produces,
he claims that

> the carnivalesque suggests a demystifying instrument for every-
> thing in the social order which renders such collectivity difficult of
> access: class hierarchy, political manipulation, sexual repression,
> dogmatism and paranoia. Carnival in this sense implies an attitude
> of creative disrespect, a radical opposition to the illegitimately
> powerful, to the morose and the monological. (p. 55, quoted in
> Stallybrass and White 1986: 19)

Carnival may not always be disruptive, but the elements of
disruption are always there, it may not always be progressive
or liberating, but the potential for progressiveness and libera-
tion is always present. Even in the carefully licensed, tele-
visually modified versions there are traces of the enormous

vitality and energy of popular forces that survive defiantly and intransigently. As Bennett (1986: 148) says:

> The value of excess associated with carnival . . . formed part of an image of the people as a boundless, unstoppable material force, a vast self-regenerating and undifferentiated body surmounting all obstacles placed in its path.

It might be taking Bennett too literally to suggest that his "vast self-regenerating and undifferentiated body surmounting all obstacles" is an unwittingly accurate description of Andre the Giant or King Kong Bundy, but there is a sense in which the grotesque wrestler is a metaphor for the body of the people, the subordinated body, the laboring body, the oppositional body. Television wrestling momentarily lifts the corner of the carpet and makes visible the dirt that patriarchal capitalism has swept under it. Making a spectacle out of the repressed and the hidden is a liberating recognition of just how hard bourgeois hygiene has to struggle to control the proletarian dirt that it can never eliminate.

Popular Texts

Some texts are selected by the people to be made into popular culture, others are rejected. In this chapter and the next, I wish to outline some of the characteristics of texts that are made popular, and to explore some of the key criteria that shape the selection process.

THE PRODUCERLY TEXT

A popular text should be producerly. To understand this term we need to refer to those characteristics discussed by Barthes (1975a) in his distinction between readerly and writerly tendencies in texts, and the reading practices they invite. Briefly, a readerly text invites an essentially passive, receptive, disciplined reader who tends to accept its meanings as already made. It is a relatively closed text, easy to read and undemanding of its reader. Opposed to this is a writerly text, which challenges the reader constantly to rewrite it, to make sense out of it. It foregrounds its own textual constructedness and invites the reader to participate in the construction of meaning. In his elaboration of these textual tendencies, Barthes is concerned primarily with literature, and concludes that the readerly text is the more accessible and popular, the writerly the more difficult, avant-garde, and therefore of minority appeal.

The category of the producerly is needed to describe the popular writerly text, a text whose writerly reading is not necessarily difficult, that does not challenge the reader to make

sense out of it, does not faze the reader with its sense of shocking difference both from other texts and from the everyday. It does not impose laws of its own construction that readers have to decipher in order to read it on terms of its, rather than their, choosing. The producerly text has the accessibility of a readerly one, and can theoretically be read in that easy way by those of its readers who are comfortably accommodated within the dominant ideology (if any such readers actually exist, do oil magnates watch *Dallas*?), but it also has the openness of the writerly. The difference is that it does not *require* this writerly activity, nor does it set the rules to control it. Rather, it offers itself up to popular production; it exposes, however reluctantly, the vulnerabilities, limitations, and weaknesses of its preferred meanings; it contains, while attempting to repress them, voices that contradict the ones it prefers; it has loose ends that escape its control, its meanings exceed its own power to discipline them, its gaps are wide enough for whole new texts to be produced in them—it is, in a very real sense, beyond its own control.

The commodities produced and distributed by the culture industries that are made into popular culture are those that get out of control, that become undisciplined. But they do not, like the writerly text, "make strange," their indiscipline is the indiscipline of everyday life, it is familiar because it is an inescapable element of popular experience in a hierarchal, power-structured society. They do not, then, require this writerliness, for to require it is to discipline it (the writerly reader of an avant-garde text is a disciplined one), but they allow it, they are unable to prevent it. The social experience that determines the relevances that connect the textual to the social and that drive this popular productivity is beyond textual control, in a way that is different from the more specifically textual competence and experience of the writerly reader of the avant-garde text.

To return to de Certeau's metaphor (see Chapter 2), the colonizing army that wishes to maintain control of difficult, mountainous territory must expose itself to guerrilla raids—it can protect itself only by withdrawing to its citadels. Popular culture is always difficult mountainous territory for those who wish to control it (whether for economic, ideological, or

disciplinary reasons), and its guerrilla readings are a structural necessity of the system. The economic needs of the industries can be met only if the people choose their commodities as adequate resources for popular culture; hegemonic force can be exercised only if the people choose to read the texts that embody it, and they will choose only those texts that offer opportunities to resist, evade, or scandalize it; strategic top-down power can operationalize itself only at the points of resistance where it meets tactical, bottom-up power. Popular culture is shot through with contradictions, and the "contra" element of its "diction" derives from the producerly readers of its (reluctantly) producerly texts.

Analyzing popular texts, then, requires a double focus. On the one hand we need to focus upon the deep structure of the text in the ways that ideological, psychoanalytic analyses and structural or semiotic analyses have proved so effective and incisive in recent scholarship. These approaches reveal just how insistently and insidiously the ideological forces of domination are at work in all the products of patriarchal consumer capitalism. When allied with the work of the political economists, and the critical theorists of the Frankfurt School they expose, with terrifying clarity, the way in which the economic and ideological requirements of the system determine, and are promoted by, almost every aspect of everyday life. But to confine ourselves to this focus alone is not only to cut ourselves off from an equally important area of culture in capitalist societies, but also to confine ourselves to a position that is ultimately debilitating in its pessimism. It may justify our righteous distaste for the system, but it offers little hope of progress within it, and only a utopian notion of radical revolution as a means of changing it.

The complementary focus is upon how people cope with the system, how they read its texts, how they make popular culture out of its resources. It requires us to analyze texts in order to expose their contradictions, their meanings that escape control, their producerly invitations; to ask what it is within them that has attracted popular approval. Traditional academic analysis and professional criticism have rarely focused upon popular texts in this way; critics, whether academic or professional, tend to act as disciplinary prefects, for their traditional role is

threatened by popular productivity and by popular discrimination. One starting point for the popular analyst, then, is to investigate what traditional critics ignore or denigrate in popular texts, and to concentrate on those texts that have either escaped critical attention altogether or have been noticed only to be denigrated. The combination of widespread consumption with widespread critical disapproval is a fairly certain sign that a cultural commodity or practice is popular. Let me look at some of these reasons popular culture is dismissed, derided, or attacked and see if there might be some positive side to these "vulgarities."

LANGUAGE

Popular culture is often attacked for its (mis)use of language. The question at issue here is whether the mass media and popular culture debase our language or revitalize it, and, allied to this, we must ask why it is that the popular use (or "misuse") of language causes such offense and concern to so many (who happen, not surprisingly, to be members of the educated bourgeoisie with a vested interest in preserving their control over education and the "proper" use of language that it teaches). One scandalous, undisciplined use of language will serve as my focus here—that of the pun.

Let me start with a specific example. A *New York Post* (5 February 1988) story begins: "An emotional Senate GOP leader Robert Dole yesterday wrote a $500 personal check to the Nicaraguan Contras in the wake of the House's 'grievous mistake' in voting down a $36 million aid package." The headline is DOLE BUYS INTO NEW CONTRAVER$Y.

The tabloid press does not reproduce vernacular speech—to do so would be impossible, for such speech patterns vary immensely across class, race, age, gender, and regional differences—but it has developed a form of language that enables various oral cultures to find resonances between it and their own speech patterns, and to find pleasure in relating the two. It achieves this largely through its departures from official,

correct language. There is a tone of disrepect running through-
out it that ensures that Dole's personal check to the Contras is
hardly likely to be read as an admired heroic act. Part of this
disrespect is carried by the pun "buys into," where the
vernacular metaphoric usages (which are surprisingly hard to
pin down) come into collision with a specific literal use (all $500
of it). The difference between the multiple vernacular usages
and this singular literal one is the difference between vernacular,
oral, popular cultures and the literate, official, disciplined
one.

The pleasure in the pun is twofold. There is the pleasure in
playing with the different uses of language as a microcosmic
moment in the constant play of class and social differences: the
pun offers a variety of street vernacular meanings of the check
that differ from Dole's as widely as do the social positions of
Dole and the *Post*'s readers, and the pun allows the "vulgar"
meanings to be seen as "more true" and so more powerful than
the official one. The pun's pleasure lies not just in its linguistic
miniaturization of social relations, but in its inversion of the
power that normally structures them. The second type of
pleasure is that of productivity: puns invite producerly read-
ings, there is a pleasure in spotting and solving the pun that
matures into the greater pleasure of making one's own
pertinent meaning from the collision of discourses within it.
Puns cannot control the relationships among their contra-
dictory discourses, they simply bundle them up together and
let the reader do the rest. (There may also be a less marked, but
discoverable, pleasure in the irony of a Republican senator
whose name is a word more commonly associated with poverty
and social welfare. The discovery and decoding of irony offers
similar pleasures to that of the pun.)

The "word" CONTRAVER$Y works differently. The lexical
association of the Contras with controversy may, at one level,
serve to trivialize, and thus show disrespect for, the political
battles that have been fought over the issue—its trivialization
may be a mark of its distance from, and irrelevance to, the
everyday life of the reader. The pun of $ for S may work in the
same way, a sign that the big dollars are over there, away from
us (along with Dole's check), spoken in a tone of streetwise
skepticism. But again, the punning does more than allow a

linguistic reexperience of social difference (or distance, aliena-
tion); it also misuses "their" language. It is a refusal to submit
to linguistic discipline, a momentary tactic by which the
linguistic system is raided and used "trickily," disrespectfully.

De Certeau's (1984) distinction between reading and
decipherment is relevant here. Decipherment is learning how
to read someone else's language on the other's terms; reading
is the process of bringing one's own oral, vernacular culture to
bear upon the written text. Decipherment requires training and
education organized by the same social forces that control the
linguistic system; it is part and parcel of the same strategic
deployment of power. Its function is to subjugate the reader to
the authority of the authored text, and thus of the critic-teacher
as a strategic agent who gains from the power in which he or
she participates. Reading, however, requires an oral culture
that precedes the written (the scriptural), that has developed
beyond or against the "official" language and is thus opposed
to its discipline. Decipherment promotes the text as an example
of *langue*, an embodiment of the universal system of language
that cannot be argued with but can only be used, and in its use
will use its user; decipherment trains its readers to be used by
the system. Reading, however, emphasizes *parole* over *langue*,
practice over structure. It is concerned with the everyday uses
of language, not its system or correctness. Reading emphasizes
contextuality, the unique relations of this particular linguistic
use to this particular contextual moment. It is thus concerned
with the transient and impermanent, for relevance must be
impermanent, as social allegiances change and are forged
differently for different moments and purposes. The pleasure
of CONTRAVER\$Y is that it has not been used before and will
not be used again (this may or may not be "factually" true, but
the point is that the "word" presents itself as unique, created
for this momentary context and specific to it). The uniqueness,
the contextuality, resides in the domain of the popular, it is part
of the culture of everyday life, and as such is opposed to the
generality, the normalization, and thus the discipline, of the
linguistic system in which is inscribed "correctness" and whose
rules are important not just because they control the way it
should be used, but because acceptance of them is yet another
way in which people govern themselves.

Puns are vulgar, part of oral culture: literacy prefers the serious, disciplined use of language that puns disrupt (what school teaches its students to pun? The idea is almost unthinkable.) Written language is linear, its connections are logical, bound by the laws of cause and effect. Puns are associative, they escape these laws, for associative relations are far freer than logical ones. Puns dissolve the linear flow of thought by which the reader is led by the hand from one idea to the next; rather, they involve parallel processing, the ability to process disparate but simultaneous flows of information.

Of course, punning is equally characteristic of some writerly, literary texts: James Joyce's work, for example, is full of puns. In avant-garde texts punning performs a similarly offensive function as in producerly texts, but it does so for a different readership and with a different relationship to the everyday. The readers of the avant-garde belong to a literary minority, an artistic leadership whose role is to free art from the conventions of its tradition and to open it up to new modes of representation in the future. Such writerly works have to teach their readers the codes and reading practices by which to make sense of them; they are in advance of their readers, their originality and their difficulty are two sides of the same coin.

Producerly punning, however, reproduces textually the contradictions that its readers already experience socially. It therefore has no "educational" function, it is not in advance of its readers; it is a textual device that allows them to articulate their social experience in it, so it does not attempt to make that experience unfamiliar, only to allow its contradictions a moment of recognition.

We must be clear, however, that the difference between writerly and producerly punning lies in their reading practices rather than in any essential differences between the puns themselves. CONTRAVER$Y is actually quite a Joycean word.

Greenfield (1984) suggests that some of the reasons many adults (particularly well-educated ones) are inept at, and therefore critical of, video games is because the ability to play them involves parallel processing, the ability to absorb multiple patterns of information simultaneously and to perceive rather than analyze the structured relationships between those patterns. The mental processes are quite different to those

linear ones so well trained into the literate elite. The advertisement for a hair conditioner that shows the head and naked shoulders of a young woman, with the caption "Use your head, give your hair body" is packed with parallel lines of thought. To "use your head" is simultaneously to think clearly and to make its attractiveness the bait for the male. Giving the hair body is what the product does, as it is what the reader does as her (his?) imagination is asked to create the (naked) body below the shoulders, and in so doing to produce the implied body of the male looking at her. Three bodies are given here, and give each other—those of the hair, of the female, and of the implied male. Reading the advertisement is not a literate skill, for it requires the parallel (not sequential) processing of words and image, of puns within words, of puns between words and image. The truck-stop sign

EAT HERE

GET GAS

allows no punctuation marks, prepositions, or conjunctions (all the organizers of relationships and therefore closers of meaning in literate language) to control the associations between its two activities. They may be alternate, sequential, consequential, simultaneous, or even unrelated; and the vulgar, offensive, punning meaning is available only because of this associative freedom. This freedom creates the space that allows what Bakhtin (1968) calls the language of the low to disrupt the official, polite meaning. The tension between the meanings is, like all semiotic tension, social as well as semantic.

Pop song lyrics characteristically use puns (see *Reading the Popular*, Chapter 5a). Frequently these are sexual, where the official, respectable meaning is undercut by the disrespectable, sexual one. The illicit pleasure of the sexual is heightened by the presence of the controlling discourse: the oppositional relation between the two gives greater pleasure than if the sexual meaning was circulated freely, on its own. Meanings "out of control" must contain traces of the control they are escaping if they are to be popular.

In "Thriller," Michael Jackson exploits the puns in the title word to the fullest extent. As he and his girl watch a horror movie, the chorus goes

> This is the Thriller, Thriller night
> Cause I could thrill you
> more than any ghost would dare to try
> Girl this is thriller
> So let me hold you tight and share a killer,
> thriller night.

The main pun brings together the flesh-creeping thrill of a horror movie with the flesh-blowing thrill of sexual orgasm—a killer in both senses. But the "boy" of the lyric is simultaneously Jackson the star and the "ordinary" boyfriend he plays in the video, so the girl is simultaneously the "ordinary" girlfriend and the star's fan. The puns work both in the boy-girl conversation and in the parallel star-fan conversation that brings to them the "thrill" of a Michael Jackson performance, the *jouissance*, the reading with the body, that is the effect upon his fans. This thrill, what Barthes would call an eroticism of the text (or, in this case, performance) is both sexual and horrific: text, orgasm, and terror reverberate within the word *thrill*. In the video, Jackson's personae shifts in parallel to the meanings of the word—he slides among Jackson as ordinary boyfriend, Jackson as star performer, and Jackson as werewolf or zombie. Under the public meanings of going to the movies or being a Michael Jackson fan lie dark orgasmic and horrific experiences that are both threatening and liberating in their escape from control.

DOLE BUYS INTO NEW CONTRAVER$Y is a miniature replay of discipline and indiscipline, of control and creativity, of linguistic system and contextual usages. Those of us who groan or grimace at its puns but find a wry pleasure as we do so are simultaneously aligned with each side of the tension. Our pleasure derives from the creativity of the release from linguistic discipline, our displeasure from our social investment in the system that is momentarily scandalized.

Puns ("bad" puns) are common in commercial culture—advertisements, headlines, pop songs, slogans—for precisely

these reasons. They pack a multiplicity of meanings into a small space, these meanings overflow, and escape control; they require productive reading, they never come ready-made. Insofar as puns are considered a frivolous, trivial use of language they embody the tension between the correct and the playful, and the playful always has the potential to be undisciplined, scandalous, offensive. The pizza house that calls itself the Leaning Tower of Pizza and decorates its facade with a crude stucco pastiche of the original offers a set of popular pleasures that exceed and outlast those of its product.

Puns are essentially oral: one has to speak them aloud to set up not only the oppositions between the discourses they embody, but also the opposition between the oral and the literate. They offend literacy because they "oralize" it, they move language away from the discipline of literacy toward the less controlled, more context-determined usages of an oral culture. They are part of a vulgar written language that is neither oral nor literate, but a bastard form, a written language that approximates the oral and offends the literate. We might call it an oralized script.

The discipline of the literate is marked by its rules of correctness, particularly those of syntax and spelling. An oralized script has no need of correct spelling and syntax, its markers of oralization are its errors, its deviations (deliberate or ignorant) from the discipline of literacy. Oralizations such as *tonite, thru, bar-B-Q*, and *Stop 'n' Go* are so common as to have almost lost their offensiveness. They are deliberate, almost accepted. More offensive to many people are the misuses that ignore correctness such as the common ignoring of the rule that the apostrophe distinguishes among a plural, a possessive, and an elision. In oral language the context alone is enough to distinguish between *its* and *it's*, and only literate pedants care when the local grocer proclaims the freshness of his "tomato's." Oral language has no need to know if *Granny Smiths* should be equipped with an apostrophe, or, if so, whether it should precede or follow the *s*.

It is not just that oral language does not need to spell, for an oralized script does, it is that oral language is context and function oriented rather than rule oriented. If it works, that's enough. As Bourdieu (1984) points out, the working class

requires that art be functional. This oralized script is functional, it serves its purpose. And part of its purpose is not to conform, to expose the arbitrariness of linguistic rules and to show that they are not so much functional as socially distinctive and disciplinary: breaking them rarely destroys meaning but says much about social class. Oralized language has moved toward the functional—*tonite* and *thru* are shorter, and even in that minimal sense, are more functional than their correct versions.

This sort of bastardization is quite different from "Pentagonese," which is excessively literate; it detaches words from their immediate context or speaker, spells them correctly, and uses them grammatically. This is language that depends so exclusively upon its systematic rules that it decontextualizes itself entirely: it refuses any concrete specificity, whether of speaker, of context, or of reference.

Deviation from the norm is not in itself a mark of a popular language, though it is often evidence of an attempt to achieve it. The shop window proclaiming "Chocolate Kreations Easter Speshals" deviates to draw attention to itself and thus to serve the purposes of the merchant; its popular potential appears to be much more limited, though it may, for some reader-consumers, signal a pleasurable difference between holiday and everyday shopping. This possible reading apart, it would appear to be neither particularly pleasurable nor functional. In this it differs from an apparently similar deviation, "Kra-Zee Golf" in garishly irregular letters. Here it is the context, the specificity of its uses, that increases its popular potential. The release that it offers from linguistic rules is paralleled by a release from the rules of conventional golf that is in turn a parallel of the release from social normality that a holiday offers ("Kra-Zee Golf" is, of course, a holiday entertainment). Its context presents greater opportunities for offensive pleasures than does that of the "Easter Speshals," whose difference from any other special offer does not provide as carnivalesque a moment for the language to work within.

Oral language is context based, and the context is not just physical, but also temporal and social. The holiday meanings of "Kra-Zee Golf" work only if one is physically in a resort, in a holiday period, and thus in an appropriate set of social allegiances. In such a context the oralized script is more likely

to be taken into the popular (while retaining its base in the commercial). Oralized script is both the commercial attempt to approximate the popular and the popular appropriation of that attempt.

EXCESS AND THE OBVIOUS

Popular culture tends to the excessive, its brush strokes are broad, its colors bright. This excessiveness invites its denigrators to attack it as "vulgar," "melodramatic," "obvious," "superficial," "sensational," and so on. Highbrow criticism is frequently accurate in its analysis, but wrong in its evaluation, so we may well accept its characterization of popular texts as excessive and obvious, while rejecting or even reversing its negative evaluation of these characteristics.

Excessiveness and obviousness are central features of the producerly text. They provide fertile raw resources out of which popular culture can be made. Excessiveness is meaning out of control, meaning that exceeds the norms of ideological control or the requirements of any specific text. Excess is overflowing semiosis, the excessive sign performs the work of the dominant ideology, but then exceeds and overspills it, leaving excess meaning that escapes ideological control and is free to be used to resist or evade it. The excessive victimization of the heroine of a romance novel, her exaggerated suffering at the hands of the hero, exceeds the "normal" victimization and suffering of women in a patriarchy. Norms that are exceeded lose their invisibility, lose their status as natural common sense, and are brought out into the open agenda. Excess involves elements of the parodic, and parody allows us to mock the conventional, to evade its ideological thrust, to turn its norms back on themselves.

The cover of *Weekly World News* (15 March 1988) is excessive, sensational and obvious (see Figure 7). There is nothing muted or subtle about it, but there is a pattern, there is an appeal, there is a point to its pleasures. It, and its many look-alikes that enliven supermarket checkout lines, speaks to the

PARENTS CATCH CHILD ABUSER — ON VIDEOTAPE!

WEEKLY WORLD

NEWS

55¢

Too late for love? NEVER!
Woman, 77, elopes with
90-year-old boyfriend

March 15, 1988 30587 VOL. 9, Issue 23

'Finally, the proof we've been waiting for,' say scientists

ALIEN MUMMY FOUND!

He looks like an E.T. who
never made it home

★ ★ ★

Top model marries leper

★ ★ ★

QUIZ REVEALS HOW
SEXY YOU REALLY ARE

★ ★ ★

Laser beam sets
brain surgery
patient ablaze

Was this
man fired
— for being
too fat?

Hitchhiking ghost causes car wrecks

Figure 7

disaffected. The great American dream is a bitter illusion for the millions who are not enjoying its promised prosperity, who do not control their own lives and do not experience the satisfaction of being successful, powerful individuals. Every headline on the page is a sensational example of the inability of "the normal" (and therefore of the ideology that produced it) to explain or cope with specific instances of everyday life. The world it offers the reader is a world of the bizarre, the abnormal. It investigates the boundaries of common sense in order to expose its limits. And common sense is, of course, the dominant ideology at work.

This page, then, is not an escapist fantasy bringing some unusual stimulation into the drabness of the everyday. Such a dismissive "explanation" of sensationalism leads one finally to the belief that those who find pleasure in it are essentially undiscriminating and have such blunted sensibilities that only the crassest, most exaggerated sensationalism can get through to them at all—a view that may do much for the egos of those that hold it, but that does little to explain the popularity of such magazines in contemporary America. Such sensational exposures of the inadequacy of the norms are pleasurable in themselves, especially for those whose material social experience is "abnormal," that is, those who, if they adopted the dominant bourgeois values, would have to make sense of their own lives as "failures." So the story about a top model marrying a leper or a 77-year-old woman eloping with a 90-year-old "boyfriend" are pleasurable because they enable those whose sexual relationships "fail" to accord with the romantic ideology of the "normal" couple to question the norms rather than their own experience. So, too, the pleasures in the failures or inadequacies of science (the laser beam that set the brain surgery patient ablaze, or scientists' inability to explain the alien mummy) are the pleasures of seeing the dominant, controlling explanations of the world at the point of breakdown, pleasures that are particularly pertinent to those who feel barred from participating in controlling discourses of any sort, scientific or not. The sensational is the excessive failure of the normal, and as such pushes the norms to the limits of their adequacy and then exceeds them, pushes them over the edge.

A "normal," good-looking young working man holding an

excessively abnormal mummified alien from outer space is an illustration of a special everyday experience that differs from ordinary experience only in degree, not in kind, for it is a moment when the inadequacy of the ideological norms can be experienced in an abnormally extreme form. The abnormality is one of degree only; the normality is the failure of the dominant social values to match the everyday experiences of the disadvantaged millions.

Such sensationalism does not, of course, articulate the actual experience of the disaffected and disadvantaged, for the ways in which different social groups are prevented from achieving these ideological norms are multifarious and depend upon the many social positions that can be described as "disadvantaged." What all groups have in common is the experience of subordination and exclusion, so the demonstrated failures of that from which they are excluded open the text up for the various readers to make various pertinences between it and their own lives. Portraying "the other" negatively allows for an open range of positive pleasures to be negotiated.

The popularity of such sensational publications is evidence of the extent of dissatisfaction in a society, particularly among those who feel powerless to change their situation, and the fact that there are more of them, and that they are more visible, in the United States than in, for example, Australia or the United Kingdom may say something about the exclusiveness of American ideology and the harshness with which it treats those it excludes. The more socialist inflections of capitalism in Australia and the United Kingdom (despite Thatcherism) may offer some explanation of why there are fewer such publications in those countries.

Sensational, obvious, excessive, cliched—the qualities of popular texts are almost indistinguishable from one another. In the next section I argue that the obvious refuses the "in-depth" truth, which is finally a controlling discourse—the obvious offers no insightful explanation, and leaves itself open. But obviousness is not just a characteristic of what is dealt with, it lies also in the way it is handled—the obvious and the cliched are two sides of the same coin.

In the days of movable type, a cliche was a word or phrase that printers would leave whole, or "clenched" together (the

meaning of the French word *cliché*), because they knew that such words or phrases would be used frequently. It is not enough to dismiss cliches as evidence of lazy thinking or lack of linguistic creativity; rather, we should ask why it is that certain words or phrases are used so frequently by certain people at certain times—what is it about them that makes them popular?

Cliches are the commonsense, everyday articulations of the dominant ideology. So the metaphor found in such phrases as "Time is money," "spending (or wasting) time," or "investing time in" is so much a cliche that we forget it is a metaphor, because it makes time conform perfectly to the Protestant work ethic—it makes a capitalist sense of time by turning it into something that can be possessed, saved, invested, something that some people can have more of than others, that can reward the efficient and penalize the lazy. The metaphor is fully hegemonic, it is common sense in performance as an ideological practice.

Similarly, Ron Perlman, who plays Vincent, the beast in the TV series *Beauty and the Beast*, talks in cliches when he says:

> I think women want to be romanced. They want to be treated specially. They want to have poetry read to them, instead of sitting there watching this guy in an undershirt watching football games. (*Star*, 8 March 1988: 25)

The cliches of women as sensitive and romantic, and domestic, and of men as slobby, selfish jocks, are, at one level, the common sense of patriarchal capitalism. Behind them lies the "common sense" that the man is like this at home only because his goal-oriented attitudes and behavior are work-specific and he has earned the right to relax at home, and that the romantic nature of women means that they can find true happiness only in the love of a man, not in career or other satisfactions. (The fact that most men fail to live up to women's needs is not allowed to invalidate these needs and thus to question the ideology.that has produced them.) Romance can be explained as the training of women for marriage (see *Reading the Popular*, Chapter 5b). There is, of course, a heavy and relatively explicit irony here, that the price women have to pay to maintain their

actual marriages is the extinction of those romantic feelings that the ideology of patriarchal marriage produced as essential elements of femininity in the first place. Cliches bear ideological norms, which is why they are such powerful constructors and circulators of common sense. But this does not explain all their cultural uses: they can also work to expose the gap between that ideology and everyday experience. The contradictions between the poetic woman and the sports-mad man can work not only to make a cliche of the price women have to pay, but to make that price visible and accountable.

Thus, a fan writes to Perlman:

> Please keep Beauty and the Beast on the air. I need to be able to pretend Vincent is real. I wish he were, but then if he was, I'd probably leave my husband and children and run away and live with him. And what would my mother think? (*Star*, 8 March, 1988: 25)

A complex, but typical, set of negotiations is at work here. First there is a recognition of the gap between the unattainable norm and everyday reality that is reproduced in the recognition of the difference between the televisual representation and the real. This recognition gives the viewer the right (and ability) to deny that difference, and to treat the representation as though it were the real in order to increase textual pleasure. This ability to move into and out of the text, simultaneously to affirm and deny its textuality, is pleasurable because it is a movement under the control of the viewer. She is not the dupe of the text, but is in charge of her own reading relations. Reading the popular text is no simple escapism in which the everyday is temporarily left behind. The fan knows that even if Vincent were "real" she would not run away with him—her jocular reference to her mother is a wry acknowledgment of the internalized discipline by which people govern themselves, and of the fact that this discipline is restrictive and destructive of pleasure. The cliches are experienced as cliches—that is, as an ideological common sense produced by others—but they have been internalized so that they are simultaneously *ours* and the *other*'s. The gap between the internalized *other* of the cliche and the unique *ours* of our everyday life is a skeptical, demystifying one (the writer is aware of the commonality of

dissatisfaction with husband and children—she feels no need to justify or expand on it, but can rely on other women to recognize the feeling in general, though her experience of it, the form it takes with her husband and her children is, or at least feels, uniquely hers).

Cliches deny the uniqueness of the text, which is why they are so abhorred by the critical values that establish priorities for textual uniqueness and the creativity of the author: they allow for meaningful pertinences to be made between the specificities of everyday life and the ideological norms they embody. Cliched writing is writing by norm, writing as naked ideological practice. The cliche is read as its norms intersect with the practices and experiences of everyday life. Far from being a hegemonic agent with an effectiveness close to that of brain-washing, the cliche often exposes the "otherness" of the dominant ideology and often makes strange the extent of the compromises that have to be made to accommodate it with everyday life.

CONTRADICTIONS AND COMPLEXITY

Popular culture is contradictory: It is shot through with contradictions that escape control. Those who accuse it of being simplistic, of reducing everything to its most obvious points, of denying all the subtle complexity, all the dense texture of human sentiment and of social existence, are applying inappropriate criteria and blinding themselves to where the complexities of popular culture are actually to be found. Of course, popular culture does not resemble a highly crafted sonnet or lyric poem, nor does it attempt to reproduce the psychological depth and density of texture of a novel by Henry James (for which we should all be truly grateful). The complex-ities for which poetry and literature are valued are located typically in its use of language and its ability to use the full resources of a language to provide an artistic correlative of the subtle varieties and fine differences of individual sentiment. The valued links are those between people at the level of our

essential humanity: It thus denies the social, and in particular avoids the political.

I am not arguing an essentialist view of literature here, but am pointing to the way it is taught and circulated in our society—its differences from popular culture lie more in the ways it is used in society than in its texts. Those critics who argue that Shakespeare used to be popular culture but is no longer draw entirely the wrong conclusion from their observation: the implication should not be that the popular tastes of the twentieth century are more degraded than those of the seventeenth, but rather that the institutionalization of literature (in which these same critics are so active) has made Shakespeare into high art, given him correct meanings, confined him to expensive or arty theaters and above all made him into an examinable subject, so that those who decipher him better receive higher grades and thus are eventually established as better, brighter individuals than those whose decipherment is less "insightful." How can a text be popular when it is used to discriminate among individuals and to train people into the habits of thought and feeling of another class? Bourdieu's (1984) main argument is, as the title of his book *Distinction* indicates, that culture is used to distinguish among classes and fractions of classes, and to disguise the social nature of these distinctions by locating them in the universals of aesthetics or taste. The difficulty or complexity of "high" art is used first to establish its aesthetic superiority to "low," or obvious, art, and then to naturalize the superior taste and (quality) of those (the educated bourgeoisie) whose tastes it meets. A critical industry has been developed around it to highlight, if not actually create, its complexity and thus to draw masked but satisfying distinctions between those who can appreciate it and those who cannot. Artistic complexity is a class distinction: difficulty is a cultural turnstile—it admits only those with the right tickets and excludes the masses.

Conversely, a popular art is characterized as simple and arouses what Bourdieu (1984: 486–488) calls the "disgust of the facile." The facile text, which gives itself to all comers, is talked of in terms of its "easiness"—terms also applied to a woman of "easy" virtue who is an "easy lay." These discursive links between the disrespectable, easy text and disrespectable

sexuality are extended to cover other physical pleasures, particularly those of eating disrespectable foods. So popular texts are not only "easy," they are "sickly," "sugary," "cloying." The vocabulary is that of childish taste, an immature, easy, undeveloped taste that is *of itself* inferior to the mature taste of the adult bourgeoisie. The discursively constructed similarities among childishness, femininity, and the subordinate classes is a typical piece of patriarchal bourgeois ideology working in the realm of culture.

Reading texts is a complex business; and the complexity of popular texts lies as much in their uses as in their internal structures. The densely woven texture of relationships upon which meaning depends is social rather than textual and is constructed not by the author in the text, but by the reader: it occurs at the moment of reading when the social relationships of the reader meet the discursive structure of the text. *Dallas* is a complex text because so many and such diverse audiences can make so many and diverse intersections between it and their social relations. Its dialogue, its representation of relationships among people, its psychological depth, its exploration of the infinitely subtle problems and rewards in accommodating the needs of the individual with the demands of the social—all of these may be only alluded to, sketched in superficially in the broadest brush strokes. But that is precisely its strength. It is a text full of gaps, it provokes its producerly viewers to write in their meanings, to construct their culture from it.

The reader of a novel is often told in great detail of the interior feelings and motivations of a character: The viewer of television has to infer all of these from a raised eyebrow, a downturn at the corner of the mouth, or the inflection of the voice as it speaks the cliche. By "showing" rather than "telling," by sketching rather than drawing completely, popular texts open themselves up to a variety of social relevances. Telling or revealing the truth hidden below the surface is the act of a closed, disciplinary text and requires decipherment rather than reading. Showing the obvious leaves the interior unspoken, unwritten; it makes gaps and spaces in the text for the producerly reader to fill from his or her social experience and thus to construct links between the text and that experience. The refusal of depth and of fine distinctions in the text devolves

the responsibility for producing them to the reader. And we know that some readers, at least, do just that. The way that some women, for instance, talk about soap opera shows how intimately they fill in, or rather flesh out, the emotional lives of the characters in a way that makes them as completely rounded as any produced by a psychological dramatist. The productivity is in the reading rather than in the writing.

TEXTUAL POVERTY AND INTERTEXTUALITY

Behind the criticism of the poverty of popular texts lies the uninspected assumption that a text should be a highly crafted, completed, and self-sufficient object, worthy of respect and preservation; universities, museums, and art galleries are all curators of such texts. But in popular culture, texts as objects are merely commodities, and as such they are often minimally crafted (to keep production costs down), incomplete, and insufficient unless and until they are incorporated into the everyday lives of the people. They are resources to be used disrespectfully, not objects to be admired and venerated.

Much contemporary cultural theory argues that all texts are incomplete and can be studied only intertextually and in their modes of reception, but the social and academic practices of textual analysis, preservation, and display still grant to the "aesthetic" text a degree of completion, self-sufficiency, and respect that is inappropriate to popular texts. Popular texts are to be used, consumed, and discarded, for they function only as agents in the social circulation of meaning and pleasure; as objects they are impoverished.

A pair of jeans in a museum of fashion is not totally meaningless—depending on their relationships to other garments in the display they could carry a number of generalized meanings about twentieth-century America—but they are still an impoverished text. Their meanings can be brought to fruition only intertextually, by including the ways they are promoted commercially, the ways they are worn and talked/thought about by their users, and the meanings that the press

and other social commentators make of them. In other words, the study of popular culture is the study of the circulation of meanings—treating a text as a privileged object artificially freezes that circulation at a particular (if convenient) point and overemphasizes the role of the text within it. The popular text is an agent and a resource, not an object.

So Madonna (see *Reading the Popular*, Chapters 5a and 5b) is circulated among some feminists as a reinscription of patriarchal values, among some men as an object of voyeuristic pleasure, and among many girl fans as an agent of empowerment and liberation. Madonna as a text, or even as a series of texts, is incomplete until she is put into social circulation. Her gender politics lie not in her textuality, but in her functionality. She is an exemplary popular text because she is so full of contradictions—she contains the patriarchal meanings of feminine sexuality and the resisting ones that her sexuality is *hers* to use as she wishes in ways that do not require masculine approval. Her textuality offers both patriarchy and ways of resisting it in an anxious, unstable tension. She is excessive and obvious; she exceeds all the norms of the sexualized female body and exposes their obviousness along with her midriff. Her sexualization of her navel is a parody of patriarchy's eroticization of female body fragments—she is a patriarchal text shot through with skepticism.

Far from being an adequate text in herself, she is a provoker of meanings whose cultural effects can be studied only in her multiple and often contradictory circulations. Popular culture circulates intertextually, among what I have called primary texts (the original cultural commodities—Madonna herself or a pair of jeans), secondary texts that refer to them directly (advertisements, press stories, criticism), and tertiary texts that are in constant process in everyday life (conversation, the ways of wearing jeans or dwelling in apartments, window shopping, or adopting Madonna's movements in a high school dance) (see Fiske 1987a, 1987b). All the texts of Madonna—primary, secondary, or tertiary—are inadequate and incomplete. Madonna is only the intertextual circulation of her meanings and pleasures; she is neither a text nor a person, but a set of meanings in process. Even though she can be studied only in her texts and the relations between them, for those are the

moments when meanings in process become most visible, the texts themselves are not signifying objects, but agents, instances and resources of popular culture.

When the movie *The Shining* was first released in Britain, the press circulated different meanings of it around different social classes. Newspapers aimed at an upscale readership promoted it as a Stanley Kubrick film; they identified its key moments as ones that bore his signature (long, eerie tracking shots down hallways, for instance) and they organized its intertextual relations around its author-creator. The tabloid press, on the other hand, spoke of it as a genre film; they related it not to other Kubrick films, but to other horror movies, selected its scariest moments as its crucial ones, and evaluated it using generic, not authorial, comparisons. *Spare Rib*, for its feminist readership, read it as another agent in the victimization of women and thus related it intertextually to patriarchal cinema (and culture) in general, the widest and most explicitly political sense of intertextuality of all.

Intertextuality may not be unique to popular culture—it was central to the "high" cultural readings of *The Shining* as well, but it works differently. The high cultural intertextual relations organized around the author-artist are more limiting than ones organized around genre or gender politics, and they accord well with the status of the text as a crafted object. Indeed, the veneration of the author-artist is a necessary correlative of the veneration of the text. In popular culture the object of veneration is less the text or artist and more the performer, and the performer, like Madonna, exists only intertextually. No one concert, album, video, poster, or album cover is an adequate text of Madonna. Intertextual competence is central to the popular productivity of creating meanings from texts.

The poverty of the individual text in popular culture is linked not only to its intertextual reading practices, but also to its ephemerality and repetitiousness. For it is not just the needs of the industry that require the constant reproduction of the cultural commodity, but also the forces of popular culture. The poverty of the individual text and the emphasis on the constant circulation of meanings mean that popular culture is marked by repetition and seriality, which, among other effects, enable it to fit easily with the routines of everyday life. Magazines are

published weekly or monthly, records played constantly, television organized into series and serials, clothes worn and discarded, video games played time and again, a sports team watched game after game—popular culture is built on repetition, for no one text is sufficient, no text is a completed object. The culture consists only of meanings and pleasures in constant process.

Because of their incompleteness, all popular texts have leaky boundaries; they flow into each other, they flow into everyday life. Distinctions among texts are as invalid as the distinctions between text and life. Popular culture can be studied only intertextually, for it exists only in this intertextual circulation. The interrelationships between primary and secondary texts cross all boundaries between them; equally, those between tertiary and other texts cross the boundaries between text and life. As Bourdieu (1984) argues, one of the main distinctive features of popular culture against high culture is its resolute refusal of any distance between the aesthetic and the everyday (see Chapter 6). It is only the completed, venerated text beloved of the bourgeoisie that benefits from this aesthetic distance.

The texts of popular culture, then, are full of gaps, contradictions, and inadequacies. It is what aesthetic criticism would call its "failures" that enables the popular text to invite producerly readings; they allow it to "speak" differently in different contexts, in different moments of reading, but this freedom is always struggling against textual (and social) forces that attempt to limit it. The popular text is a text of struggle between forces of closure and openness, between the readerly and the producerly, between the homogeneity of the preferred meaning and the heterogeneity of its readings. It reproduces and recreates the struggle between the disciplinary power of the social order and the multiple resistances to this power, the multiple bottom-up powers that contest differently the more singular top-down power.

Popular texts must offer popular meanings and pleasures—popular meanings are constructed out of the relevances between the text and everyday life, popular pleasures derive from the production of these meanings by the people, from the *power* to produce them. There is little pleasure in accepting ready-made meanings, however pertinent. The pleasure

derives both from the power and process of making meanings out of their resources and from the sense that these meanings are *ours* as opposed to *theirs*. Popular pleasures must be those of the oppressed, they must contain elements of the oppositional, the evasive, the scandalous, the offensive, the vulgar, the resistant. The pleasures offered by ideological conformity are muted and are hegemonic; they are not popular pleasures and work in opposition to them.

Popular Discrimination

Chapter 5 outlined some of the characteristics of texts that enable them to be made into popular culture, but the presence of these characteristics does not, of itself, guarantee that a text will be chosen. The people discriminate among the products of the culture industries, choosing some and rejecting others in a process that often takes the industry by surprise, for it is driven by the social conditions of the people at least as much as by the characteristics of the text. This popular discrimination, then, is quite different from the critical or aesthetic discrimination promoted by schools and universities to evaluate the quality of highbrow texts. Popular discrimination is concerned with functionality rather than quality, for it is concerned with the potential uses of the text in everyday life. Three main criteria underlie this selection process: relevance, semiotic productivity, and the flexibility of the mode of consumption.

RELEVANCE

Popular culture is made at the interface between the cultural resources provided by capitalism and everyday life. This identifies *relevance* as a central criterion. If the cultural resource does not offer points of pertinence through which the experience of everyday life can be made to resonate with it, then it will not be popular. As everyday life is lived and experienced fluidly, through shifting social allegiances, these points of pertinence must be multiple, open to social rather than textual determinations, and transient.

Popular discrimination is thus quite different from the aesthetic discrimination valued so highly by the bourgeoisie and institutionalized so effectively in the critical industry. "Quality"—a word beloved of the bourgeoisie because it universalizes the class specificity of its own art forms and cultural tastes—is irrelevant here. Aesthetic judgments are antipopular—they deny the multiplicity of readings and the multiplicity of functions that the same text can perform as it is moved through different allegiances within the social order. Aesthetics centers its values in the textual structure and thus ignores these social pertinences through which text and everyday life are interconnected. Aesthetics denies the transience of popular art, it refuses to recognize that the social order changes and thus that art that is relevant today will be irrelevant tomorrow. It refuses to recognize the shifting nature of the allegiances that constitute "the popular," that what the people are today they will not be tomorrow and thus what is popular today will not be popular tomorrow. Aesthetics refuses to recognize that people position themselves variously in the social structure and that social differences must produce cultural differences. Aesthetics requires the critic-priest to control the meanings and responses to the text, and thus requires formal educational processes by which people are taught how to appreciate "great" art. Aesthetics is a disciplinary system, an attempt by the bourgeoisie to exert the equivalent control over the cultural economy that it does over the financial. "What is at value in aesthetic discourse . . . is nothing less than the monopoly of humanity" (Bourdieu 1984: 491). Aesthetics is naked cultural hegemony, and popular discrimination properly rejects it.

Unlike aesthetic criteria, those of relevance can be located only in the social situation of the reader; they can reside in the text only as a potential, not as a quality. Relevance is a quality determined by and activated in the specifics of each moment of reading; unlike aesthetics, relevance is time- and place-bound. The critic/analyst may be able to identify textual characteristics that constitute this potential, and may be able to hypothesize or predict ways in which it may be activated, but such predictions are haphazard, partial, and never authoritative. Nor are they evaluative in a textual sense: one reading

cannot be "better" than another if the criteria are ones of social relevance rather than aesthetic quality. The evaluative work of popular criticism becomes social or political, not textual: the critic attempts to explore and evaluate the sociopolitical effectivities of the relevances made out of the text. The critic becomes concerned with what the text does, or is made to do, rather than what it *is*. (Though, of course, what it *is* has some determining effect upon what it can be made to do.) Relevance is discovered or produced by the reader; it is the moment and process of production in the cultural economy that takes the text beyond its role as commodity in the financial. Popular discrimination, then, does not operate between or within texts in terms of their quality, but rather in the identification and selection of points of pertinence between the text and everyday life. This means that any one text can offer, potentially at least, as many relevances as there are different social allegiances of its readers. Indeed, Eco (1986: 141) suggests that socially pertinent meanings can be made from a text as apparently intransigent as an ad, and that such meanings may even be directly revolutionary:

> The messages set out from the Source and arrive in distinct sociological situations, where different codes operate. For a Milanese bank clerk a TV ad for a refrigerator represents a stimulus to buy, but for an unemployed peasant in Calabria the same image means the confirmation of a world of prosperity that doesn't belong to him and that he must conquer. That's why I believe that TV advertising in depressed countries functions as a revolutionary message.

Hodge and Tripp (1986) found that schoolchildren constructed a complex set of pertinences between their own social position within school and those of the convicts within the prison in the TV soap opera *Prisoner*. This metaphoric relationship between prison and school is precise but not explicit: both are total institutions, both are there to turn their inmates into the sort of people that society thinks they ought to be, which may not coincide with the sort of people they think they are or wish to be. There are parallels between the wardens and school staff; the wardens included most stereotypes of schoolteachers—the tough, unfeeling bullying one, the young nice one the students could get around, the decent one who

treated them well but who came down hard if they stepped out of line, and so on. There were also strategies of resistance in *Prisoner*: the prisoners were good at communicating under the eyes of the wardens with a secret language of nudges and winks and slang, just like school students. There were struggles over cultural control of various domains within the prison. The laundry, where a lot of the program was set, was a site of constant struggle as to whether it was in the control of the prisoners or the wardens: the same sort of territorial battles go on in the school toilets and bicycle sheds during recess. Throughout, *Prisoner* was being read and being used by the schoolchildren to articulate and make their own sense of their experience of subordination and powerlessness within an institutional social structure. The students were reading it in a very active way, articulating it with their social experience, and thus making it their popular culture, not because they had been turned into a commodity by it but because it provided them with a discursive repertoire from which to make their popular culture. This sometimes spilled over into their schoolyard games. Palmer (1986), for instance, investigated a case when a friendly teacher was co-opted to play the role of a particularly unpleasant warden—it was the social role of teacher-warden and the power inscribed in it that was significant, not the personality of the individual filling it. The viewers made *Prisoner* into their popular culture because they discovered and then used the relevances between it and their social experience.

The work of Katz and Liebes (1984, 1985, 1987) and Ang (1985) has shown how *Dallas* offers an enormously wide range of relevances to its enormous variety of viewers across the world. *Dallas* is a supermarket of meanings from which its viewers make their selection, which in turn they cook up into their culture. So Arabic meanings of *Dallas* are cooked up quite differently from Jewish ones; a Dutch Marxist and a Dutch feminist read it quite differently but equally relevantly. *Dallas* offers pro- and anticapitalist meanings, pro- and antipatriarchal meanings; it allows its viewers to produce their own significance of the relationships between wealth and happiness, among commercial relationships, sexual relationships, and family relationships; it is variously about capitalism and kinship. However much it may be a commodity in the financial

economy, in the cultural it is a rich and comparatively undetermined bank of resources out of which various popular cultures can be fashioned.

The pleasures of popular culture lie in perceiving and exploiting these points of pertinence and in selecting those commodities from the repertoire produced by the culture industries that can be used to make popular sense out of popular social experience. But the production of relevance does not mean the confusion of the social with the textual: Popular discrimination is well aware of the difference between material social experience and textual representation, even though it produces relevances through which the two can be made to interact and inform each other. There is a difference between the representation of social forces or values and the experience of them in everyday life. Popular readers enter the represented world of the text at will and bring back from it the meanings and pleasures that they choose. When the experiences of everyday life conflict with the represented world of the text, that is when social meanings conflict with textual; then social meanings will be dominant, for socially produced meanings are constantly reinforced by social rewards or punishment as we interact with other people in our daily lives. Textual meanings, however much they may support each other, have nothing like such a strong reinforcement system. It follows, then, that however we might wish to change the social meanings and textual representations of, say, women or nonwhite races, such changes can only be slow and evolutionary, not radical and revolutionary, if the texts are to remain popular. Too radical a change would break the relevances between textual representation and social experience: Neither *Charlie's Angels* nor *Cagney & Lacey*, for instance, would have been popular if their female detectives had operated completely free of any sort of patriarchal dominance. They would have seemed "unrealistic" in their lack of relevance to the social experiences of women—none of which occurs outside patriarchal structures. Popular texts may be progressive in that they can encourage the production of meanings that work to change or destabilize the social order, but they can never be radical in the sense that they can never oppose head on or overthrow that order. Popular experience is always formed within structures of dominance; popular culture

is concerned with producing and enlarging popular spaces within these structures. Popular meanings and pleasures are never free of the forces that produce subordination, indeed, their essence lies in their ability to oppose, resist, evade, or offend these forces. The need for relevance means that popular culture may be progressive or offensive, but can never be radically free from the power structure of the society within which it is popular.

While ethnographic studies of how people use the media have proved useful in showing us how and why popular discrimination is exercised, in showing which points of relevance can be constructed at any one reading, they are not the only way of investigating the relevance of popular culture. Larger-scale systematic, or structural, approaches can help, too.

Today's popular culture is violent. The recognition of relevance as a defining characteristic of popularity should lead us to look for social rather than psychological explanations for this. To argue that human nature is at base aggressive, so that to be popular the mass media merely have to appeal to the lowest human instincts, is to ignore two facts: only *some* violent films, books, and television programs are popular (many violent texts are rejected), and the violence in them is tightly organized so that, for instance, there are no popular texts, however violent, in which an ugly, middle-aged Hispanic heroine kills a succession of young, white, good-looking male villains.

Our suspicions about the commonsense explanation that violence is popular because it appeals to the lowest human instincts should be further aroused as we notice that the proponents of the argument appear to confine such low instincts to the lower classes, thus neatly obscuring the class-based nature of the explanation.

Represented violence is popular (in a way that social violence is not) because it offers points of relevance to people living in societies where the power and resources are inequitably distributed and structured around lines of conflicting interests. Violence on television is a concrete representation of class (or other) conflict in society. The heroes and heroines that a society chooses to make popular at any one point in its history are those

figures that best embody its dominant values. Conversely, its popular villains and victims are those who embody values that deviate from this norm. A character's chances of being alive and free at the end of a popular television program or film increase with the embodiment of the following values: masculinity, youth, attractiveness, anglo-Saxon characteristics, classlessness or middle-classness, a metropolitan background, and efficiency. Conversely, to the extent that a character embodies different or deviant social values, he or she is likely to be a victim or villain. The victims are those who embody the values and characteristics of disadvantaged social groups (for bourgeois ideology teaches us the paradox that it is normal to be advantaged); the villains are, interestingly, closer to the heroes and heroines, but are typically equipped with two or three negative features (they are of the wrong age or race or are less physically attractive—for the socially moral is typically embodied in the physically beautiful!).

Violence (i.e., physical conflict) is popular because of its metaphorical relationship to class or social conflict. Popular representations of the relationships between the socially central or dominant and the deviant are violent because the social experience of the subordinate is one of conflict of interests, not of a liberal pluralist or ritualistic consensus. So it is no surprise to find that the United States, where the difference between the haves and the have-nots is extreme, has the most violent popular television, whereas Britain and Australia, whose welfare and taxation systems mitigate *some* of the socioeconomic differences, have fewer acts of violence per hour on their screens, and the Soviet Union has the least violent television of all.

It is the social system that makes violence popular, not the "baseness" of the citizens: the roots of violence are to be found in society, not in individual morality. So it is predictable that the movement to eradicate violence from our screens would be led by middle-class moralists. By "blaming" social violence on television they avoid having to consider the uncomfortable idea that it might be their own position of social privilege that actually provokes most violent and criminal activity among the disadvantaged. Television and the apparent gullibility of its "mass" audience become convenient scapegoats upon which to displace the social responsibility of their own class position.

It is ironic, but again predictable, to note that when in the late 1970s such campaigning did influence the TV networks and did reduce the amount of violence represented on television, the broadcasters, in order to maintain popularity, resorted to another form of violence that stemmed from another form of social inequality—visual violence against women. This period of reduced televisual violence became known as the "tits and ass" period (D'Acci 1988). There is, incidentally, no evidence to suggest that actual violence decreased as a result, and it would be surprising if any were to be discovered.

Violence is popular because it is a concrete representation of social domination and subordination, and therefore because it represents resistance to that subordination. The socially and racially disadvantaged can see their social representatives in conflict with the forces of dominance, and, in the early stages of the narrative, in *successful* conflict: the villains win all but the final fight. A colleague returning from Latin America reported to me that *Miami Vice* was popular there because of its portrayal of Hispanics (albeit as villains) with all the trappings of success in a white society: the popular pleasure in the drug barons' displays of mansions, speedboats, limousines, servants, women, and swimming pools far overrode their narrative defeat by Crockett and Tubbs—indeed, their ultimate defeat by the forces of order is necessary for the construction of relevance.

It is significant, too, that violence is an element of masculine popular cultures. To say this is not to deny the pleasure of many women in violence, but to point to the masculinity of using violence as a cultural resource from which to produce resisting meanings of subordination. The patriarchal ideology of masculinity is a cause of cultural anxiety for many subordinate males because the economic system that it underpins denies them the social means to exercise the power and control upon which it tells them their masculinity depends. Sylvester Stallone, as either Rambo or Rocky, performs his violence with a race- and class-subordinated body whose muscularity represents to the subordinated their only conceivable means of achieving masculinity, however symbolically.

In such masculine popular culture women are typically represented as victims or whores—the two main metaphors by

which their subordination to men can be most productively materialized. In popular culture, the axes of power may support, contradict, or compensate for each other. So class subordination may coexist with gender domination, a sense of racial superiority with class inferiority, or racial subjugation with sexual chauvinism. Power is experienced and exercised, both socially and discursively, in relatively discrete domains.

The politics of such popular forces are difficult to discern in general terms. Aboriginal meanings of Rambo, which may well overlap with male blue-collar readings in many respects, may be progressive in the politics of race and class, but very reactionary in the politics of gender. Certainly I am not aware of any feminist appropriations of Rambo. But Flitterman (1985) argues that the masculine body of Tom Selleck, in *Magnum, P.I.*, has been treated by the camera and narrative structure in such a way as to open its muscularity up to feminine appropriation: the series developed conventions of showing Selleck's body (typically on the beach) in ways that do not align it with masculine power, and at narrative moments that do not show it in purposeful action. This is quite different from the textual representations of Stallone's muscularity in the Rambo movies.

However productive popular readers may be, they cannot make *any* meanings out of a text, nor will they choose to read *any* text thrust before them. They will choose to engage with only those texts that offer reasonable chances of success for the guerrillas in evading hegemonic capture. So while there may be feminine pleasures in Stallone/Rambo's body, the displeasure of the excessively masculine violence with which it is involved would, for most women, make a guerrilla raid upon it too risky to be worth undertaking. Magnum's violence, however, is more muted, less frequent, and often laced with parodic humor, all of which lessen the chances of the feminine guerrilla being caught by hegemonic masculinity.

It is not violence per se that characterizes popular culture, but only that violence whose structural features make it into a metaphor for the distribution of power in society. Violent relations have to be related to social relations if their representations are to allow the subordinate to construct socially relevant and therefore pleasurable meanings from them.

Bourdieu argues that one of the key differences between middle- and working-class tastes is that between "distance" and "participation": middle-class "distance" is a dual concept, for it encompasses both the distancing of the reader from the work of art and the distancing of the work from the trivia of everyday life. Working-class tastes, however, tend toward participation, that is, reader participation in the experience of the work of art, and the participation of the work of art in the culture of everyday life. The aesthetics of the bourgeoisie demand that their art should be valued to the degree of its appeal to human and aesthetic universals rather than to the specifics of the here and now: even though some art may be "realistic" and refer explicitly to the details of the everyday, the middle-class "appreciation" must be able to look through these to the "universals" underlying them. Relevance to one's immediate social context is not a middle-class criterion for the evaluation and enjoyment of art. This separation between the aesthetic and the everyday is reflected in the separation between the artist/performer and the reader/spectator, and between the text and the reader. This distance is one of respect, of critical appreciation, which is quite different from the popular identification of fan with star or favorite character, of involvement in the text/performance.

> One of the most radical differences between popular entertainments—from Punch and Judy shows, wrestling or circuses, or even the old neighborhood cinema, or soccer matches— and bourgeois entertainments is found in audience participation. In one case it is constant, and manifest (boos, whistles), sometimes direct (invasion of the stage or playing field): In the other it is intermittent, distant, highly ritualized, with obligatory applause, and even shouts of enthusiasm, reserved for the end of the performance. Jazz, a bourgeois entertainment which mimics popular entertainment, is only an apparent exception: The signs of participation (hand-clapping or foot-tapping) are limited to a silent sketch of the gesture (at least in free jazz). (Bourdieu 1984: 488–489)

This distanced, appreciative bourgeois audience contrasts vividly with the fans of soap opera or rock shows, who participate in a wide variety of ways in the object of their fandom. (It is interesting to speculate that the involved fans of

Dickens in the nineteenth century would have come from the more subordinated sections of his readership, while his respectable readers would have maintained a greater critical [and bourgeois] distance.)

This popular involvement with the art form is reproduced in the involvement of the popular art form with everyday life. Bourdieu argues that popular taste integrates aesthetic consumption into the world of everyday consumption in a way that denies the art object any special "respect," the text is "used" in the way that any other commodity is, and, like any other commodity, is rejected if it is not useful. The criteria that pertain in everyday life are applied to works of art, and thus work via the points of relevance between what he calls the "things of art" and "the things of life."

Art must, for popular taste, serve a purpose or have a point. Bourdieu argues that, from the middle-class point of view, it is "barbarism" to ask what art is *for* because to do so would question its disinterestedness or distance. But popular art is valued to the extent that it is of "interest," that is, interested in everyday life and not distant from it. The working class expects every image to fulfill a function and expects to be able to evaluate this function according to social norms of pleasure, morality, or ordinariness.

So video arcades are popular, particularly among subordinated males (subordinated by class, age, race, or any combination of the three), because they can be used to think through, to rehearse in practice, the experiential gap between the masculine ideology of power and performance and the social experience of powerlessness (see *Reading the Popular*, Chapter 4). The players use the machines as symbols of our capitalist society, so that playing (against) them becomes a reenactment of social relations, but the retelling is from the point of view of the subordinate—the meanings and pleasures they produce in playing are theirs, and therefore the relationship between human and machine is the reverse of that normally experienced in social life.

In the social conditions of work, the skill of the machine operator generates greater profits for the owners; in the video arcade the reverse is the case. Many a player reports with pride the length of time he can make a quarter last (often, I am sure,

with a fisherman's exaggeration), and some are explicit in their satisfaction of "winning" an evening's entertainment for less than a dollar. They know they are beating the system, that their skill as guerrillas is winning small victories against the strategy of the owners. A guide to the games (a sort of manual of guerrilla tactics) is quite explicit in this:

> Manufacturers are developing games that are downright difficult to play. Their idea is to get you spending more money. Even the games that were once simple are being transformed into quarter-eaters. . . . You've got to learn to fight back. (Consumer Guide 1982: 64; see *Reading the Popular*, Chapter 4)

The players also find great pleasure in their manipulation of the narrative being played out on the screen. The joystick and the firing button extend the control beyond that of viewers of television, for their control is limited to the meanings of the narrative, whereas video players can affect the events of the narrative, albeit within the overall structure controlled by the chip in the machine. The players can participate in video games even more actively than they can participate in television, a pleasure that Greenfield (1984) has found is particularly important to young children. Other video players see that the dog-eat-dog world of the game, in which they eat the monster or the monster eats them is an accurate metaphor for the society "out there."

Video games are relevant and functional because their structure can be related to the social system, and playing them can therefore enact the social relations of the subordinate with the one crucial inversion—in the video arcade the skill, performance, and self-esteem of the subordinate receive rewards and recognition that they never do in society.

These functional pleasures of relevance are ones of *plaisir*, but they are underwritten by ones of *jouissance* or loss. The intensity of concentration required to play the games results in the loss of social identity and the ideology it bears; it is an evasion of the forces of subordination. The player's body interacts with the signifiers on the screen in a pure eroticism of the text, and the muscular spasm followed by partial collapse of the body that marks the end of the game, the loss of the final life, is as orgasmic a pleasure as any symbolic experience can offer.

These social relevances of popular art mean that it is always seen as pluralistic, conditioned, relative; it is not viewed in terms of the absolutes and universals by which middle-class taste operates, but in relativistic terms such as "as a news photo it's not bad," or "all right if it's for showing to kids." Bourdieu (1984: 42) concludes:

> This aesthetic, which subordinates the form and the very existence of the image to its function, is necessarily pluralistic and conditional. The insistence with which the respondents point out the limits and conditions of validity of their judgements, distinguishing for each photograph, the possible uses or audiences, or, more precisely the possible use for each audience shows they reject the idea that a photograph can please "universally".

A popular text, to be popular, must have points of relevance to a variety of readers in a variety of social contexts, and so must be polysemic in itself, and any one reading of it must be conditional, for it must be determined by the social conditions of its reading. Relevance requires polysemy and relativity—it denies closure, absolutes, and universals.

Bourgeois tastes are contrasted with popular tastes not only in terms of their valorization of distance and of absolutes, but also in their absence of fun and of a sense of community. Participation brings with it the pleasures of revelry and festivity, of self-expression and the expression and experience of solidarity with others. Popular taste encompasses

> everything that is engendered by the realistic (but not resigned) hedonism and sceptical (but not cynical) materialism which constitute both a form of adaptation to the conditions of existence and a defense against them. (Bourdieu 1984: 394–395)

Realistic hedonism and skeptical materialism are the determining values of popular discrimination. Popular taste is formed by the conditions of subordination, and the commodities out of which it makes popular culture are ones that are relevant both to the readers' experience of those conditions and, more generally, to the conditions themselves.

POPULAR PRODUCTIVITY

Too many theorists in the past have emphasized the centralized production that is characteristic of both the financial economy and the bourgeois critical industry, and have ignored the tireless but quiet activity of that "entirely different kind of production called "consumption" (de Certeau 1984). In this the products of capitalism became the raw materials, the primary resources, of popular culture. The metaphor is extreme, for clearly the products of capitalism cannot be entirely raw, they cannot be entirely primary. But, in the literal sense of *determine* (that is, "set the boundaries of"), "natural" raw resources do determine their cultural uses (a soft metal such as gold cannot be fashioned into a glass cutter, nor can a degradable one such as iron form the basis of a currency). But though the nature of the resource may limit its use, it cannot limit the creativity of those that use the resource. Just as the fabrication of an object out of raw material is always a struggle between the nature of the raw material and the cultural needs of the producer, so too popular culture is a struggle between the "nature" (ideological, strategic, disciplinary) of the resources provided by the financial economy and the cultural needs of everyday life.

If we conceptualize popular culture not as the consumption of images, but as a productive process, then our theoretical focus and analytical object shifts from representation to semiotic activity, from textual and narrative structures to reading practices. Academic theorists who concentrate on the power of the text (whether this power is conceived of as aesthetic, ideological, psychoanalytical, or whatever) concentrate on the ability of the text to limit its cultural uses, to prefer certain meanings and perform certain social functions rather than others. They analyze and explain the disciplinary and antipopular nature of the resources with which the people have to struggle to construct popular culture. Such approaches frequently overestimate the disciplinary powers and under-value, or even ignore, the productivity and creativity of the popular.

The question has to shift from *What* are the people reading? to *How* are they reading it? Let us return to our example of

Charlie's Angels. A textual analysis of this television series would reveal how patriarchal control reasserts itself over signs of feminine liberation. Three women detectives are shown solving crimes, shooting guns, and arresting criminals—roles previously reserved for men. Patriarchy asserts itself in their conventional sexual attractiveness, in their having to be "rescued" by the male Bosley at least once in each episode, and in their ultimate control by the masculine voice of the never-seen Charlie who gives out assignments and approval with equal paternalism. The narrative closure of each episode is strongly patriarchal, as is the pleasure offered by the visual style of the program, and a textual or ideological analysis would conclude that patriarchy is recuperating signs of feminine liberation. Yet many women have reported reading *Charlie's Angels* selectively, paying attention to the strong women detectives and almost ignoring the signs of the patriarchal closure. Some said that they would typically leave the TV set before the end of the episode and thus avoid altogether one of the main moments of patriarchal narrative power. Textual and ideological analysis presumes the disciplined, respectful bourgeois reader, who reads the whole text with equal attentiveness throughout.

The undisciplined popular reader, however, approaches the text quite differently: popular reading is often selective and spasmodic. Altman (1986) suggests that *Dallas* is a "menu" from which viewers select certain meanings and pleasures to make up the "meal" that they "consume." De Certeau (1984) uses two metaphors: one of the reader as poacher, encroaching on the terrain of the cultural landowner (or textowner) and "stealing" what he or she wants without being caught and subjected to the laws of the land (rule of the text), and one of the text as a supermarket, in which readers wander, selecting and rejecting items and then combining their selection into a creative "meal." Gans (1962), in his study of the Italian community in Boston, shows how the men selected images of masculinity from the supermarket of cop shows that TV offered them. They watched only those programs in which the hero worked with and respected the working class of the city. Then, within their selected shows, they watched mainly the beginning and end, the posing of the initial enigma and the

triumphant achievement of masculinity in its resolution. The process itself interested them less. This was quite the reverse selective practice, or poaching raid, from that of the women viewers of *Charlie's Angels*, who watched the narrative process rather than the patriarchal posing or resolution of the enigma. Katz and Liebes (1987), to give another example, found that many U.S. viewers of *Dallas* found pleasures in its generic features as soap opera, whereas non-American viewers watched it more for its content. Even within this choice, further choices were made. Some selected its content as that of kinship relations detached from their American context, whereas others found its Americanness very significant. Russian Jews newly arrived in Israel thought it was a criticism of capitalism, but some of the Dutch viewers studied by Ang found great pleasure in its celebration of the American glitzy fast-lane life-style. Lewis (1985), in his study of viewers of a British news program, found that many viewers remembered a live film insert better than the studio narrative that "framed" it, and thus recalled a completely different meaning of the story than the one that a textual analysis would arrive at. Popular reading is often a textually undisciplined selection of relevant moments.

Jenkins (1988a) found that children watched *Pee-wee's Playhouse* in sharp spurts and that their retelling of the narrative left out causal and logical links, but emphasized sensational scenes or moments of intense spectacle. They also showed a developed cultural competence and knew which parts of the formula were likely to provide "the good bits." They, too, selected especially those bits that had perceived social relevance to them, particularly relevances to school. Hodge and Tripp (1986) also report that up to the age of about 12, children are likely to view in this "childish" way, but by 12 they "learn" the "adult," disciplined style of viewing (though, I must add, they do not necessarily employ it). This selective, episodic viewing is a way of resisting or at least evading the ideology and social meanings structured into the text; it dodges the work of preference performed by this structure, and opens the text up to different and multiple points of pertinence.

Such childish, undisciplined ways of reading are also popular ways. They treat the text with profound disrespect: it is not a superior object created by a superior producer-artist (as is the

bourgeois text), but a cultural resource to be raided or poached. Its value lies in the uses it can be put to, the relevances it can offer, not in its essence or aesthetics. Popular texts must offer not just a plurality of meanings, but a plurality of ways of reading, of modes of consumption.

Such undisciplined reading practices are not confined to symbolic texts, but extend throughout popular culture. The unemployed youths and senior citizens who use shopping malls selectively (see *Reading the Popular*, Chapter 2) are consuming only those parts that suit their interests—their public spaces, their warmth, their sitting and meeting areas. Gibian (1981) has shown in detail how the history of malls has been the history of their designers' attempts to attract and discipline the public simultaneously. In their middle period, malls attempted to direct people's passage through them by walkways, hidden gardens, and rustic bridges, and to motivate them to move on by providing unexpected views around corners—all in the attempt to keep them walking past every store window in the mall. More contemporary mall designers, however, have had to produce more open texts, in which shoppers and others can wander at will, not necessarily laying themselves open to maximum consumer seduction. The strategy is now to produce environments in which people will wish to linger; in order to do this, malls must be opened up to a wider range of popular (mis)uses.

In my analysis of the beach as a text (*Reading the Popular*, Chapter 3), I show how the author/authorities attempt to discipline the beachgoers both directly (through prohibition notices, warnings, and lifeguards) and indirectly (through the provision of lawns, boardwalks, showers, benches, and the like), and how some users (surfers, topless sunbathers, and dog walkers) resist or evade this discipline. Finding a spot on a beach where one can tan topless or drink alcohol without being caught by the beach patrol is the equivalent of the Madonna fan making her meanings without being caught by the patriarchal ideology, or the gay fans of Judy Garland who found spots in her performances where gay meanings could, like breasts, be brought out into the open.

Hall's (1980a) preferred reading theory was an early attempt to account for the processes by which popular readers could

make their meanings out of the text, but it still assumed that they engaged with the whole text in the way that the text itself "wanted." The readings preferred by the dominant ideology were structured into the text as a whole, and they could be resisted or negotiated with only in terms of an engagement with this complete text. Selective or partial readings are able to avoid this ideological work, and play down the overall structure of the text while opening it up as a less determined (but not undetermined) cultural resource. Preferred meanings are those proffered by the text; relevant meanings are those produced from selections from the text by the productive popular reader.

This accords better with Hall's (1986) later theory of articulation, in which he accounts for the double way in which texts work in popular culture: a text-centered way, and a reader-centered way. To *articulate* has two meanings—one is to speak or utter (the text-centered meaning) and the other is to form a flexible link with, to be hinged with (the reader-centered meaning in which the text is flexibly linked with the reader's social situation). What a text "utters" determines, limits, and influences the links that can be made between it and its readers, but it cannot make them or control them. Only readers can do that. For a text to be popular, it must "utter" what its readers wish to say, and must allow those readers to participate in their choice of its utterances (for texts must offer multiple utterances) as they construct and discover its points of pertinence in their social situation. So Madonna (see *Reading the Popular*, Chapter 5a) utters quite different meanings for her teenage girl fans and her *Playboy*-reader fans, who each find in her quite different pertinences to their different positions in the patriarchal social order. The theory of articulation maintains a nice balance between seeing the text as a producer and circulator of meaning and seeing it as a cultural resource open to a wide, but not limitless, range of productive uses.

FANS AND PRODUCTIVITY

Fans are excessive readers: Fan texts are excessively popular. Being a fan involves active, enthusiastic, partisan, participatory

engagement with the text. Fandom is part of what Bourdieu identifies as proletarian cultural practice, in contrast to the bourgeois distant, appreciative, critical stance to texts.

Fans may differ from less excessive popular readers in degree, but not in kind. Fandom is characterized by two main activities: discrimination and productivity. Fans draw sharp and intolerant lines between what, or who, they are fans of and what they are not. Radway's (1984) group of romance fans were quite clear that romances worthy of their fandom had to have feisty, spunky heroines who railed and fought against their treatment by the domineering male hero. Grossberg (1984), too, has shown how rock and roll fans draw sharp lines of discrimination. These textual discriminations are often homologous of social discrimination. Choosing texts is choosing social allegiances and fans form themselves into a community much more explicitly than do the middle-class appreciators of highbrow art. The links between social allegiance and cultural taste are active and explicit in fandom, and the discrimination involved follows criteria of social relevance rather than of aesthetic quality. (Bourgeois critical discrimination is equally socially determined, but it refuses to recognize this and attempts to use "aesthetics" to universalize its practice and deny its class specificity. In this respect it is less "honest" than popular discrimination.)

Fans are productive: Their fandom spurs them into producing their own texts. Such texts may be the walls of teenagers' bedrooms, the way they dress, their hairstyles and makeup as they make of themselves walking indices of their social and cultural allegiances, participating actively and productively in the social circulation of meaning. Other fan texts may be more subdued, less concrete, as the gossip of soap opera fans becomes a pre-text of the actual script of their soap, predicting what will happen. Sports fans, too, engage in similar "writing in advance." The flip-side of this creativity of course is retrospective "rewriting"—the what-would-have-happened-if script can be just as productive as the predictive one. In this way, fan gossip fills in the gaps in the text. It explains motivations and consequences omitted from or buried in the text itself; it expands explanations, offers alternative or extended insights; it reinterprets, re-presents, reproduces. The

original text is a cultural resource out of which numerous new texts are made. Its structure may limit or determine the range of new texts that can be produced from it, but it can never limit the creativity, the "producerliness" of the fans that use it.

Such producerly activity closely parallels that required to produce the original text. It requires both cultural competence—the knowledge of the conventions or rules of that genre or sport—and social competence—how "people" are likely to act, feel, or react within such conventions. The boundaries between text and nontext, between the representation and the real, become blurred. This is the creativity of social relevance rather than that of aesthetic quality. It is popular creativity, popular culture at work. It refuses clear-cut role distinction, and thus political distinction, between artist and audience, between text and reader. It does not accept cultural power as one-way, top-down, but as a democratic power that is open to all who have the competence (and discrimination) to participate in it. This producerly activity is often interior and personal, often social and gossipy, though sometimes more material, as when soap opera fans write to the producers in attempts (often successful) to influence the outcome of certain plot lines, or when they take part in polls conducted by fanzines in order to express collective preferences concerning future events or relationships (it is rare to find a fanzine that does not encourage and organize such producerly participation of its readers).

Sometimes this fan productivity can go to even greater lengths, producing texts that rival, extend, or reproduce the original ones. Thus Madonna fans not only articulate her appearance with their own into their version of her look, they also participate in Madonna look-alike contests, in lip-sync contests where they mime to her records, and in 1987, they produced their own pastiche reproductions of her music videos.

MTV and Madonna ran a "Make My Video" competition for her song "True Blue," expecting a few dozen entries at the most. Instead, they were swamped with entries, a selection of which they ran for 24 hours of continuous broadcasting. The videos ranged from the semiprofessional, with the "look-alike" fan dancing in Madonna style in carefully choreographed

moves in carefully chosen locations, to far more "amateur" efforts, which were significant for the way that they incorporated details of the girls' everyday lives into the Madonna world of the song, so bedrooms, clothes, family photographs, family cars, favorite local places (particularly beaches and riverbanks) were all related to the song. The milieux of these home videos were suburban, ordinary. Some even showed the fans doing the dusting or washing the dishes as they "sang" to her music. Others were not shot especially for this contest, but were compilations of old family movies and photographs. But at the center of each was the girl fan herself, usually dressed and made up as Madonna, acting as the point of relevance between the empowered, free, public world of the star and the powerless, constrained, private world of the teenager. The creativity was in the construction of links between the two, and the pleasure lay both in the girl's ability to project herself into the Madonna image and in the productivity that transformed this from its more normal form of an interior fantasy into a material, and potentially public, text. But the difference between these actual, public texts and the private fantasy texts on which they were based should not lead us to devalue the fantasy, simply because it is not normally given material form. Fantasy can be as "real" an experience as any other (see *Reading the Popular*, Chapter 5b).

The fans of *Star Trek* and other science fiction series such as *Blake's 7* can be equally productive. They, too, make videos, which they circulate among themselves (see Bacon-Smith 1988). These fans select a popular song and then illustrate it not with material shot themselves, but with images "stolen" from the broadcast episodes in a fan's tape library. The most proficient and productive video makers gain considerable status within the fan community. The pleasures involved in producing these videos, and in producing sense, and therefore pleasure, in viewing them require considerable cultural competences. The more competent the fans are, the more they will be able to recognize the origins and original contexts of each shot, and the richer will be the resources out of which they construct their meanings and pleasures. There are multiple pleasures at work here, pleasures of recognition (of the original context/ meanings), of reproduction (of accepting the video's invitation

to play with the new textual contexts and thus of reproducing anew its own reproduction) and of production (of producing significant linkages among the reproduced images, the fan knowledge of the series, and the everyday life of the fans involved).

Jenkins (1988b) has studied the enormous variety of verbal texts produced by the "Trekkies" (fans of *Star Trek*), which range from newsletters to full-length novels, most of which are romances filling in the gaps left in the original series by expanding on the personal (particularly romantic) relationships among the crew of the *Enterprise*. A few of these novels become soft porn, as their focus shifts from the romantic to the sexual. This fan productiveness often involves genre mixing, as fans bring to one genre the cultural competencies of another. The *Star Trek* videos are the result of the fans' competencies in both MTV and *Star Trek*. The novels bring to *Star Trek* the competencies in the romance genre.

Popular productivity is a constant process of recombining and reusing the cultural products of capitalism in a form of bricolage (and, as such, does not differ in kind from so-called artistic originality, though it differs greatly in its critical reception and cultural acclaim). Bricolage is, according to Lévi-Strauss, the everyday practice of tribal peoples who creatively combine materials and resources at hand to make objects, signs, or rituals that meet their immediate needs. It is a sort of nonscientific engineering, and is one of the most typical practices of "making do." In capitalist societies bricolage is the means by which the subordinated make their own culture out of the resources of the "other." Madonna's "look" is a bricolage that enables *her* to make *her* meanings out of *their* resources and in which her fans can participate. Hebdige (1979) has shown how this is a typical practice of youth subcultures, and Chambers (1986) argues that it is particularly characteristic of contemporary metropolitan youth culture. It is particularly obvious in subcultural dress, where punks, for instance, can combine workingmen's boots with bits of military uniform and mix Nazi and British insignia into a "new" style that does not "mean" anything specific, but rather signifies their power to make their own style and to offend their "social betters" in the process. Bricolage is equally, if less obviously, at work in the

reading of popular texts, in the construction of fantasies, and in the mingling of mass with oral culture, of cultural commodity with the practices of everyday life.

A more subdued, but still producerly, example of bricolage is the practice of pop music fans of compiling their own "album" of tracks on a tape from the range of commercial albums available to them. This practice may not be resistive ideologically, but it is productive, it is pleasurable, and it is at least evasive, if not resistive, economically. Tracks from a paid-for album may figure on a limitless number of tapes produced by the cultural bricoleurs who have access to it.

It is perhaps not surprising that many of the extreme examples of this productive activity should be provided by women and girls. Such popular creativity is typical of subordinated groups who have no, or limited, access to the means of producing cultural resources, and whose creativity therefore necessarily lies in the arts of making do with what they have. So much women's art, from quilting to cooking to writing diaries, has been denied the status of art and designated "mere" craft. Such a critical distinction, of course, tells us more about the values of the patriarchal order that employs it than it does about any differences in the cultural objects produced or in the creativity involved in their production.

Popular discrimination, then, is not merely the process of selection and rejection from the repertoire of cultural resources offered; it involves a productive use of the chosen meanings in the constant cultural process of reproduction by which texts and everyday life are brought into meaningful contact. It is not concerned with the evaluation of quality, but rather the perception of relevance. It is less concerned with the text than with what the text can be made to do. It is thus textually disrespectful. The relevance of the text to the everyday allows its textuality to be participated in; readers are cultural producers, not cultural consumers.

MODES OF CONSUMPTION

Certain commodities or texts of mass culture are popular not *only* because socially relevant meanings can be made of them:

the media that deliver these commodities have to have characteristics that are equally adaptable to the practices of everyday life. Watching television, listening to records, and reading books are neither neutral nor singular practices, but ones imbued with different meanings at different times, and therefore ones that can produce a variety of pleasures. There is no universally similar activity that we can call watching television, or reading a book, just as there is no universally valid meaning for *Dallas*. The mode of consumption is as context-specific as any meanings that are made from the cultural commodity.

The interface between capitalist industries and everyday life is negotiated not only textually, but also spatially and institution-ally. Television, to take my main example, is typically received in the family home—a social institution materialized into a physical place (both provided by capitalism), within which the culture of everyday life is practiced. The physical structre of the house or apartment is the raw resource, provided for profit by the landlord and/or the building industry. This place is turned into the spaces of the everyday by the practices of dwelling: Each family produces from the same house or place different spaces that they construct and possess for as long as they dwell in it. Similarly, the family is an institutionalized structure within which different people negotiate different ways of relating and behaving that make it theirs, and that they can move into or out of at will as they can the house. So, too, television is made into popular culture as its texts are "lived in," moved into and out of, used (or not) as cultural resources.

Watching television, then, is not a single activity—indeed, as a singular concept, it is meaningless, and positivist studies that use it unproblematically and singularly are not worth the biodegradable paper they ought to be printed on. Palmer (1986), for instance, has shown us the wide variety of activities performed by children while "watching" television. These vary from concentrating intensely on television to the exclusion of everything else to playing with their backs to the screen while monitoring it by ear and turning to watch only when something on the sound track sounds relevant to them. Children watch television according to the way they wish to integrate the act of watching into the rest of their everyday lives. For very few, and

for very limited periods, television watching is a solitary, self-absorbed activity. More typically, it is part of wider social relations—children watch with family, with friends, or with pets. Part of television's appeal is that watching it can be phatic, that is, it can be used to maintain and strengthen social relationships.

Television's segmented texts mean that its viewers can switch channels easily and frequently as their attention wanders, or as the relevances it offers fade. Children are particularly active channel switchers, an activity they extend to the medium, so that they are also active medium switchers. They switch their attention from screen to companions, to books, to play, and back again with equal facility. Their first act on their return home from school may be, as Palmer shows, to turn on the TV, but they then ignore or pay close or distant attention to it at will. Children can control a number of communication media simultaneously—they can watch television, do their homework, and hold a conversation, switching their attention from one medium to the other, never switching one off completely, but shifting the degree and direction of their attention at will. Morley (1986) shows how adults, particularly women, show similar flexibility in the way they combine watching television with household work and with maintaining relationships within the family. Television is a cultural resource that people use as they wish, not a cultural tyrant dictating its uses and dominating its users; if it were such a tyrant, it is unlikely it would play as large a role in our popular culture as it does.

The cultural practices of family life are diverse and complex, and the resources available to its members may be mobilized quite differently. The different family roles played by different people will be enacted and reconstituted in these cultural practices, which determine not only the meanings and pleasures made from the texts brought into the home, but also the way that these texts are received. Morley (1986) shows how watching television itself is part of the gender politics of the household, and underscores the point that there is nothing in television itself that determines how it should be used, but quite the reverse: it is the culture of everyday life that determines the uses of television.

In the lower-class urban households Morley studied, he found consistent patriarchal patterns in the domestic uses of television. For instance, the husband/father was typically in control of the channel switching. The remote-control device lived on the arm of his chair and few, if any, other family members had access to it. This physical power over the family viewing extended to evaluative control as well, so that programs that met his tastes (e.g., news, sports, documentary and factual programs) were deemed of higher quality and greater value than those appealing to feminine tastes, particularly the interior dramas of soap operas and romances. Tulloch and Moran (1986), in their study of Australian households, report similar findings and give an example of this patriarchal value system extending into gender-differentiated talk about television—men "discussed" their programs, whereas women "gossiped" about theirs.

For the man, the home was part of the culture of leisure. He had earned his relaxation, and so felt free to indulge himself in paying undivided attention to the screen, frequently stopping his wife and/or children from talking or otherwise distracting him. For his wife, however, the home was more likely to be the place of work, and television watching had to be combined with domestic labor or other feminine family roles. So women typically did something else while watching— ironing, knitting, cleaning, folding clothes, or talking to the children as part of their role as the manager of personal relationships. The only times the home could become a place of leisure for these women (and thus when they could watch television undistractedly without guilt) were times when other family members were not present. Many women therefore used VCRs to time shift their favorite programs so they could be watched with undivided attention, usually late at night or very early in the morning when the rest of the family was in bed. I must note here that women working outside the home felt no such problems—they could watch guiltlessly in an undistracted "masculine" manner. The gender differences in watching are produced by the economic structure of the traditional patriarchal family, not by essential, or even more broadly social, differences between men and women. When there was more than one TV set in the house, the main (usually color) one was typically in the living

room under paternal control. If there were others, possibly in the kitchen for the wife or in a bedroom for the children, they were likely to be smaller and quite possibly black and white. Hobson (1982) reports on women watching their soap operas in black and white in the kitchen while preparing their husbands' food and slipping into the living room at special moments if they wished to see something in color—often a dress.

The ways in which television is watched can be used to define and live the differences between genders, between work and leisure, between waged work and domestic work, between the centered, focused mode of masculine attention, and the decentered or other-centered mode of feminine. It is people's position in the culture of everyday life that determines how they integrate their TV watching into it, and not TV that determines people's everyday lives.

In the same way, television watching is part of the age politics of the home. Parents often attempt to control the amount of television their children watch as well as to influence and limit their choice of what to watch. Deprivation of a favorite program has become a common form of punishment for bad behavior, and censorship has become one of the most contentious areas of "responsible" parenting. This censorship can be both negative and positive—in either case, where there is a conflict between adult and child cultural tastes, adult power is used to "prove" that adult tastes are inherently better (just as patriarchal power "proves" men's tastes are superior to women's). There are thus two forms of discipline at work here—the control of a child's behavior by using TV as a reward or punishment, and the control of a child's culture by disciplining the tastes or knowledges (particularly of adult life) that TV is allowed to inculcate into child culture.

And, of course, adults, for all their good intentions, frequently underestimate their children's TV literacy and their power of discrimination. The adult "taste" that prefers news and documentaries ("good" television) over cartoons and adventure drama such as *The A-Team*, ("bad" television) refuses to grant any validity to children's discrimination, which, in this case, would be the reverse of theirs. Children as young as 7 or 8 are quite aware that nobody is "really" hurt in *The A-Team*, that the violence is formulaic and unreal, and they

are not distressed by it because they have developed the cultural competence to handle it. Violence on the news, on the other hand, is far more distressing to them, for they have not developed the competence to handle "real-life" death and injury as readily (Hodge and Tripp 1986).

Many adults justify the imposition of their cultural tastes upon children by arguing that children cannot tell the difference between television and real life, but studies such as Hodge and Tripp's show that 7-, 8-, and 9-year-olds are adept at handling television's different modalities. Modality is the measure of the closeness of the representation to the real, and is the equivalent of "mood" in language, so that news, for instance, can be said to work in the indicative mood, it says, "The world *is* like this." News is of high modality. Cartoons, on the other hand, are of low modality, they work in the conditional mood, and say, "The world would be like this *if*" Children not only know the difference between the high modality of the news and the low modality of cartoons, they also understand the "if" to which they have to assent to make the cartoons make sense. By the same age, children know not only the differences between programs and ads, but also the different modalities involved. Despite parental fears, children can become skeptical readers of commercials at an early age. Children are not only highly selective viewers (see Palmer 1986, cited above), but also literate and knowing viewers, and, paradoxically, parental attempts to shield children from television's undesirable influences may actually hinder their development of the television literacy that is itself the best defense that parents could ask for.

Meyrowitz (1985) wonders if the widespread adult fear over television's effect on children might not be in part due to the impossibility, in the age of television, of controlling the flow of information about adult life to children. He argues that in both oral and print-based cultures it is easy for adults to control the information about the world that children receive. In oral cultures, one can control which adults a child meets and the circumstances of the meeting. In print-based cultures one can control both the books to which children have physical access, and, because reading is a taught skill, one can control the type of information conveyed by books written for different reading

ages. Dick and Jane, for instance, do not find their mother kissing the milkman. Television, however, is another matter. It is harder to control physical access to it than it is to control access to books, and when this access has been gained, it is almost impossible to limit the flow of "adult" information by means of linguistic difficulty. Children learn to make sense of television very quickly, for watching it requires the oral skills of "reading" (that is, making sense of the words and other signs in the text), rather than the literate skills of "decipherment" (recognizing the words and sentences for what they are). An "adult" soap opera, therefore, is as accessible to children as any Dick and Jane book (probably more so), and in a soap opera children *are* likely to see mothers and milkmen kissing (and more). But Meyrowitz argues that TV's effect goes further than its content: *what* TV tells children about the adult world is finally less important than the fact that it shows adults in their "backstage" or "private" mode of behavior—the mode that is normally censored from children. The mystique of adulthood, by which adults maintain their discipline over children, is exposed. Adults are shown as fallible, contradictory, and therefore less awesome to children, and thus the naturalness of their power is called into question. Children may be less amenable to social discipline in the television age simply because television exposes the imperfections of adulthood to them.

Meyrowitz's argument receives support from the observation that many of the programs that children enjoy explore the inadequacy of the adult explanations or control of the world. *TV Bloopers* or *Candid Camera* show adults failing to cope; cartoons suspend the "natural" laws (of which adult power is one); shows like *Ripley's Believe It or Not* tread the boundaries of common sense and the orderly world it produces. The possible relevances a child might construct between watching a star's failure to maintain a "perfect" performance on *TV Bloopers* and watching his or her parents perform their roles more or less (im-)perfectly in the home are almost limitless. So, too, are the possible connections among the tearful tantrums and petty jealousies of adults on soap operas, children's experience of their own emotional life and adult attempts to discipline it, and their experience of the differences between their parents' official "onstage" behavior toward them and the glimpses they get

of their unofficial, "backstage" behavior toward each other.

Children can use television not only to subvert or mock adult discipline, but also to evade it, to construct a fantasy world for themselves where they are free of the constant adult control to which they are subjected in the school and home. Children watch TV for many purposes and in many different ways, but the one that most offends adults and that adults (erroneously) think of as typical is the mode of total attention, when the children lie close to the screen and apparently "lose" themselves in it, or become helpless victims of it. This seems to threaten adults because it is an instance of children creating their own popular culture outside adult control. Adults' common admonition to children to move back from the screen is an attempt to create a social as well as physical space between television and the child into which the parent can insert adult influence and values. There is no firm evidence that watching TV in this way is physically harmful (either to the eyesight or to the pattern of electronic impulses in the brain—two of the most common "panics" called up by adults as they discipline the way their children watch television), and Palmer has shown how this "absorbed" viewing is untypical, and that children will create their own distance from the screen sooner or later, when they wish to change their mode of viewing, to change the relationship of television with the rest of their everyday lives. If children occasionally watch TV with self-loss and absorption it is because they choose to, for reasons relating to their social situation, not because TV has cast a spell over them like some wicked witch.

To be popular, the commodities of the cultural industries must not only be polysemic—that is, capable of producing multiple meanings and pleasures—they must be distributed by media whose modes of consumption are equally open and flexible. Television, books, newspapers, records, and films are popular partly because their nature as media enable them to be used in ways in which the people wish to use them. As they cannot impose their meanings on people, neither can they impose the way they are received into everyday life. Popular discrimination extends beyond the choice of the texts and the points of pertinence within them, to cover the choice of medium that delivers the text and the mode of consumption that best fits the "consumer's" sociocultural position and requirements.

Politics

POPULISM AND THE LEFT

I have tried in this book to point to the political potential of popular culture, for I believe that such culture is always, at its heart, political. It is produced and enjoyed under conditions of social subordination and is centrally implicated in the play of power in society. But in investigating its politics we must not confine our definition of politics to direct social action, for that is only the tip of the iceberg, resting upon a less visible, but very real, politicized consciousness—the consciousness of, and in, popular culture.

Under certain historical and social conditions this submerged consciousness can break through the surface into visible political action, and this is the focus of this final chapter. I am interested in ways in which the progressive political potential of popular culture can disrupt the social surface, and central to my interest are the relationships between macro- and micro-politics, and between radical and progressive thought and action.

Laclau's (1977) analysis of populism is a good starting point, although his concern is primarily with the radical and the macropolitical, whereas I believe popular culture to be most effective in the progressive and the micropolitical. Laclau suggests that populism takes three main forms in capitalist socieities, all of which are defined by their relation to the state.

First, Laclau identifies a "democratic populism" in which the differences between the state and the various formations of the people are organized and understood as complementarities,

not antagonisms. This is essentially a liberal-pluralist view of social difference, in which the principle of difference is integrated into the system so that class, or other, conflicts and resistances are neutralized. While such a populism is produced by a system of domination, it is absorbed by that system, which therefore takes into its sphere of control all the experiences, pleasures, and behaviors of the subordinate. The relationship of the disempowered to the system that disempowers them is finally one of complicity and consent, however unconscious or unwilling. Such a view cannot account for the vitality and offensiveness of popular formations; it cannot account for the precariousness and brevity of hegemony's victories, or for why the dominant ideology has to work so hard and so insistently to maintain its position. There would be no need for capitalism (or patriarchy) to promote its values so assiduously if there were not ample popular experience of its inadequacies and inequalities. Such a liberal-pluralist theory of populism is not one I find convincing.

Then Laclau theorizes what he calls "popular" and "populist" oppositions. Both differ crucially from his "democratic populism" in that they conceptualize relationships between the people and the state as essentially antagonistic: the difference between them is that popular opposition is structured into a system organized to cope with the challenges it offers, whereas a populist opposition arises at a point of social crisis, when historical conditions make the state vulnerable to transformation, or even revolution. "Popular" oppositionality is like "democratic populism" without its consent or complicity, so that domination is experienced as oppression. It recognizes that the various formations of the people have interests that necessarily conflict with those of the state, and that they never allow the forces of domination to relax or feel secure in their control. While they might not actively work to overthrow the power-bloc, they do keep it constantly under pressure and keep their own oppositionalities vigorously and intransigently alive. Such "popular" opposition can, at certain historical moments of heightened social antagonism, be transformed into a radical "populist" movement that directly challenges the power of the state.

The popular culture of capitalist societies works primarily in

the realm of popular rather than populist opposition, and its politics are therefore progressive rather than radical. I would also stress, in a way that Laclau does not, that such popular progressive politics are a necessary precondition, if not a necessary cause, of populist radical movements. Popular culture not only maintains social differences, it maintains their oppositionality, and people's awareness of it. It can thus empower them to the extent that, under the appropriate social conditions, they are able to act, particularly at the micropolitical level, and by such action to increase their sociocultural space, to effect a (micro)redistribution of power in their favor.

Popular culture is progressive, not revolutionary. Radical art forms that oppose or ignore the structures of domination can never be popular because they cannot offer points of pertinence to the everyday life of the people, for everyday life is a series of tactical maneuvers against the strategy of the colonizing forces. It cannot produce the conditions of its existence, but must make do with those it has, often turning them against the system that produces them. Radical art tries to create its own terms of existence, to free itself from the status quo. It has an important place in a system of culture, and some of its radicalness may filter through to, and increase the progressiveness of, popular art, but it can never, in itself, be popular. Indeed, Bourdieu (1984) argues that radical art is bourgeois and lies outside the bounds of popular taste, while Barthes (1973) suggests that avant-garde art can only cause a conflict between fractions of the bourgeoisie, but can never be part of a class struggle. The political effectivity of radical art is limited by inability to be relevant to the everyday life of the people, and, by the same token, any radicalness of popular art is equally limited by the same requirement of relevance.

The politics of popular culture has often been misunderstood and its progressiveness unrecognized by theories that fail to take account of the differences and the relationships between the radical and the progressive, and between the micropolitics of everyday life and the macropolitics of organized action. The absence of the radical, and of direct effects at the macro level, does not mean that the popular is reactionary, or quiescent, or complicit, or incorporated, but it does point to a major problem facing left-wing academic and political theorists whose focus

upon the macro and the radical has led them to neglect, or worse still to dismiss, the micro and the progressive. The left needs to pay greater attention to the relationships between progressivism and radicalism, between the micro and macro—left-wing theorists need to explore the conditions under which the submerged 90 percent of the political iceberg can be made to rear up and disrupt the social surface.

The forging of productive links between the resistant tactics of the everyday and action at the strategic level is one of the most important and neglected tasks of the left as we move toward the 1990s. The left has generally failed to win the support (or the votes) of the people whose interests they support, and with whom they wish to be aligned. Indeed, some Marxists deny the validity of "the people" as a category within a theory of social relations. With few exceptions, left-wing theorists have failed to take account of central areas of everyday life. Most glaringly, they have failed to produce a positive theory of popular pleasure. The result of this is that their theories can all too easily appear puritanical; the society they envision is not one in which fun plays much part, if it exists at all—they have allowed the right to promise the party. One of the central arguments of this book is the importance of understanding popular pleasures and their politics.

Another problem with some left-wing theory is its tendency to demean the people for whom it speaks. It casts them as the victims of the system (which, up to a point, they are) and then, quite logically, concentrates it efforts upon exposing and criticizing the agencies of domination. But the negative side of this concern is its failure to recognize the intransigence of the people in the face of this system, their innumerable tactical evasions and resistances, their stubborn clinging to their sense of difference, their refusal of the position of the compliant subject in bourgeois ideology that is so insistently thrust upon them. It is inadequate to conceptualize subordinate groups simply in terms of their victimization at the structural level and to downplay their power in coping with their subordination at the level of everyday practices. Consequently, the tricks they use against the system, the pleasures they find in evading or resisting it, and their gains in enlarging their cultural space within it are all devalued and explained away by the theory of

incorporation. Instead of being valued for these everyday resistances, the people are demeaned as cultural dupes for finding pleasure or satisfaction in them. Because these practices are not strategic battles, opposing the system head on with the aim of defeating it and overthrowing it lock, stock, and barrel, their tactical raids are devalued. It is hardly surprising that the people, in their variety of social allegiances, are reluctant to align themselves with political and cultural theories that demean them, that fail to recognize their pleasures or their power, and whose emphasis on structures and strategy can seem disconnected from the practices they have evolved by which to live their everyday lives within and against the system.

Of course, the left's distrust of populism is well grounded. In the West, at least, the most successful populist movements have been right-wing ones—both Hitler and Mussolini rose to power on a populist vote, and both Thatcher and Reagan are mistresses of populist rhetoric. The strong blue-collar (and female) vote for right-wing populist leaders can be argued to be instrumental in maintaining their formal political power. Bennett (1983b) and Hall (1980b, 1982, 1983) both argue the need for the left to understand and develop a form of socialist populism that will reconnect left-wing theory and left-wing political platforms with the everyday lives of the people who stand to gain the most by them.

Throughout this book runs the theme that popular culture is organized around the various forms of the oppositional relationship between the people and the power-bloc. This opposition always has the potential to be progressive, and in practice it generally is. Insofar as the popular forces are attempting to evade or resist the disciplinary, controlling forces of the power-bloc, they are working to open up spaces within which progressiveness can work.

But we must recognize that opposition need not necessarily be progressive. There are alliances among the people for whom the power-bloc has advanced too far, has been too progressive, and whose political and cultural impetus is reactionary in at least some aspects. There is a right-wing populism, there are some formations of the people that act as a reactionary, not progressive, force.

In the United States there is a populist religious right, and a

more popular evangelical movement, often in black communities, that is opposed to what it sees as the dangerous liberalism of the power-bloc. There is a similar "redneck" populism whose allegiances form around the opposing notions of the traditional country against the liberal city, which has regionalized variants such as the South against the North, or the Midwest against the coasts. What these oppositionalities, whether progressive or reactionary, have in common is the desire of subordinated people for some control over certain aspects of their lives, in particular over their culture. The struggle against the power-bloc is a struggle against social and cultural control, and thus, where the left is influential in the power-bloc or where elements of progressivism exist within it, popular oppositionalities may, in some cases, be reactionary.

This poses a real problem for the left, and exposes a paradox that the right has been quick to capitalize on. The left's concern for the interests and well-being of the powerless and the weak, and its belief that such powerlessness and weakness are the results of the social system, and not of the inadequacies of the people within it, leads it to propose a political program of social action. The right has been eager to equate any such program with an increase in the power of the power-bloc and thus a reduction of people's ability to exercise control over their own lives. The right has been able to turn this popular desire for control to its own interests by articulating it with its own ideology of individualism. It has therefore been able to construct and have circulated a right-wing set of meanings of the opposition between the people and the power-bloc, a set of meanings that are relevant to popular culture because they align the people with individualism and freedom and the power-bloc with state control. By its use of a populist rhetoric the right has, in the domain of party politics at least, been able to define the left as antipopular and itself as concerned with the interests of the people, and at the same time has been able to disguise the paradoxical nature of the definition.

In this rhetoric, politicians and legislators are constructed as the visible embodiments of power, and thus the (healthy) popular skepticism with which such roles are viewed has been turned into the "common sense" that the state can never be concerned with the interests of the people in their construction

as free individuals. Ultimately framing all of this, of course, is the overarching alignment of the state with communism and the individual with Americanism.

Against the right-wing rhetoric of individual freedom, the left tends to use one of social conscience and justice, a rhetoric that has little appeal to popular consciousness or pleasure. It needs to find ways of articulating its concerns with health, welfare, and education with the popular desires for freedom and control. As Williamson (1986) argues, by criticizing the materialism and individualism through which the system apparently satisfies (however illusorily) the needs of the people, the left has tended to invalidate the needs themselves instead of looking for more progressive ways of meeting them. Such a search, if it is ever undertaken, can be based only upon an understanding of the ways that the people have developed for meeting their needs and desires within the system that seeks ultimately to channel and control rather than satisfy them.

The left also needs to disarticulate social action from the workings of the power-bloc and to rearticulate it with popular control. It needs to show that the power-bloc does not consist merely of the manifest operations of the state, but that its antipopular forces are spread throughout the social order, especially in the economic sphere.

But this book is not about political action and rhetoric; it is about popular culture, where popular skepticism, resistance, and evasion may be a lot more apparent than in the political sphere. This is not to say that there are no links between popular culture and politics, but that we must not expect such links to be direct or immediate—rather, we must expect them to be diffuse, deferred, and not necessarily entailed at all. Sometimes the political potential of popular culture may never be activated, even within the realm of micropolitics; at other times it may be, but when it is not we should not allow this to deny the existence of the potential. We must admit, too, that on some occasions the politics of popular cultural practices are contradictory, as when racial or class progressiveness is accompanied by gender conservatism.

The politics of a cultural form lie in its social mobilizations rather than in its formal qualities. These are difficult to trace, and we are only now beginning to develop appropriate

methodologies and ways of theorizing the contradictions and complexities of cultural practices.

Country music is a case in point. On the face of it, country music is both popular and reactionary, yet its mobilization to express the felt collectivity of rural people against the forces of metropolitan control may be liberating at least, and may contain a progressive potential, not so much in its formal content as in its maintenance of social difference, in its legitimation of a "country" consciousness against a metropolitan hegemony. Under certain historical conditions such a consciousness may be radical or progressive; under others, it may be reactionary. What is important is that it is there.

Australia provides an interesting example of the problems of understanding the politics of popular culture. Traditionally, the most popular non-Aboriginal music among tribal Aborigines has been country and western, and, in Western Australia, the most influential (progressive rather than radical) Aboriginal politician is a country and western singer with a number of albums to his credit. More recently, some younger, urban Aborigines have turned to rock, and more explicitly politicized ones to reggae. Rock and reggae are widely considered to carry voices of social opposition, country and western far less so. But as Aborigines were able to make Third World meanings of *Rambo*, so the antiurbanism of country and western may allow them to produce antiwhite meanings that serve an Aboriginal consciousness.

So, too, on a visit to a Cherokee reservation the most common music I heard was country and western. Certainly it was performed for mainly white tourists, but it was significant that this was the musical form chosen to be part of the tourist experience of visiting an Indian reservation. Even the most economistic explanation of this needs to allow for some Indian appropriation. All the other tourist traps were economically successful because they had strong markers of Indianness— they were westernizations of Indian culture into a sort of bastard form. With the music, the process appeared to be in the opposite direction, an Indianization of western culture, but there *was* an Indianizing process at work. This was supported by my own observations; I felt, but could not prove, that the performance was not just a masquerade for the tourists, but that

the Cherokee musicians had, in some ironically contradictory way, made this anti-Indian music into a cultural form that could carry elements of Indianness. I felt, too, that the young Indians clog dancing to it were not only performing for the whites (and encouraging them to join in) but were also, as a subtext, dancing for and with each other. The looks, smiles, and expressions they exchanged as they danced conveyed, it seemed to me, Indian meanings and pleasures that exceeded and were not required by the tourist performance. There is something in country and western music that enables it to be mobilized in different white subcultures, in some Aboriginal and some Indian cultures, and its various mobilizations cannot be explained only in terms of its apparently reactionary form.

There is no guarantee that the politics of any cultural form or practice will be mobilized in any particular reading, any oppositionality may remain as a "sleeping" potential; and, if mobilized, there is equally no guarantee as to whether its direction will be progressive or conservative. So Bruce Springsteen's "Born in the USA" can be claimed by both the right and the left to articulate their very different meanings of Americanness, and Midnight Oil's "The Beds Are Burning" is popular among Australian outback mine workers despite the pro-Aboriginal land rights message contained in its lyrics, which directly contradicts their racial prejudice, at the personal level, and the politics of their industry, whose economic interests are challenged by the Aboriginal land rights movement. They hear only the hard rocking music, not the left-progressive lyrics. The politics of a popular form lie more in the conditions of its reading than in its textual qualities, or, rather, they are to be found in the interface between the two.

The progressive and empowering potential of *Cagney & Lacey*, for example, is activated by those fans whose social situation contains elements of gender antagonism, who are living in their version of a social crisis, however muted its everyday form. Those whose social situation accommodates them more easily in patriarchy are less likely to make progressive meanings from it. So *Dallas* may offer contradictory political meanings to its variously socially situated readers— and such readings may be reactionary or progressive, or even both, as when progressive gender politics may be allied with a

class politics that is purely reactionary. The point is that politics is social, not textual, and if a text is made political, its politicization is effected at its point of entry into the social.

This does not mean that all texts are equally political (even potentially), or that all politicized meanings are equally available in any one of them. Politics is always a process of struggle between opposing forces, always a matter of forging alliances and of defining and redefining the opposition. If the political potential of a text is to be mobilized, the text must reproduce among the discourses that comprise it a struggle equivalent to that experienced socially by its readers. And just as power is not distributed equally in society, so potential meanings are not distributed equally in texts. It would appear to require more of a struggle, for instance, to produce profeminine meanings from *Dallas* than from *Cagney & Lacey*. We must recognize, too, that any progressive meanings that are made are never experienced freely, but always in conflicting relationships with the forces of the power-bloc that oppose them. The empowering feminine meanings of Christine Cagney, for example, can be experienced as resistant only if the reader simultaneously produces the masculine meanings of the structure of the police force and the power of the law in society. Resistance is not an essence, but a relationship, and both sides of the relationship must be contained within its practice.

THE POPULAR, PLURALISM, AND THE FOLK

The reading relations of popular culture are not those of liberal pluralism, for they are always relationships of domination and subordination, always ones of top-down power and of bottom-up power resisting or evading it. When the political potential of popular readings is realized, typically at the micropolitical level, their effectivity is to redistribute power socially toward the disempowered. It is never to work toward that liberal pluralist consensus within which social differences are held in a negotiated and comparatively stable harmony, and where all are relatively happy with, or at least resigned to, their

positions within it. It is liberal pluralist accounts of popular culture that describe it as a form of ritual that smooths over social differences and melds them into a cultural consensus. It is liberal pluralism that explains popular culture as a sort of cultural forum where all have equal opportunity to speak and be heard regardless of social condition. Such accounts profoundly misrepresent the politics and the processes of the popular.

Popular culture in elaborated societies is the culture of the subordinate who resent their subordination, who refuse to consent to their positions or to contribute to a consensus that maintains it. This does not mean that they live their lives in a constant state of antagonism, for those are the conditions of crisis either social or personal, but that the oppositionality is sporadic, sometimes sleeping, sometimes aroused into guerrilla raids, but never finally anesthetized. Some resistances may be active and offensive, others more inclined to dogged refusals of the dominant, and others more evasive, carnivalesque, and liberating. The forms of opposition are as numerous as the formations of subordination, but running through them all, sometimes acute, sometimes muted, is this central thread of antagonism.

Popular culture, therefore, is not the culture of the subdued. People subordinated by white patriarchal capitalism are not helplessly manacled by it. Their economic and social deprivation has not deprived them of their difference, or of their ability to resist or evade the forces that subordinate them; on the contrary, it motivates them to devise the constantly adaptive tactics of everyday resistances that never allow the power-bloc to relax and feel that the victory is won.

If popular culture cannot be explained by liberal pluralism, we must be equally wary of turning uncritically to explanatory models derived from folk culture. The people in industrial societies are not the folk, and popular culture is not folk culture, though the two do share some characteristics. Folk culture, unlike popular culture, is the product of a comparatively stable, traditional social order, in which social differences are not conflictual, and that is therefore characterized by social consensus rather than social conflict. Those who attempt to study the popular culture of capitalist societies by anthropological

methods developed to study traditional tribal cultures often apply, wrongly, models of tribal ritual to industrial popular culture. Conceiving popular culture as a form of folk culture denies its conflictual elements. It denies, also, its constantly changing surface as the allegiances that constitute the people are constantly formed and reformed across the social grid. The idea of the people as an industrial equivalent of the folk is all too easily assimilated into a depoliticized liberal pluralism.

Popular culture, unlike folk culture, is evanescent and ephemeral. Its constant, anxious search for the novel evidences the constantly changing formations of the people and the consequent need for an ever-changing resource bank from which popular cultures may be produced and reproduced.

Popular culture, unlike folk culture, is produced by elaborated, industrialized societies that are experienced in complex and often contradictory ways. Our experience of our social relations moves along a continuum from the macro to the micro. We know ourselves, for instance, as members of Western capitalist democracies, of particular national or regional groups within them, and as members of immediate, local communities. These relationships are transected by others, such as those of gender, race, or class. So, to be popular, *Dallas*, for example, must offer complex and contradictory meanings about Americanness, about class, gender, and family, to name only a few. Without this polysemic potential it could not be incorporated directly and variously into the everyday lives of its viewers. Folk cultures are much more homogeneous and do not have to encompass the variety of social allegiances formed by members of elaborated societies. A folk culture, for instance, does not have to cope with the problem of a bigoted white nationalist watching blacks win gold medals for his country in the Olympics.

Popular cultures, unlike folk culture, is made out of cultural resources that are not produced by the social formation that is using them. Popular culture is made out of industrially produced and distributed commodities that must, in order to be economically viable and thus to exist at all, offer a variety of cultural potentialities to a variety of social formations. The resources from which popular culture is made are circulated across a range of social differences. So popular culture always

entails a set of negotiations between the center and the circumference, between the relatively unified allegiances of the power-bloc and the diversified formations of the people, between singular texts and multiple readings. The allied interests of the power-bloc are both economic and ideological; they are strategic interests constantly at work, but constantly opposed and evaded by the heterogeneous and conflictual interests of the people. Popular culture is a culture of conflict in a way that folk culture is not.

To be sure, there are, or have been, folk cultures of oppositional industrial groups, such as those of some logging or mining communities, which express their opposition to their exploitation. The songs that they produce are folk culture, specific to the community that produces and reproduces them in each singing. Such songs may, of course, be sung (and enjoyed) in other social formations—in, for instance, downtown folk bars—but in these contexts their pleasures are always ones of the other, of the alien. When folk culture is transported beyond the social formation that produced it, it always retains the alienness of its origins, so "peasant" baskets or "native" pottery in suburban homes always carries a sense of the exotic. Folk culture outside the social conditions of its production is always *theirs*; popular culture is *ours*, despite its alienated origins as industrial commodity.

There are also cultural forms produced and circulated within specific communities within our society that do not extend beyond them. There are formations of the gay community, for instance, who produce and circulate their own cultural forms. Such a culture is not popular, in the sense that I use the term. Far from turning the resources produced by the dominant system to its own interests, it recognizes that its opposition to the social order is so radical that any cultural resources produced by it are so contaminated by its values as to be unusable. It therefore produces its own subculture, a form of radicalized folk culture.

But there are similarities between the culture of the people in industrial societies and the culture of the folk in nonindustrial ones. There is a sense of the people that can cross social distances, even ones of the magnitude of those between industrial and nonindustrial societies.

Seal (1986) lists four key characteristics of a folk culture that are worth pursuing in a little more detail. His work is concerned with tracing the ways in which a folk culture can and does exist within modern industrial societies, particularly in its oral forms. So he is already looking for those points of contact and divergence between folk culture and more official and industrialized cultures.

First, Seal says that folklore defines and identifies the membership of a group for its members, often in opposition to other groups. This highlights one of the key problems of popular culture—whether its resistances are individualized and thus rendered harmless to the social order or whether it promotes any sense of solidarity, any sense of class consciousness that may be translated into some form of social action. I have argued in this book that popular culture is normally politicized at the micropolitical level only. It is at this level that we can trace continuities between the interior, semiotic resistances of meaning or fantasy and the practices of everyday life and its immediate, lived social relationships. The teenage girl fan of Madonna who fantasizes her own empowerment can translate this fantasy into behavior, and can act in a more empowered way socially, thus winning more social territory for herself. When she meets others who share her fantasies and freedom there is the beginning of a sense of solidarity, of a shared resistance, that can support and encourage progressive action on the microsocial level. Similarly, women who find profeminine and antimasculine meanings in soap opera may, through their gossip networks, begin to establish a form of solidarity with others. Such resistances at the microlevel are necessary to produce the social conditions for political action at the macro level to be successful, though they are not necessarily in themselves a sufficient cause of that macropolitical activity.

But the relationships among the interior, the micropolitical, and the macropolitical remain a largely unexplored problem for the cultural theorist. It may well be that one of the most productive roles for the cultural critic is to facilitate and encourage transitions among these sociocultural levels of consciousness and action. Theory can help to cultivate a social dimension within interior or fantasized resistances, to link them to social experiences shared with others and thus discourage

them from becoming merely individualistic; theory can situate the specificities of everyday life within a conceptual framework that can enhance the awareness of their political dimension. It can thus facilitate their transformation into a more collective consciousness, which may, in turn, be transformed into more collective social practice.

Such problems and possibilities become even more acute for cultural theorists as technology enables and encourages the domestication and privatization of culture. More and more cultural practice occurs within the home, as more sophisticated equipment enhances home-based culture, particularly in music, though the visual equivalent of hi-fi and stereo is technically available and only waiting for the right commercial conditions. This more sophisticated equipment interacts with cheaper equipment, so, in relatively affluent middle-class homes at least, the engagement with popular texts is not confined to the family room, but can also be further privatized into the individual rooms of family members. The "personal stereo" (such as Sony's Walkman) is, I suppose, the most privatized of all cultural technology, even more than the book, for headphones can isolate the user from the social experience of walking in the street in a way that no book can.

Folk culture, on the other hand, is a social culture; it is produced in societies where social experience is more important than private experience, and is typically produced and reproduced communally. Its social conditions lead it to encourage and enhance a sense of solidarity, in a way that the contemporary social conditions that produce our popular culture do not. It is important, then, for the cultural theorist to devise ways of contradicting the privatization of popular culture, not by denying its validity, but by enhancing the social potential it already possesses, by facilitating its transformation from the private to the public.

The second characteristic of folk culture mentioned by Seal is that it is transmitted informally, either orally or by example, and consequently does not distinguish clearly between transmitters and receivers. In practice, this is almost indistinguishable from the third characteristic of folk culture, which is that it operates outside established social institutions such as the church, the educational system, or the media, although it can interact with them and traverse them.

Popular culture circulates in a number of ways. There is the circulation of its resources or texts, often international, usually national, but always encompassing a wide variety of social formations. Popular culture is made when these cultural resources meet the everyday lives of the people. It may consist only of this dialogic relationship between the reader and the industrial text, it may exist only in the interior fantasy, but it will not remain at this level in all cases: the interior fantasy will typically demand some form of social circulation. One obvious form is that of talk—the media and other cultural resources such as sport or shopping malls form one of the most common subjects of conversation in homes, the workplaces, social organizations, bars, or anywhere else people meet face to face. The telephone and mail service extend this form of interaction beyond the limits of immediate social interaction. Such talk is selective and productive, and is read back into the media, so that the meanings and pleasures of a TV show, a football game, or a shopping trip are in part produced by conversation, both before and after the event, with others in one's social formation. Indeed, some meanings and pleasures are deferred, put on ice as it were, until they can be activated in later conversation with friends. Many people have told me, for example, that they often say to themselves as they watch a TV show, "I can't wait to hear what so-and-so has to say about this." The productivity of popular culture has been one of the central arguments of this book and does not need elaborating here.

But there is a less direct social circulation of meaning that does need some further comment. This often takes a commercial form, and thus its popular dimension can be underestimated. When fans buy secondary texts or spin-off products they are not just being further commodified consumers, but are actively contributing to the social circulation of their meanings of the primary text. The choice of which Madonna T-shirt to buy is a choice about which meanings of Madonna to circulate. The choice of which fan magazine to buy, or which article to read, is equally a way of circulating some meanings rather than others. Writing letters to these secondary texts can make this productivity more direct and more influential, for these secondary texts and spin-off products exist not only to make money but also to participate in the popular circulation of the

meanings and pleasures of the primary texts. The ones that are commercially successful are the ones that fans can use to make social or public their own meanings. Some of these secondary texts are almost as important a cultural resource as the primary. The information that they contain about stars' private lives, about studio intrigue and business dealings, is an important part of the cultural competence brought to bear upon the primary text. They help to stock the cultural pantry at home, with which the goods selected from the supermarket of the primary text are combined to cook up a meal or a reading.

These secondary texts are a source of popular empowerment; they help prevent the reader from feeling victimized by the original. So studies of soap opera fans, for example, reveal the pleasure fans experience in knowing that a particular actor's or actress's contract is not going to be renewed. This pleasure is additional to the pleasures offered by the primary text as the character is written out of the narrative, and is an empowering one in that it demystifies the commercial imperative concealed behind it and thus gives the reader a sense of semiotic control at least. Knowledge is power.

These secondary texts that circulate gossip and insider knowledge about the industry are popular, in part at least, because they offer a form of symbolic participation in the production processes, a knowledge that makes the fan seem less alienated and that the fan can use to fuel her or his productivity in reading. This popularity can be traced on a broader scale, too. Disempowered people in our society can often feel excluded from the explanation of "what is really going on." The skepticism that Bourdieu finds so typical in the culture of the subordinate means that official explanations or insights are never taken at their face value. There is always a sense that those with more power in society know more than those with less. These magazines fuel this skepticism by offering scandalous, offensive, undisciplined insights into that which the power-bloc would like to conceal.

Of course, these secondary texts are as shot through with contradictory forces as are the primary. Such revealing gossip is as open to incorporation by the power-bloc as any other popular practice, and so stars, sports people, politicians, and other personalities are sometimes complicit in the revelation of

their "true secrets," but sometimes even brought down by it. We should expect these secondary texts to exhibit as conflicting relations between the people and the power-bloc as any other resources of popular culture. These texts are made popular by people who *resent* their normal exclusion from the insider information of what is really going on in society, and some of this resentment can result in an antagonism in reading relations that reproduces that in social relations.

Even the most commercialized secondary texts, such as the toys that spin off from children's TV shows, are not necessarily limited to their economic function. The toy version of ALF, for example, may well enable children to take to bed with them not only a soft cuddly commodity, but also a set of meanings— meanings of the childlike ALF whose otherness from the adult world can be expressed only by his origination in another planet, whose childlike non-sense may at times be superior to the adult sense that constantly attempts to control and discipline him. The fact that the parent may have paid $17 for the toy does not prevent the child from cuddling up to some very antiadult and prochild meanings as he or she falls asleep. The toy aids the imbrication of the pleasures of the program into the everyday life of the child.

The fourth of the characteristics by which Seal defines folk culture is that there is no standard version of a folklore text; folklore exists only as part of a process. This again accords well with the processes of popular culture—the industrially pro- duced and circulated cultural commodity may exist in a way that no standard folk text does, but it becomes textualized only in its moments of reading, only when its meaning-potential is actualized. It thus performs a limiting or determining function that has no equivalent in folklore, and so the popular reader producing culture by struggling against resources produced by the other is not the precise equivalent of the participant in folk culture. But still, like folklore, popular culture exists only in its processes of production and reproduction, only in the practices of everyday life, not in stable, self-sufficient texts.

Though popular culture is not folk culture, the two do bear some similarities. Both are, in their different social contexts, the culture of the people. What popular culture is not, however, is mass culture. *Mass culture* is a term used by those who believe

that the cultural commodities produced and distributed by the industries can be imposed upon the people in a way that irons out social differences and produces a unified culture for a passive, alienated mass audience. Such a process, if it existed, and it does not, would be anticultural and antipopular; it would be the antithesis of culture understood as the production and circulation of meanings and pleasures, and of the popular as an intransigent, oppositional, scandalous set of forces. There is no mass culture, there are only alarmist and pessimistic theories of mass culture that, at their best, can shed light only on the industrial and ideological imperatives of the power-bloc, but none at all on the cultural processes by which the people cope with them and either reject them or turn them into popular culture.

PROGRESSIVE SKEPTICISM

In this book and its companion volume my emphasis has been the opposite of that of the mass cultural theorists: I have focused on those moments where hegemony fails, where ideology is weaker than resistance, where social control is met by indiscipline. The pleasures and the politics of such moments are, I argue, the theoretically crucial ones in popular culture, for they are the articulation of the interests of the people. Popular culture always has a progressive potential, so it is theoretically and politically important to identify the ways in which that potential may be realized, and the historical and social conditions under which such realizations are most likely to occur. In focusing on this progressive potential I have tried not to neglect the fact that the politics of popular culture are full of contradictions, and that some of them, under some historical and social conditions, may be reactionary. But they are rarely purely reactionary—often reactionary gender politics, for instance, may serve to strengthen class or racial solidarity.

Equally, the pleasures of popular culture are met by the pleasures offered as ideology's free lunch, or as the bait on the hegemonic hook. But these are pleasures organized around the

interests of the power-bloc; they are antipopular, they are the safe, controlled pleasures that power tries to substitute for the dangerous, unpredictable ones of the people. The domain of pleasure is as full of conflict as that of meanings.

In this book I have tried to sketch out some of the possible relationships between the meanings and pleasures of popular culture and political action, particularly at the micro level, but also, potentially, at the macro level. As an academic, albeit a politically aware one, I have concentrated on trying to shed some light upon the processes of popular culture, rather than on developing a program of action whereby this understanding can be used instrumentally to mobilize these processes politically. My reluctance stems from two main sources—partly the belief that the programs of political action can be developed only in specific sociohistorical conditions, but largely from my fandom, which warns me of the people's skepticism about "preachiness," whether from the left or the right, the realization that insensitive or historically inappropriate attempts to organize the people can destroy the pleasures that motivate popular resistance.

I listen to these warning voices inside me, for besides being an academic theorist, I am also a fan of popular culture; I have strong vulgar tastes and my academic training has failed to squash my enjoyment and participation in popular pleasures— I watch TV game shows, for instance, mainly because of the enormous fun they give me, and secondarily because they arouse my theoretical interest and curiosity. I experience them both as a fan from the inside and as an academic from a critical distance. I am 50 years old, and I have spent large amounts of my leisure time participating in popular culture. I enjoy watching television, I love the sensational tabloid press, I read trashy popular novels and enjoy popular block buster movies. I have spent many happy hours in Disneyworld, shopping malls, Graceland, and on the Universal Studios tour—and despite all this, I do not think I am the dupe of the capitalist system because I can find great pleasure within it; in fact, *my* pleasures typically have an edge of difference to them, an awareness that they are *my* pleasures that I produce for myself out of *their* resources, and that in some way I am, from their point of view, misusing their resources for my pleasure. My

laughter occurs at moments they might not have chosen as risible; it contains a cynical bite they might not welcome. And in this I believe I am typical of the people in general, that my experience of popular pleasure is not special or privileged because I am also an academic with a variety of theoretical perspectives that are not part of everyday life. My academic theorist side pushes me to lay out a program whereby an understanding of popular culture may be harnessed to promote a more democratic social order; the fan inside me warns that popular culture is produced by the people and does not take kindly to anything it perceives as outside interference. So I tread warily.

One of the many debts we owe to Foucault is his insistence that power relations cannot be adequately explained by class relations, that power is discursive and is to be understood in the specific contexts of its exercise, not in generalized social structures. Social power does not equate with class or any other objectively defined social category: a woman can participate in patriarchal power ("Just you wait till your father gets home") in one social allegiance (that of "the parent"), just as she can resist or scandalize it in her mocking gossip with fellow soap opera fans in a typical shift of social allegiance. So, too, a privileged man may have many experiences of powerlessness within the system (as well as ones of power within it). Power is a social force that crosses social categories, though obviously it bears some relation to them. Men may participate in (or evade or resist) patriarchal power, as may women, but they will do so differently. As a white, middle-class male I may be able to share some experience of powerlessness with members of far more disadvantaged categories, but our class differences must make some difference. Social power cannot be adequately explained by social categories, but, equally, it cannot be understood or experienced independently of them.

Similarly, the social allegiances so crucial to popular culture are formed within the social structure, but are not limited to, or produced by, its categories. The social person is not as passively overdetermined as the more extreme inflections of subjectivity theory would have us believe. Our consciousness is not simply produced for us by our social relations and the ideology at work in them: the discursive and cultural resources available to us

from which to make our sense of our social relations and experience are not monoglot, they are not limited to telling one story only, to making only one set of (ideologically determined) meanings. They are resources that we use, just as much as they use us: we are social agents rather than social subjects.

Of course, our experiences are produced and bounded by the social order, but the sense we make of them, and of ourselves within them, is not necessarily the one that the dominant forces in that order would wish. Nor is it one that is tightly determined by the linguistic and other semiotic systems into which we are born, and into which the dominant ideology is inscribed more or less insistently. Language systems are complex and contradictory—their cultural work cannot be confined to the reproduction of the dominant ideological framework, for our society has not been produced by an uncomplicated triumphal march of capitalism, or patriarchy, or any other social force: its history is one of constant conflicts in which all victories are partial, all defeats less than total. Popular histories make this clear: Darnton (1985), for example, shows us how specific formations of the people (e.g., printing apprentices) in eighteenth-century France expressed their (resistant) sense of their subordination in their oral and everyday culture, and how pleasurable (and offensive) these practices could be. Our social structure, our oral culture, our cultural resources are indelibly inscribed with the contradictory traces of these oppressed, but not eliminated, social formations: these contradictory forces, kept alive and in circulation in the local practices of everyday life, are equally available to, and necessary for, the productive agents of popular culture, as are the resources provided by the cultural industries. Popular culture is made out of, and contains, these quite contradictory social impulses.

The classic theories of subjectivity (whether social or psychoanalytic) stress the resolution of contradictory forces in favor of the dominant: they explain the construction of social subjectivity in terms of the victory of the dominant forces. Their outcome is, inevitably, a relatively unified, singular social subject, or subject in ideology. More recent theories, however, stress the disunited, contradictory subject, in which the social struggle is still ongoing, in which contradictory subject positions sit sometimes uncomfortably, sometimes relatively comfortably,

together. Other models are those of the nomadic subjectivity, which envision the social agent as moving among various subject positions, where the arrival at a new one can never obliterate the traces of those left behind, but instead builds on or over them. I can watch Madonna simultaneously as a patriarchal subject (I find voyeuristic pleasure in her erotic body), and as a post patriarchal (or antipatriarchal) one (I find pleasure in her challenge to my voyeurism and the "rights" it claims to give me).

There are active contradictions within subjectivities as there are within social experiences, there are active contradictions within texts, there are active contradictions in the discursive resources used in the making of sense. The necessity of negotiating one's way among these contradictory forces means that the members of elaborated societies are social agents rather than social subjects: the contradictions that characterize such societies and their cultures require active agency rather than subjectivity. Reading, like other cultural and social practices, is the activity of a social agent negotiating contradictions and constructing relevances and allegiances from among them, it is not the subjected reception of already-made meanings. The activity of such agency is not that of voluntarism or free will, but is social in that it is produced and determined by the contradictoriness that is the core experience of the subordinate in elaborated, capitalist societies. Any lines of social force working to close down or limit the space within which the agency of the subordinate can operate are contradicted by intersecting or opposing lines that work to enlarge it. Pleasure is the reward of grasping the opportunities offered by these unstable forces of empowering and enhancing one's social agency. Subjects cannot be skeptics, and hedonistic skepticism is so characteristic of the people because it is produced at those moments when the forces of ideological and social control meet the intransigent conditions of everyday life.

I find great, but contradictory, pleasures in the report that a World War II bomber has been photographed on the moon (*Weekly World News*, 5 April 1988). As an educated person, rewarded with the advantages of believing in a scientific, empirical order of things, I take pleasure and power in distinguishing myself from (inferior) systems of belief (i.e.,

"superstitions") that contradict my scientific "truth" that it is impossible for it to have got there. But at the same time, I have a skepticism about "science" (particularly, but not exclusively, in medical and environmental matters) that finds pleasurable points of pertinence in apparent facts that lie beyond its explanatory ability and therefore discursive power. I can experience these pleasures both simultaneously and alternately (or, at least, with one in alternate dominance over the other). My skepticism may be directed either toward "science" or toward "superstition," and in the contradiction between the two I am freed from subjection to either. My skepticism is both produced by and exploits the contradiction, and is pleasurable insofar as it allows me to negotiate my way between these conflicting knowledges, it allows me to be a social agent rather than a social subject, a cultural producer rather than a cultural dupe. It creates a space within which I can experience myself as a producer of meanings, some of which are pleasurably relevant to my experiences of social powerlessness: I enjoy being able to establish, momentarily, my difference from "the system" by being able to say, "They can't explain everything, they don't know everything, they want to repress that which they can't explain, because what they can't explain is what escapes their power."

My pleasure is resistive in that it recognizes that the discursive power of science is aligned with the discursive and economic power of capitalism, and that, albeit at the most tenuous level, the inability of science to explain a bomber on the moon is at one with the inability of capitalism to encompass and control the experience of the subordinate. A baffled scientist facing the limits of his power can become, by discursive transference or displacement, a baffled bourgeois facing the limits of his power; the moonstruck bomber becomes a metaphor for the social experiences of the subordinate that lie outside the meanings (and power) offered by the dominant discourses. The pleasure lies not in the bomber on the moon, but in the refusal of official truth. It is offensive, and thus science (or power) will seek not to explain it (for that would be to admit its validity) but to repress or deny it. The story allows me the pleasure of understanding science in my (popular) terms—that is, as a system of power—not in its own, dominant, terms, as a

system of nonsocial, nonpolitical truths grounded in nature and thus objective, universal, and unchallengeable. The story demystifies, challenges, offends, scandalizes, sensationalizes, articulates with "our" popular experience of "them," and is thus easily made into popular culture and its momentary pleasures. It invites productivity, it provokes gossip, argument, the play of belief and disbelief, of common sense and skepticism, of official and unofficial knowledges, of top-down and bottom-up power. It is destabilizing, sensational, and excessive, and its pleasures are those of the productive cultural agent, not of the dupe or of the subjected.

PRODUCING RELEVANCE

Popular culture must not preach. The problem with some forms of social(ist) realism is that they attempt to provide an answer for, or a "true" insight into, the problems of industrial society. However politically correct this might be, it denies the productivity of popular culture: it minimizes the producerly elements in the text, or, at least, attempts to close them down. It attempts to do the work of the cultural agent by identifying its relevance to the social experience of the reader. This sort of "preachy" social realism is unlikely to be made into popular culture. That is not to say that no forms of social realism can be popular, but it does raise the question. *Dallas*, for instance, is watched by a huge variety of social groups throughout the Western world. In some cases, at least, it is made into surprisingly different popular cultures: it is read resistingly and/or incorporated within the daily lives of people whose social experience is far removed from that of the Ewings. The relevance of *Dallas* does not lie in the material conditions of the world it represents. Indeed, for many of the popular readers, the pleasure of these material conditions lies in their difference: they embody the dominant ideology that popular experience differs from, but relates to.

There are British television shows, such as *Coronation Street* or *EastEnders*, that represent more directly the social condi-

tions of subordinate classes (and, in *EastEnders*, races); these representations are a form of social realism insofar as they encourage viewers to form social allegiances with the subordinate. But they are popular to the extent that they avoid closed or preachy social realism; they do not propose a "party line" of socially correct meanings, but offer contradictory and controversial representations, and thus allow for producerly readings. Indeed, Buckingham (1987), in his study of *EastEnders* and its younger fans, found that although the show did, at times, appear somewhat didactic or preachy about issues such as race, the school-age viewers that he studied were adept at avoiding such moralizing. They did not, however, avoid the issues; on the contrary, they dealt with them thoroughly, but through active discussion of "the characters' moral dilemmas, through the rehearsing of past incidents and the prediction of future developments" (Buckingham 1987: 163).

In other words, their readings were far more producerly than a preachy text would allow. Such producerly popular texts work to provoke the reproduction and recirculation of meanings in gossip or conversation; their open but relevant contradictions stimulate viewers to connect them to their daily lives, and enable viewers in different social allegiances to make different meanings out of the different points of pertinence that they find. Morley (1986) has shown how pleasurable the recognition of relevance at the level of social representation can be, but this is clearly a different sort of relevance from that perceived by, for instance, Russian Jews in *Dallas*. There are different pleasures at work here. Some activate negative features on the level of representation to produce pleasures of difference, while others activate more positively represented elements to produce pleasures of similarity: represented relevance may operate along axes of similarity or difference. Thus the Moroccan Jews who read *Dallas* as a demonstration that the Ewings' money did not bring them happiness found this meaning pleasurable insofar as it was relevant to their sense of difference from Western materialism. There were pleasures of recognition that Morley's (1986) lower-class London viewers found with the representation of "local" characters and events in *Only Fools and Horses*. In this, they were similar to the *Cagney & Lacey* fans studies by D'Acci (1988).

Both sorts of representational relevance can allow popular, resistant readings. But it may be that the relevances of difference can reach a wider variety of formations of the popular than those of similarity. So *Dallas* can be popular across a wider range of national and social formations than either *Only Fools and Horses* or *Cagney & Lacey*. But its wider, rather than greater, popularity may also be the result of the greater encouragement it offers viewers to align themselves in a nonpopular way with the forces of domination: *Dallas* may also attract more hegemonically complicit readings than *Only Fools and Horses* or *Cagney & Lacey*. Our current knowledge cannot resolve the debate. The effectivity, or otherwise, of *Dallas*'s hegemonic thrust depends upon the social allegiances of its viewers and on whether they construct either relevances of similarity (between its represented world and their values) or ones of difference (between its represented world and their experienced one). The most significant relevances may not be those of similarity. The popularity of science fiction or historical romance cannot lie simply in represented social relevances at the level of the material details and conditions of everyday life. Perhaps, for some Third World viewers, *Dallas* is read as politically conscious science fiction, a futuristic dystopia that warns against development as the West defines it for them. We can, at this stage of our understanding of popular culture, do little more than speculate.

There are other sorts of relevance that exist at the level of discourse rather than of representation. The headline "CON-TRAVER$Y" in no way represents popular social experience, nor does the story of the moonstruck bomber. These are popular discourse, not because of the representation of the world that they offer, but because they combine contradictory discursive orientations to that world. Their relevancies lie in the relationships between the reading practices that make sense and pleasure out of them and the social practices that are used to make sense and pleasure out of everyday life. The pleasure in hearing the feminine voice speak "No way, Jose" when the masculine has already pronounced "Yes, master" is not confined to its representation of bedroom conflicts; two discursive attitudes are contradictorily and unresolvedly present in the same couple, and these contradictions are relevant

to a wide variety of contexts within which specific couples live and contest a patriarchal power: it reproduces the gender-political terrain upon which patriarchal strategy and feminist tactics engage rather than represents the "reality" of any specific engagement. This is a relevance to the discursive strategies and tactics employed in the making of meanings rather than to the recognition of elements of that social experience of which the meanings are being made.

Relevance is a complex criterion of popular discrimination: at the level of representation it operates along axes of similarity and difference. But it is not confined to the level of representation; indeed, it appears that discursive relevance is more productive of popular culture than representational relevance because it is more likely to be a foregrounded element in producerly texts: representational relevance can be made to fit more easily with readerly, nonproductive, texts, and these are unlikely to be as widely chosen as the raw resources of popular culture. Representational relevance in a nonproducerly text is unlikely to produce popular culture.

Progressives and radicals often wish to intervene in the production of mass culture to increase the variety of representations of the world that it offers, to increase the number of voices and visions that it carries, and to make it contest and contradict itself more explicitly. Such enlargement, enrichment, and variation of the resources out of which popular culture can be made are potentially a positive force for social change, but this potential can be realized only if it takes proper account of the productivity and discrimination involved in making popular culture. The mass media do not deliver ready-made popular culture as the mailman delivers mail. Seeing the mass media as the purveyors of cultural commodities and the people as mere consumers of those commodities leads to the fallacious belief that changing the commodities will change popular culture, which will, in turn, change the social order. Neither culture nor politics is that simple.

For those of us wishing to change our media or to encourage alternative media, it is all too tempting to concentrate upon the level of representation and to ignore the roles of popular discrimination, relevance, and popular productivity. Progressives will not help their cause if they produce new cultural

commodities that extend the range of representations of the world but that the various formations of the people discriminate against because they fail to offer what popular culture demands. Where relevance is taken into account, it is often confined to the representational axis of similarity, and ignores, in particular, discursive relevance and its greater potential for producerly pleasures. Progressive or radical cultural theorists can all too easily underestimate the importance of fun, of the carnivalesque, and produce sober, puritanical texts. Their desire to promote specific meanings of social experience (however resistant or progressive) can all too easily lead to the production of closed, nonproducerly texts. Producerly texts are risky texts, because their meanings are out of control, but cultural production is, necessarily, a risky business. The producers of texts cannot control either popular discrimination or popular productivity. Popular culture does not take easily to central control, however benevolent. There is a risk involved in allowing excess, for that allows meanings to get out of control: the power of the left is as open to carnivalesque inversions and evasions as is that of the right, but this is a risk that must at times be taken if the progressive is to be the popular.

POPULAR CULTURE AND SOCIAL CHANGE

Radical theorists have consistently underestimated and demeaned popular forces. I would like to start to redress this by suggesting first that we can learn at least as much, if not more, about resistances to the dominant ideology from studying popular everyday tactics as from theorizing and analyzing the strategic mechanisms of power. Second, I suggest that the popular motives for social change are quite different from theoretical and radical ones and that failure to recognize this difference has resulted in radical theorists and politicians being unable to mobilize popular energies and forces to work as effectively as possible to hasten social change. It has also led to the underestimation of the amount of social change or progress that popular forces have achieved within and against the system that dominates their social experience.

Two quite different, and possibly mutually exclusive, models of social change are being put forward here. We might call them the radical and the popular. Radical social change, which results in a major redistribution of power in society, is often described as revolution (armed or otherwise), and occurs at relatively infrequent crisis points in history. Popular change, however, is an ongoing process, aimed at maintaining or increasing the bottom-up power of the people within the system. It results in the softening of the harsh extremities of power, it produces small gains for the weak, it maintains their esteem and identity. It is progressive, but not radical.

We are wrong to expect popular culture to be radical (and thus to criticize it for not being so). Radical political movements neither originate nor operate at the level of representation or of symbolic systems. This does not mean, however, that when historical conditions produce a radical crisis the media and popular culture cannot play an active role in the radical change that may occur: what it means is that symbolic or cultural systems alone cannot produce those historical conditions. Despite the severe problems facing many Western societies today (economic, environmental, social), there are few signs that these problems constitute a historical crisis that will result in the overthrow of patriarchal capitalism. Under these conditions, popular culture cannot be radical. The most we can hope for is that it will be progressive.

Of Laclau's types of oppositional populism, the popular equates with progressive popular culture and the populist with radicalism, though as yet there is little evidence of a popular left in the political realm. The voices of Thatcher and Reagan speak with a right-wing popular rhetoric (appropriate to our difficult, but noncrisis conditions—the populist rhetoric of a Hitler or Mussolini would seem ludicrously inappropriate to all but the most extreme right-wingers). What the left lacks is a popular rhetoric: it has many historical examples of populist radical rhetorics that may have been appropriate to their historical moments, but are not appropriate for contemporary Western societies.

For theorists of popular culture, then, the problems are of two kinds. The first is to develop ways of investigating whether or not the forms of popular culture can be usefully evaluated in

terms of their degree of progressiveness, and, if so, how this differential progressiveness can be identified in specific texts and their readings. Then comes the need to think through the nature of resistance, the relationships between interior resistance (whether evasive or productive) and organized resistance at the sociopolitical level, which in itself encompasses the micro- and macropolitical levels, with their still largely unexplored interrelationships.

Evaluating the potential progressiveness of popular culture is beyond us at the present state of our understanding, and may well remain so. In this book I have tried to sketch in some of the characteristics of texts that make them available for use in some of the cultures of the people. The presence of these characteristics does not guarantee that a text will be used, but their absence makes its use less likely and less flexible. Textual analysis may be able to identify a text's popular potential, but it can only speculate about if or how this potential will be actualized. The speculations can be conducted with some theoretical rigor, for they must be situated within both appropriate textual theory and appropriate social theory, but they can never pass beyond the illustrative, they can never be exhaustive, for they will always be taken by surprise by some of the practical, contextual uses to which the text will be put. Similarly, it is impossible to predict which of these uses will be more or less progressive than any other. While the analyst will be able to situate his or her speculative potential readings of a text in relationship to the meanings that serve the dominant ideology, and thus to arrive at a rough measure of their ideological difference, this does not constitute a measure of a text's progressive potential, though it must bear upon it.

Ethnographic analysis of specific instances of a text's use can help us toward understanding under what conditions and in what ways the progressive potential may be actualized. But they are always analyses of a cultural process that has already occurred; their predictive value is limited, though not nonexistent.

For instance, D'Acci (1988) has shown how the sense of empowerment that some of the fans of *Cagney & Lacey* derive from the show enables them to change their social lives; similarly, Radway (1984) has found that some romance fans

discover that their reading enhances their self-esteem to the point where they are able to stand up better to their husbands' demands and to negotiate a more empowered space for themselves within the patriarchal structure of the family. Seiter et al. (1989) have found that the representation of a married woman's affair on a TV soap opera can be used within a specific marriage as a warning to the husband to change the way he treats his wife. Such specific instances of the micropolitical use of popular texts might then lead us to predict that some Madonna fans will be empowered by their fandom to demand better treatment by their boyfriends, but we cannot predict either which fans will behave in this way or what forms those demands will take. Analysis of Madonna's texts and ethnographic studies of her fans can combine, within a sociotextual theory, with studies of specific uses of other popular texts with a similar gender-political potential (e.g., romances, soap operas, and *Cagney & Lacey*) to enable us to predict that, at the level of micropolitics, some fans of Madonna will make some socially progressive uses of her texts.

The relationships between micropolitics and macropolitics are diverse and dispersed. The most micro of micropolitics is the interior world of fantasy (see *Reading the Popular*, Chapter 5b). The preservation of fantasy as an interior place beyond the reach of ideological colonization, and the ability to imagine oneself acting differently in different circumstances, may not in itself result in social action, whether at the micro or macro level, but it does constitute the ground upon which any such action must occur. It is difficult to conceive of a movement for social change that does not depend on people's ability to think of themselves and their social relations in ways that differ from those preferred by the dominant ideology.

Such interior, privatized resistance may have its progressive potential increased if it is given a social dimension—if, through formal or informal relationships the social agent can connect with others, and can articulate his or her interior resistances with those of others. One function of the critic-theorist may be to assist in this socialization of the interior, either through the provision of a vocabulary and a theoretical framework that will help the personal to be generalized outward, or through the provision of enabling social organizations along the lines of the consciousness-raising groups of the women's movement.

The potential of such change at the micropolitical level should not be underestimated. The fan empowered by her use of Madonna to change her relationships with boys may extend this empowerment into her relationships within the family, within the school, or within the workplace. It may be part of the new way in which she walks down the street or the shopping mall, demanding that people take notice of her; it may be part of the process of claiming places within the street for women, of breaking the gendered meanings of indoors and outdoors; it might be part of changing and reducing the male's voyeuristic rights and pleasures.

Such social change, while not attacking the system radically at the level of macropolitics, may nonetheless be the sort of progressiveness that has most to offer subordinates as they live their everyday lives. We should not expect the gender progressiveness of Madonna to result in the formation of radical feminist action groups, but, equally, we should not allow her absence of radicalism to lead us to dismiss her as a gender reactionary. Radical feminists who are offended by Madonna's use of patriarchal iconography, values, and pleasures can be led to underestimate, or even deny, the progressive uses to which she can be put. In any sphere of politics radical theories can often be at odds with progressive practices.

Indeed, I would go further. There is little historical evidence to suggest that any form of radical art has produced a discernible political or social effectivity. In saying this, I have no wish to marginalize radical or avant-garde art any more than it has already marginalized itself, but I do wish to question the claims that radical art is politically more effective than the progressive uses of popular art. Barthes (1973) points to the political limitations of the avant-garde when he argues that it challenges the bourgeoisie only in the spheres of aesthetics and ethics, but in no way disturbs its economic or political power. Any effectivity it may have is confined to marginal shifts within the bourgeoisie itself. In fact, there is more evidence of the progressive effectivity of popular art on the micro level than there is of radical art on the macro level.

So while I am cautious of attributing any direct political effect to any system of representation, I do wish to recognize that all representations must have a politics, and that this politics may

be both macro and micro. On the macropolitical level, most theorists of popular culture suggest that its effectivity is reactionary, that its diffuse, long-term politics promotes the interests of the dominant classes and social groups. Such theories are persuasive only if we understand them to be describing a hegemonic thrust rather than an ideological effect.

But on the micro level the situation is different. A number of researchers have found that the sense of empowerment that may, on occasion, result from the practices of popular culture can enable or encourage progressive social action on the micropolitical level (e.g., see D'Acci 1988; Radway 1984; Seiter et al. 1989). The politics of popular culture at the macro level may be contradicted by those at the micro. If this is so, then the recent investigations into the politics and culture of everyday life would suggest that any reactionary effectivity at the macro level is powerless to prevent its subversion at the micro.

The extent to which such progressiveness is licensed and contained by the social system is debatable, and the debate centers on the problem of incorporation. On the one hand, it can be argued that progressive practices are panaceas allowed by the system to keep the subordinate content within it. By allowing the system to be flexible and to contain points of opposition within it, such progressive practices actually strengthen that to which they are opposed, and thus delay the radical change that is the only one that can bring about a genuine improvement in social conditions. Such an argument has been the orthodoxy among many radical theories of the recent past. It has still not been disproved: it still needs to be taken seriously. Its problem is that it can so easily lead to a pessimistic reductionism that sees all signs of popular progress or pleasure as instances of incorporation, and therefore conceives of power as totalitarian and resistable only by direct radical or revolutionary action. It also, ironically for such a Marxist argument, fails to account for historical conditions and thus essentializes the process. Under some conditions incorporation may be comparatively effective, but under others is is much less so. Again, the theoretical focus needs to shift from the structural process to the socially located practice.

The emphasis on incorporation may well be theoretically tenable, but it is politically sterile because, in the current and

immediately foreseeable conditions of capitalist societies, it offers no hope of being able to mobilize the popular support necessary for such radical social change. Indeed, as I argued earlier, it runs the risk of alienating the various formations of the people instead of mobilizing them.

Against this is the argument that what is called "incorporation" is better understood as a defensive strategy forced upon the powerful by the guerrilla raids of the weak. Incorporation always involves giving up some ground, the concession of space; such a continued erosive process may well provide changes in the system that allow significant improvements in the condition of the subordinate. The redistribution of power and resources within the system may not be radical, but it may alter the way that power is exercised and the nature of power itself. The economic, social, and industrial conditions of blue-collar workers have improved over this century, however patchily. Other subordinated groups have increased their power in society at both the macro and micro levels.

There is, of course, a long way still to go, but it may be counterproductive to denigrate or even discourage the everyday struggles within and against the system in favor of a radical attack on the system itself. The more modest and immediate aims of progressiveness may be more practical as well as more popular than the larger and more distant objectives of radicalism. The two models of social change should not be at odds, for radical theories that cannot enlist popular engagement are doomed to political failure, and popular progressiveness that lacks the potential to make connections with radical movements at times of historical crisis or acute political antagonism is equally ineffective. The micropolitics that maintains resistances in the minutiae of everyday life maintains a fertile soil for the seeds of macropolitics without which they will inevitably fail to flourish.

I have tried in this book and its companion volume of readings to argue a view of popular culture that is both positive and optimistic. As such, it runs counter to some academic and political orthodoxies, but if it helps toward a reconceptualization of popular forces as an untapped social resource that can fuel (and in its own way already is fueling) the motor of social change, then any disagreement I may provoke will be justified.

New knowledge is not an evolutionary improvement on what precedes it; rather, new knowledges enter adversarial relationships with older, more established ones, challenging their position in the power play of understandings, and in such confrontations new insights can be provoked. And I do wish to contest the variety of views that, in their different ways, judge the popular to be a negative social influence, for, in the final analysis, I believe the popular forces to be a positive influence in our society and that failing to take proper account of their progressive elements is academically and politically disabling. I hope I have managed to take some of my readers some of the way with me.

References

Allen, R. (1977). *Vaudeville and Film, 1895–1915: A Study in Media Interaction*. Unpublished dissertation, University of Iowa.

Allen, R. (1985). *Speaking of Soap Operas*. Chapel Hill: University of North Carolina Press.

Allen, R. (ed.)(1987a). *Channels of Discourse: Television and Contemporary Criticism*. Chapel Hill: University of North Carolina Press.

Allen, R. (1987b). *The Origin of the Leg Show: Transgression and Sexual Spectacle in Nineteen-Century Burlesque*. Unpublished manuscript, University of North Carolina.

Althusser, L. (1971). "Ideology and Ideological State Apparatuses," in *Lenin and Philosophy and Other Essays* (pp. 127–186). New York: Monthly Review Press.

Altman, R. (1986). "Television/Sound," in T. Modleski (ed.) *Studies in Entertainment: Critical Approaches to Mass Culture* (pp. 39–54). Bloomington: Indiana University Press.

Ang, I. (1985). *Watching Dallas*. London: Methuen.

Archer, R., and Simmonds, D. (1986). *A Star Is Torn*. New York: E. P. Dutton.

Bacon-Smith, C. (1988). *Acquisition and Transformation of Popular Culture: International Video Circuit and the Fanzine Community*. Paper presented at the annual meeting of the International Communication Association, New Orleans, May.

Bakhtin, M. (1968). *Rabelais and His World*. Cambridge: Massachusetts Institute of Technology Press.

Bakhtin, M. (1981). *The Dialogic Imagination*. Austin: University of Texas Press.

Barthes, R. (1973). *Mythologies*. London: Paladin.

Barthes, R. (1975a). *S/Z*. London: Cape.

Barthes, R. (1975b). *The Pleasure of the Text*. New York: Hill & Wang.

Barthes, R. (1981). "Theory of the Text," in R. Young (ed.) *Untying the Text*. London: R.K.P.

Bennett, T. (1983a). "A Thousand and One Pleasures: Blackpool Pleasure Beach," in Formations (ed.) *Formations of Pleasure* (pp. 138–145). London: Routledge & Kegan Paul.

Bennett, T. (1983b). "Marxist Cultural Politics: In Search of 'The Popular'," *Australian Journal of Cultural Studies* 1 (2), 2–28.

Bennett, T. (1986). "Hegemony, Ideology, Pleasure: Blackpool," in T. Bennett, C. Mercer, and J. Woollacott (eds.) *Popular Culture and Social Relations* (pp. 135–154). Philadelphia: Open University Press.

Bennett, T., Boyd-Bowman, S., Mercer, C., and Woollacott, J. (eds.) (1981). *Popular Television and Film*. London: British Film Institute/Open University.

Bennett, T., Mercer, C., and Woollacott, J. (eds.) (1986). *Popular Culture and Social Relations*. Philadelphia: Open University Press.

Bourdieu, P. (1984). *Distinction: A Social Critique of the Judgement of Taste* (R. Nice, trans.). Cambridge, MA: Harvard University Press.

Buckingham, D. (1987). *Public Secrets: EastEnders and Its Audience*. London: British Film Institute.

Chambers, I. (1986). *Popular Culture: The Metropolitan Experience*. London: Methuen.

Cohen, S., and Taylor, L. (1976). *Escape Attempts: The Theory and Practice of Resistance to Everyday Life*. London: Allen Lane.

Consumer Guide (ed.) (1982). *How to Win at Video Games*. Cheltenham: Bulger.

Cunningham, H. (1982). "Class and Leisure in Mid-Victorian England," in B. Waites, T. Bennett, and G. Martin (eds.) *Popular Culture: Past and Present* (pp. 66–91). London: Croom Helm/Open University Press.

D'Acci, J. (1988). *Women, "Woman" and Television: The Case of Cagney and Lacey*. Unpublished dissertation, University of Wisconsin-Madison.

Darnton, R. (1985). *The Great Cat Massacre and Other Episodes in French Cultural History*. New York: Vintage.

Davies, J. (1984). *The Television Audience Revisited*. Paper presented at the meeting of the Australian Screen Studies Association, Brisbane, December.

de Certeau, M. (1984). *The Practice of Everyday Life*. Berkeley: University of California Press.

Douglas, M. (1966). *Purity and Danger*. London: Routledge & Kegan Paul.

Dyer, R. (1986). *Heavenly Bodies: Film Stars and Society*. New York: St. Martin's.

Eagleton, T. (1981). *Walter Benjamin: Towards a Revolutionary Criticism*. London: Verso.

Eco, U. (1986). *Travels in Hyperreality*. London: Picador.

Fiske, J. (1987a). "British Cultural Studies," in R. Allen (ed.) *Channels of Discourse: Television and Contemporary Criticism* (pp. 254–289). Chapel Hill: University of North Carolina Press.

Fiske, J. (1987b). *Television Culture*. London: Methuen.

Fiske, J. (1989). *Reading the Popular*. Boston: Unwin Hyman.

Fiske, J., Hodge, R., and Turner, G. (1987). *Myths of Oz: Readings in Australian Popular Culture*. Boston: Unwin Hyman.

Flitterman, S. (1985). "Thighs and Whiskers: The Fascination of *Magnum P.I.*" *Screen* 26 (2), 42–58.

Formations (ed.) (1983). *Formations of Pleasure*. London: Routledge & Kegan Paul.

Foucault, M. (1978). *The History of Sexuality*. Harmondsworth: Penguin.

Gans, H. (1962). *The Urban Villagers: Group and Class in the Life of Italian-Americans*. New York: Free Press.

Gibian, P. (1981). "The Art of Being Off Center: Shopping Center Spaces and Spectacles." *Tabloid* 5, 44–64.

Greenfield, P. (1984). *Mind and Media*. London: Fontana.

Grossberg, L. (1984). "Another Boring Day in Paradise: Rock and Roll and the Empowerment of Everyday Life." *Popular Music* 4, 225–257.

Hall, S. (1980a). "Encoding/Decoding," in S. Hall, D. Hobson, A. Lowe, and P. Willis (eds.) *Culture, Media, Language* (pp. 128–139). London: Hutchinson.

Hall, S. (1980b). "Thatcherism: A New Stage?" *Marxism Today* 24 (2).

Hall, S. (1981). "Notes on Deconstructing 'The Popular,' " in R. Samuel (ed.) *People's History and Socialist Theory* (pp. 227–240). London: Routledge & Kegan Paul.

Hall, S. (1982). "A Long Haul." *Marxism Today* 25 (11).

Hall, S. (1983). "Whistling in the Void," *New Socialist* 11.

Hall, S. (1986). "On Postmodernism and Articulation: An Interview with Stuart Hall" (edited by L. Grossberg). *Journal of Communication Inquiry* 10 (2), 45–60.

Hall, S., Hobson, D., Lowe, A., and Willis, P. (eds.) (1980). *Culture, Media, Language*. London: Hutchinson.

Hebdige, D. (1979). *Subculture: The Meaning of Style*. London: Methuen.

Hobson, D. (1980). "Housewives and the Mass Media," in S. Hall, D. Hobson, A. Lowe, and P. Willis (eds.) *Culture, Media, Language* (pp. 105–114). London: Hutchinson.

Hobson, D. (1982). *Crossroads: The Drama of a Soap Opera*. London: Methuen.

Hodge, R., and Tripp, D. (1986). *Children and Television*. Cambridge: Polity.

Jameson, F. (1984). "Postmodernism, or the Cultural Logic of Late Capitalism." *New Left Review* 146 (July/August), 53–92.

Jenkins, H. (1988a). " 'Going Bonkers!': Children, Play and Pee Wee." *Camera Obscura* 18.

Jenkins, H. (1988b). *"Star Trek* Return, Reread, Rewritten: Fan Writing as Textual Poaching." *Critical Studies in Mass Communication* 5 (2), 85–107.

Katz, E., and Liebes, T. (1984). "Once upon a Time in Dallas." *Intermedia* 12 (3), 28–32.

Katz, E., and Liebes, T. (1985). "Mutual Aid in the Decoding of *Dallas*: Preliminary Notes from a Cross-Cultural Study," in P. Drummond and R. Paterson (eds.) *Television in Transition* (pp. 187–198). London: British Film Institute.

Katz, E., and Liebes, T. (1987). *On the Critical Ability of Television Viewers.* Paper presented at the seminar *Rethinking the Audience,* University of Tubingen, February.

Katz, J. (1988). *Moral and Sensual Attractions for Doing Evil.* New York: Basic Books.

Kottak, P. (ed.) (1982). *Researching American Culture.* Ann Arbor: University of Michigan Press.

Laclau, E. (1977). *Politics and Ideology in Marxist Theory.* London: New Left.

Lakoff, G., and Johnson, M. (1980). *Metaphors We Live By.* Chicago: University of Chicago Press.

Lefebvre, H. (1971). *Everyday Life in the Modern World.* London: Harper & Row.

Lewis, J. (1985). "Decoding Television News," in P. Drummond and R. Paterson (eds.) *Television in Transition* (pp. 205–234). London: British Film Institute.

Malcolmson, R. (1982). "Popular Recreations under Attack," in B. Waites, T. Bennett, and G. Martin (eds.) *Popular Culture: Past and Present* (pp. 20–66). London: Croom Helm/Open University Press.

McKinley, R. (1982). "Culture Meets Nature on the Six O'Clock News: An Example of American Cosmology," in P. Kottak (ed.) *Researching American Culture* (pp. 75–82). Ann Arbor: University of Michigan Press.

Mercer, C. (1983). "A Poverty of Desire: Pleasure and Popular Politics," in Formations (ed.) *Formations of Pleasure* (pp. 84–100). London: Routledge & Kegan Paul.

Mercer, C. (1986). "Complicit Pleasures" in T. Bennett, C. Mercer, and J. Wollacott (eds.) *Popular Culture and Social Relations* (pp. 50–68). Philadelphia: Open University Press.

Meyrowitz, J. (1985). *No Sense of Place: The Impact of Electronic Media on Social Behavior.* New York: Oxford University Press.

Michaels, E. (1986). *Aboriginal Content.* Paper presented at the meeting of the Australian Screen Studies Association, Sydney, December.

Morley, D. (1986). *Family Television.* London: Comedia.

Morse, M. (1983). "Sport on Television: Replay and Display," in E. A. Kaplan (ed.) *Regarding Television* (pp. 44–66). Los Angeles: American Film Institute/University Publications of America.

Mulvey, L. (1975). "Visual Pleasure and Narrative Cinema." *Screen* 16 (3), 6–18.

Palmer, P. (1986). *The Lively Audience: A Study of Children around the TV Set*. Sydney: Allen & Unwin.

Pressdee, M. (1986). "Agony or Ecstasy: Broken Transitions and the New Social State of Working-Class Youth in Australia." Occasional Papers, S. Australian Centre for Youth Studies, S.A. College of A.E., Magill, S. Australia.

Radway, J. (1984). *Reading the Romance: Feminism and the Representation of Women in Popular Culture*. Chapel Hill: University of North Carolina Press.

Rogge, J. U. (1987). *The Media in Everyday Family Life: Some Biographical and Typographical Aspects.*" Paper presented at the seminar *Rethinking the Audience*, University of Tubingen, February.

Samuel, E. (ed.)(1981). *People's History and Socialist Theory*. London: Routledge & Kegan Paul.

Seal, G. (1986). *Play*. Paper delivered to the Gender and Television Group, Perth, W. Australia.

Seiter, E., Kreutzner, G., Warth, E. M., and Borchers, H. (1989). " 'Don't Treat Us Like We're So Stupid and Naive': Towards an Ethnography of Soap Opera Viewers," in E. Seiter, G. Kreutzner, E. M. Warth, and H. Borchers (eds.) *Remote Control: Television and its Audiences*. London: Routledge.

Smythe, D. (1977). "Communications: Blindspot of Western Marxism." *Canadian Journal of Political and Social Theory* 1 (3), 1–27.

Stallybrass, P., and White, A. (1986). *The Politics and Poetics of Transgression*. Ithaca, NY: Cornell University Press.

Stamm, R. (1982). "On the Carnivalesque." *Wedge* 1, 47–55.

Stedman-Jones, G. (1982). "Working-Class Culture and Working-Class Politics in London, 1870–1900: Notes on the Remaking of a Working Class," in B. Waites, T. Bennett, and G. Martin (eds.) *Popular Culture: Past and Present* (pp. 92–121). London: Croom Helm/Open University Press.

Stern, L. (1981). "Fiction/Film/Femininity." *Australian Journal of Screen Theory* 9/10, 37–68.

Stone, G. (1971). "American Sports: Play and Display," in E. Dunning (ed.) *The Sociology of Sport: a Selection of Readings* (pp. 47–59). London: Cass.

Thompson, R. (1983). "Carnival and the Calculable," in Formations (ed.) *Formations of Pleasure* (pp. 124–137). London: Routledge & Kegan Paul.

Treichler, P. (1987). "AIDS, Homophobia and Biomedical Discourse: an Epidemic of Signification." *Cultural Studies* 1 (3), 263–305.

Tulloch, J., and Moran, A. (1986). *A Country Practice: "Quality Soap."* Sydney: Currency.

Waites, B., Bennett, T., and Martin, G. (eds.) (1982). *Popular Culture: Past and Present*. London: Croom Helm/Open University Press.

Walton, J. (1982). "Residential Amenity, Respectable Morality and the Rise of the Entertainment Industry: The Case of Blackpool, 1860–1914," in B. Waites, T. Bennett, and G. Martin (eds.) *Popular Culture: Past and Present* (pp. 133–145). London: Croom Helm/Open University Press.

Williamson, J. (1986). *Consuming Passions: The Dynamics of Popular Culture*. London: Marion Boyars.

About the Author

John Fiske is Professor of Communication Arts at the University of Wisconsin-Madison. He has written widely on the subject of popular culture and is the author of *Reading Television* (with John Hartley), *Introduction to Communication Studies, Myths of Oz* (with Bob Hodge and Graeme Turner), and *Television Culture*, and is the general editor of the journal *Cultural Studies*. Born and educated in Great Britain, Professor Fiske has taught previously both there and more recently at Curtin University in Western Australia. He is an inveterate consumer of popular culture.

Index